James McNeill Whistler

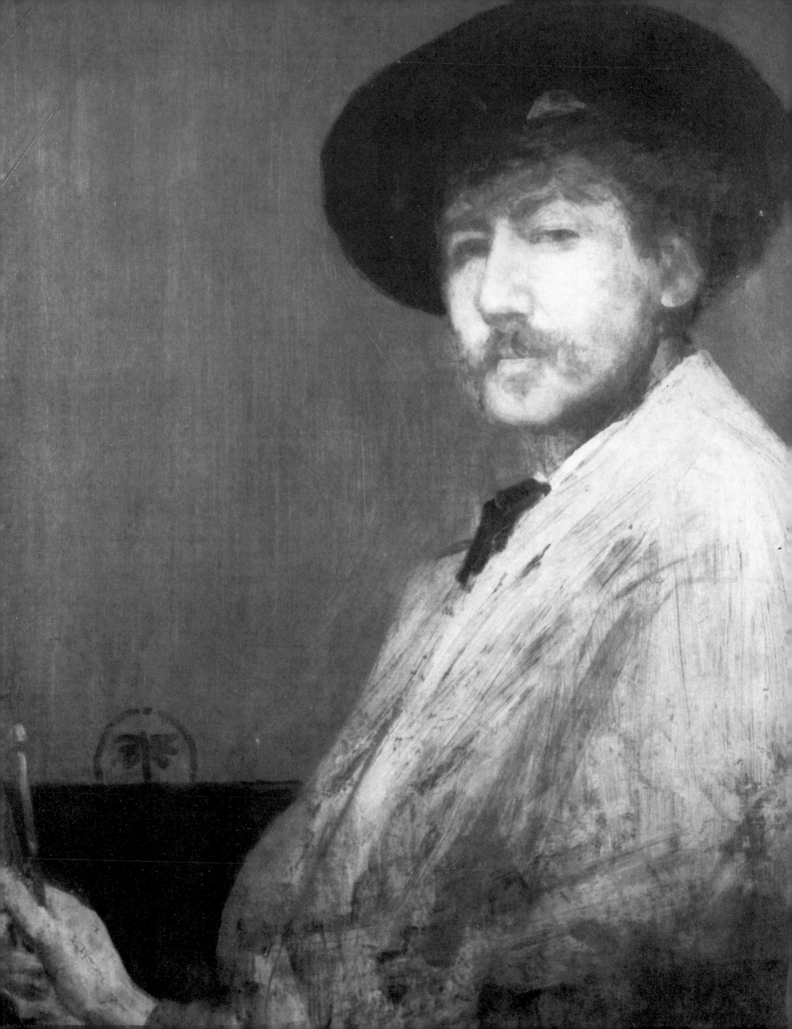

Hilary Taylor

James McNeill Whistler

TABARD PRESS

Acknowledgements

My very grateful thanks go to the numerous people who have helped me in the preparation of this book.

I must make particular mention of Ronald Pickvance, now at Glasgow, for invaluable advice and encouragement. Others who have been working on the Whistler Collection at Glasgow, especially Margaret MacDonald and the late Professor Andrew McLaren Young, have also provided a great deal of help.

Many members of the staff of galleries and museums, and several people with private collections, have given me much of their time, for which I am greatly indebted.

I am grateful to The Library of Congress, Washington D.C., and to The University Court at The University of Glasgow, for permission to quote from the Pennell Correspondence and from letters lodged in Glasgow University Library.

Finally, I should like to thank Jo Hickey, Bob Saxton and my husband for help and advice in the final stages.

All oil paintings illustrated in this book are on canvas unless otherwise specified.

Frontispiece *Arrangement in Grey: Self Portrait*, 1871–3, oil, 74.9 × 53.3 cm (29½ × 21 in.). Courtesy of The Detroit Institute of Arts; Bequest of Henry Glover Stevens; photo courtesy of The Arts Council of Great Britain.

North American rights reserved by William S. Konecky Associates

Tabard Press is an imprint of William S. Konecky Associates

ISBN: 0-914427-27-X

Printed and bound in Portugal

Contents

1 Early Years: Training, Contacts and Influences

James McNeill Whistler has been the subject of much attention, both during his lifetime and since his death in 1903. But the doggedly researched volumes on his *Life*, published by the Pennells in 1908, are typical in their tendency to concentrate on the life and legend of the man rather than on the significance of his art. His reputation as a painter has suffered in consequence. The notorious wit and fashionable dandy could not easily be recognized also as an artist of serious intention.

Almost from the start, however, Whistler was consciously examining and often contradicting the contemporary canons of art. He developed a concern for the abstract qualities of his media: for composition, balance and rhythm. There are, in a number of the astonishingly free Nocturnes of the seventies, or in the tiny panels of the nineties, examples of abstract thinking which can only be matched in some of the most sophisticated painterly experiments of this century.

Whistler was also among the first to question the traditional role of art and the artist in society. He was concerned not only with the relationship between painter and patron, but also with the broader problem of placing art in a rapidly changing society; questioning its role in daily life, its impact on attitudes and behaviour.

His ideas did not develop accidentally, nor were they the result of mere eccentricity, as a good many of his contemporaries seemed to think. From his letters, notes and essays there emerges an increasingly firm and logical pattern of thought. As a result, the impact of Whistler's art and ideas upon his time was substantial. His influence not only emerged in the work of painters who admired his art, but, more importantly, it shaped and conditioned the critical attitudes which appeared around the turn of the century. He encouraged an attitude of logical thinking, constant questioning and antagonism to insularity, all of which are fundamental to the art of this century.

Whistler's beginnings were entirely respectable, if not altogether commonplace. He was born in 1834 in Lowell, Massachusetts, and christened James Abbott (he later dropped the Abbott and adopted his mother's name McNeill). For some of his early years he lived in Russia, where his father was employed by the Tsar as engineer in charge of the construction of the railway. After his father's death Whistler travelled to England with his family, returning to enter the United States Military Academy at West Point in 1851. He was discharged in 1854 and shortly afterwards moved to the US Geodetic Coastal Survey, where his duties included etching maps and topographical plans. This too was short-lived. In 1855 Whistler determined to leave for Paris and become an artist.

Whistler's artistic endeavours up to this point seem to have been mainly in the field of portraiture, perhaps for the simple reason that friends and relatives offered the most convenient models.[1] There was certainly no indication at the outset of his career that Whistler was looking for anything other than a training along conventional lines which would lead to respectability and success.

In November 1855 Whistler arrived in Paris. In June the following year he enrolled in the studio of Charles Gleyre, doubtless encouraged by the fact that this master did not charge tuition fees. Gleyre was not actually a member of the

Académie or the Ecole des Beaux Arts, but he followed the accustomed practice of training his pupils for the Prix de Rome and the minor official competitions. He insisted on the necessity of drawing with complete facility and accuracy as a basis for all painting, though there is little evidence to suggest that Whistler followed this pattern with much assiduity. Indeed, he was not the only student to be bored by the routine groundwork considered essential. Another of Gleyre's pupils observed of his master, 'He liked one to sketch for a long time, and not begin to paint until later; he was convinced that drawing is the foundation of all art. Most of the students became impatient with drawing and began to paint before he wanted them to.'[2]

Whistler, with others, probably did not take as much advantage as he might of the thorough training to be received at Gleyre's studio. The prevailing atmosphere among the art students in Paris, epitomized by two much discussed books, Henri Murger's *Scènes de la Vie Bohème* and Théophile Gautier's *Mademoiselle de Maupin*,[3] encouraged him, and some of his friends, to lead an ostentatiously bohemian existence. His more sober English associates, Thomas Armstrong, Edward Poynter and George du Maurier, dubbed Whistler the 'Idle Apprentice'. It was in this guise that he appeared, much to his indignation, in George du Maurier's *Trilby*, which celebrated these student days and was serialized in *Harper's Magazine* in 1894.[4]

Because of Whistler's apparent lack of interest in his official studies, any influence Gleyre might have had in shaping his pupil's future development has been understated.[5] It would seem that the relationship merits a little further examination.

Ultimately Gleyre followed, in his own painting and in his instruction, the academic pattern of obtaining a carefully detailed finish with a series of superimposed coats of paint. Yet in his teaching Gleyre also had a fundamental concern to encourage originality. In this he seems to have been reflecting a growing emphasis upon the variety of individual expression manifested in the work of different artists, a reaction against the dictates of convention. This emphasis was to be found even in academic circles by the 1850s and culminated in 1863 in reforms in the system of academic training. These reforms were intended to remove the stultifying restrictions on originality imposed by the official competitions; and many of the methods which received sanction had been heralded by Gleyre.[6] He developed complete facility in the handling of media, emphasized compositional variety, frequent sketchwork before landscape and figure, and memory training; all of which must have provided an important stimulus for Whistler, and for those slightly later pupils the young Impressionists.

Perhaps the most notable aspect of Gleyre's teaching for Whistler was the emphasis placed on the careful and ordered preparation of the palette, before any approach to the canvas might be made. Each tone had its appointed place, and appropriate brushes were to hand to change regularly. Whistler took up this craftsmanly approach to his materials and their preparation, developing it until it became a process which had its own artistic, creative justification. His search for paper and canvas of the precise shade and texture; his constant change of brushes; his exacting demands on the consistency and tone of his paint; his attention to lighting, display and exhibition: all these were lifelong preoccupations, probably engendered and encouraged by Gleyre's emphasis upon planning and preparation.

Another important element of the teaching programme must have considerably facilitated a sharp awareness and easy manipulation of colour and form. Gleyre advised his students to execute studies made from the model when that was no longer before them, and was pleased to find in these studies far greater evidence of individual originality than in the first products. This use of memory in composition was, again, something Whistler converted from a simple teaching discipline into a

fundamental part of his creative process. In later years numerous followers and associates witnessed his easy dependence upon his memory for effects and subtle tonal changes, undoubtedly significant in determining the character of his whole work.

Gleyre had a particular interest in exploiting sketch techniques to develop personal expression. He himself was accustomed to painting several sketches in quick succession, laying in the overall vivid impression. These pieces he regarded as steps on the road to a completed work. But thus he bred in his students a feeling for expressive composition attained through the sketch. And though Whistler did not long continue to sketch as a mere preparatory practice, his continual development of a fairly limited range of themes and his habit of painting on small panels or etching on the spot reflect this concern for expressive and original composition based on the sketch technique.

Perhaps then Whistler applied himself to his training during these years with a little more dedication than is apparent from his own and his friends' accounts of his exploits. He does not seem to have followed the academic students' practice of copying in the Louvre or the Luxembourg as assiduously as did, for instance, his contemporaries James Tissot and Edgar Degas. But he did tell the Pennells of a number of copies, mainly commissions, which he executed at this time.[7] It was while he was copying a Velazquez in the Louvre, in October 1858, that Whistler met Henri Fantin-Latour, a French artist working in the studio of Paul Lecoq de Boisbaudran.

Through his friendship with Fantin Whistler must have become thoroughly conversant with the teaching of Lecoq. The latter had developed a specific system of instruction, imposed upon the conventional academic training, intended to promote the exercise of memory to facilitate the expressive powers of the artist.

Lecoq's training of the memory was more systematic than Gleyre's approach, and possibly more influential for Whistler. He included the study of models as they moved out of doors, in natural surroundings. Fantin recounts that expeditions were made into the country, where the students produced memory studies of one another. Lecoq thus encouraged a conscious mental retention of the image. His teaching, like that of Gleyre, encouraged a more personal manipulation of colour and content, the emphasis being upon individual reaction rather than on external convention. It was a powerful stimulus for Whistler.

Fantin was himself important. He was a scholarly and dedicated artist, and proved a powerful antidote to the aggressively bohemian attitudes of Whistler and his 'no shirt' friends. He executed copies throughout his life, not just as a bread and butter occupation, or as the result of mere academic habit; but out of a driving desire to reveal the techniques and impulses which lay behind a masterpiece.[8] Fantin must have encouraged Whistler to widen his experience of artists of past generations, and to develop the sensitive and considered approach to his art that lasted his whole career.

This devotion to the great masters of the past did not, however, preclude Fantin or Whistler from being acutely aware of the staleness of much current academic practice. With his friend Alphonse Legros, Fantin had been caught up by the almost revolutionary fervour of Gustave Courbet and his followers; Whistler soon joined the group. The attraction of Courbet lay in his forceful and declamatory rejection of many of the currently acceptable canons of art. It was the assertively individual character of the artist which was manifested in each painting, rather than the conservative spirit of the studios.

Courbet had first arrived in Paris in 1840, when he chose to work mainly in the free Académie Suisse, which offered no academic tuition.

After arriving in Paris he was very disillusioned to see the pictures of the French school, and told his companions that if this was painting he would never be a painter . . . Seeing all these efforts, he said to himself: 'The only thing to do is to go off like a bomb across all the subdivisions.'[9]

Courbet was not, however, wholly antagonistic to the Salon; at that time, of course, there was virtually no precedent for independent exhibition. He began to submit in 1844, but though he was sometimes successful his work was often rejected. From the titles (*A Monk in a Cloister*, 1840; a self portrait, *Despair*, 1841), his early work, now lost, appears to have been purely Romantic. By the end of the decade this was replaced by the bold and assertive realism of the *Stonebreakers* and the *Burial at Ornans*. The *Burial at Ornans* and the *Artist's Studio* (Plate 37) were both rejected by the committee for the 1855 Exposition Universelle. Courbet, undeterred, organized an exhibition of his own, the 'Pavilion of Realism', to take place alongside the official show. A manifesto accompanied it, in the form of a letter to Champfleury, explaining the *Artist's Studio*. This painting, by its size and content, was to prove he was

> . . . not yet dead, nor Realism either . . . It is the moral and physical history of my studio . . . the people that serve me, that support me in my ideas, that participate in my actions. These are people who live on life, who live on death; it is high society, low society, middle society; in a word, it is my way of seeing society in its interests and in its passions; it is the world that comes to me to be painted.

This statement is still, of course, full of Romantic overtones. The radical elements in Courbet's art were his passionate grasp of everyday life, presented on a massive scale; his aggressive and even crude handling of his materials; his unsophisticated, deliberately naïve composition.

Among the figures on the right of the *Artist's Studio* Charles Baudelaire is prominent. He had embarked upon his critical career with his review of the 1845 Salon and had since become a significant literary figure in the movement of revolution against accepted standards and values controlling the content and intent of a work of art. He advocated a passionate realism, a grasp of contemporary life. He was a staunch supporter of Eugène Delacroix, which to some extent tempered his enthusiasm for the more plebeian aspect of Courbet. His demand for 'modern art — that is, intimacy, spirituality, colour and aspiration towards the infinite, expressed by every means available to the arts'[10] — served as emphasis to a slightly different facet of the Realist movement, wherein the importance of the imagination and individual sensation was stressed. At this date, however, the influence of Baudelaire on Whistler, Fantin and their friends, was partly hidden behind the extrovert appearance of Courbet, the man and his art. Baudelaire's more esoteric and aristocratic approach, in which Whistler ultimately developed a fundamental interest, remained as yet of secondary significance.

There are very few early paintings by Whistler extant. The first five years of his career were evidently taken up with study, sketching, copying and etching. It is also probable that much of his work, especially of these years, has disappeared, either through his own selective destruction, or through the depredations of creditors and others who benefited from his bankruptcy in the late 1870s. To increase the vagueness of these years, the exact dating of the few extant early works is virtually impossible on other than purely stylistic grounds. Two paintings, *La Mère Gérard* (Plate 1) and the *Head of an Old Man Smoking* (Plates 2, 3) would seem to have been painted at a roughly similar time. *La Mère Gérard* is probably the earlier, being somewhat more tentative in handling and composition; it was possibly executed shortly before the sketching tour of northern France and the Rhine[11] upon which

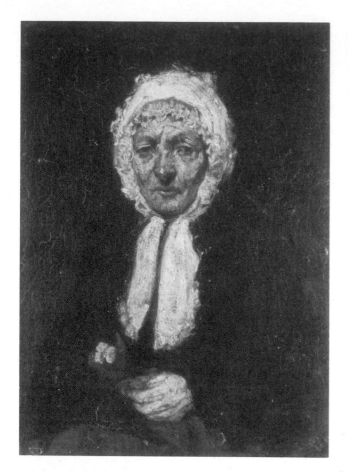

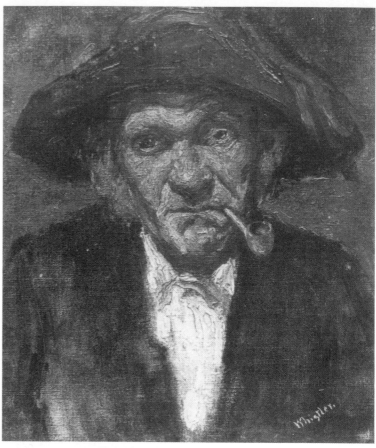

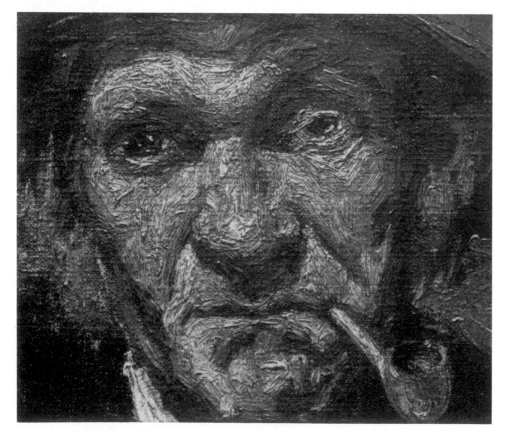

above left
1 *La Mère Gérard*, after 1855, oil on
board, 28.0 × 20.0 cm (11 × 7⅞ in.).
Private collection; photo Sotheby's.

above
2 *Head of an Old Man Smoking*, after
1855, oil, 41.0 × 33.0 cm (16¼ × 13 in.).
Louvre, Paris; photo Musées Nationaux.

left
3 *Head of an Old Man Smoking* (detail).
Louvre, Paris.

4 *The Kitchen* (K 24 II), from 'The French Set', 1858, 22.2 × 15.4 cm (8¾ × 6⅛ in.). Hunterian Art Gallery, University of Glasgow; Revillon Bequest.

Whistler embarked with his friend Ernest Delannoy in the summer of 1858. This trip resulted in the completion of the first set of etchings, the 'Twelve Etchings from Nature', now known as 'The French Set', which was printed by Auguste Delâtre in November 1858 (Plate 4). Among those etchings executed in Paris there is one of Mère Gérard.

The choice of subject, an old flower-seller from the Paris streets, and the vigorous, even harsh execution of the painting, does indicate that Whistler had some interest in Courbet perhaps even before his friendship with Fantin. As we have seen, Courbet had declared his aims in bold terms at his 'Pavilion of Realism' and in its accompanying manifesto in 1855, the year of Whistler's arrival in Paris. His assertion

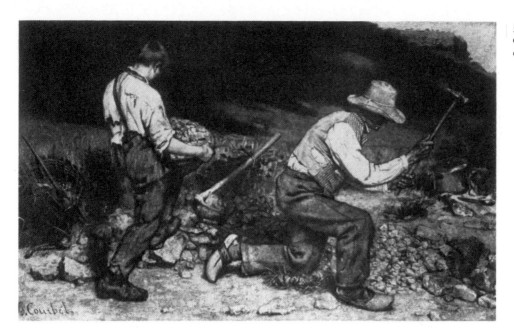

5 Gustave Courbet, *Stonebreakers*, 1849, oil, 91.0 × 115.0 cm (35⅞ × 45¼ in.). The original is now destroyed.

that the artist's role was to question and attack, rather than to uphold, the conventions of society, was obviously to the taste of those students nurtured on the heady wine of Murger and Gautier.

When Whistler's painting was shown at the Royal Academy in 1861, the critic of the *Daily Telegraph* voiced sentiments remarkably similar to those of the early critics of Courbet:

> Far fitter hung over the stove in the studio, than exhibited at the Royal Academy, though it is replete with evidence of genius and study. If Mr. Whistler would leave off using mud and clay on his palette, and paint cleanly, like a gentleman, we should be happy to bestow any amount of praise on him . . . But we must protest against his soiled and miry ways.

There are, however, other elements which would suggest further influences — presumably those elements of composition and study the critic found more gentlemanly. The concentration on a single figure, rather evocative and even pathetic in tone, is characteristic of Whistler's œuvre, and tends to remove some of the generalized political and social implications of Courbet's group representations, such as the labouring *Stonebreakers* of 1849 (Plate 5). The dramatic chiaroscuro (though doubtless the painting has darkened with age); the thickly applied, even scumbled medium; the visible marks of the brush; all are elements which would seem to indicate more than just a glance at masters as divergent as Rembrandt and Hals, Delacroix and even Géricault.

The *Self Portrait* of 1857–8 is of a similar character to Courbet's *Boy with a Black Dog* (1842) and *Man with a Pipe* (1846–7), also self portraits (Plates 6, 7). In the work of both men the declaration of personal vanity is paramount. The large black hats in two of the paintings frame strongly defined features. The broad brushstrokes of the Courbets are even more freely and vigorously applied by Whistler. And Whistler's greater subtlety of composition is already indubitable. The background spaces which swing between figure and canvas edge are strongly defined as part of the rhythmically patterned unit.

The influence of Hals is apparent in this work, in the boldly unconsidered and rather directionless application of the paint, the play upon fairly low tones, the extroverted expression of the subject (Plate 8). Possibly Rembrandt was also called

above right
6 *Self Portrait*, 1857–8, oil, 46.3 × 38.1 cm (18¼ × 15 in.). Courtesy of The Smithsonian Institution, Freer Gallery of Art, Washington D.C.

above far right
7 Gustave Courbet, *Man with a Pipe*, 1846–7, oil, 45.0 × 137.0 cm (17¾ × 53⅞ in.). Musée Fabre, Montpellier; photo Claude O'Sughrue.

right
8 Franz Hals, *Isaak Abrahamsz. Massa*, 1626, oil, 79.7 × 65.1 cm (30¼ × 25⅝ in.). Art Gallery of Ontario, Toronto; Bequest of Frank P. Wood, 1955.

far right
9 Rembrandt van Ryn, *Self Portrait with Iron Collar*, oil, 50.0 × 47.0 cm (22 × 18½ in.). Gemäldegalerie, Staatliche Museen Preussischer Kulturbesitz, Berlin (West).

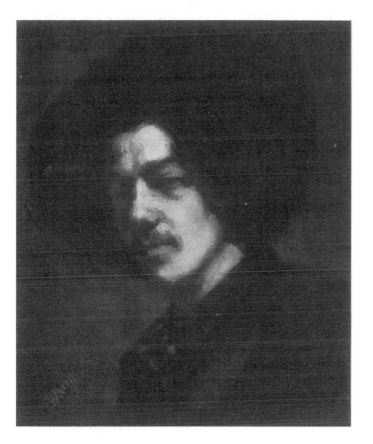

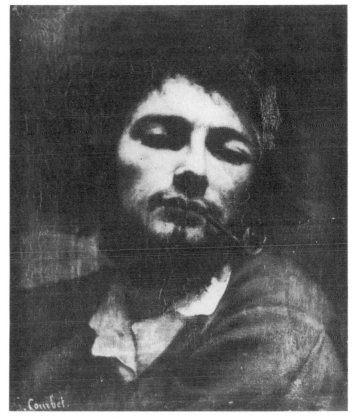

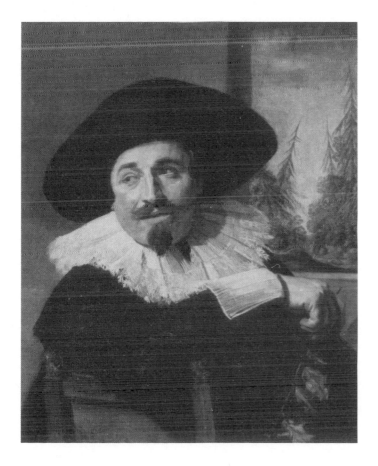

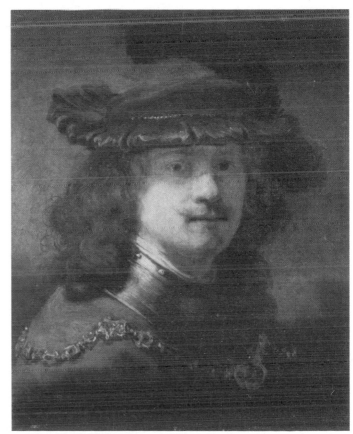

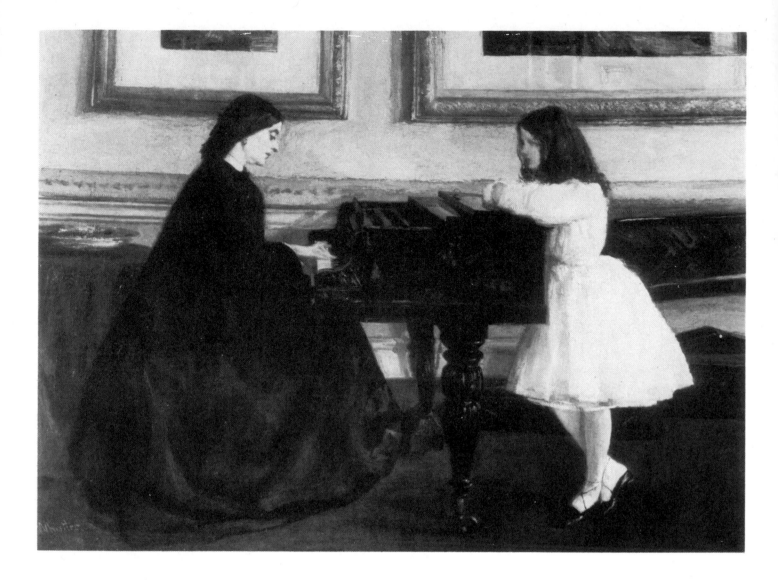

to mind when Whistler began this study of his own features (Plate 9). There was certainly, from about this time, a fair amount of attention paid by writers and critics to the art of the Low Countries. This was, of course, associated with the growing identification of politically democratic ideals and the genre themes so characteristic of seventeenth-century Holland. As the *Daily Telegraph* review quoted above indicates, there was a generally accepted parallel between a particular kind of subject-matter and handling, and plebeian or 'ungentlemanly' sympathies. And in politically unstable France of the 1840s and 1850s, with Courbet's radical example, these links were being popularly asserted even by artists, such as Whistler, who seem not to have had a deep political commitment, but who perhaps regarded such themes as a sign of artistic independence.

Vermeer of Delft was one whose reputation was exhumed, mainly by Thoré Bürger, though also by other writers, such as Gautier. Rembrandt, Hals, de Hooch, Terburg, Jan Steen and numerous other artists, mainly Dutch, were also studied. From an often-quoted reference made by Degas, one must assume that the influence was, indeed, pervasive in Paris art circles, and certainly not confined to Whistler and his immediate friends: 'In our beginnings, Fantin, Whistler and I were all on the same road, the road from Holland.'[12]

10 *At the Piano*, 1858–9, oil, 66.0 × 90.0 cm (26 × 35⅜ in.). Taft Museum, Cincinnati, Ohio; Louise Taft Semple Bequest.

11. Jan Vermeer, *Lady at the Virginals,*
c. 1662, oil, 73.6 × 64.1 cm (29 ×
25¼ in.). Reproduced by gracious
permission of Her Majesty the Queen.

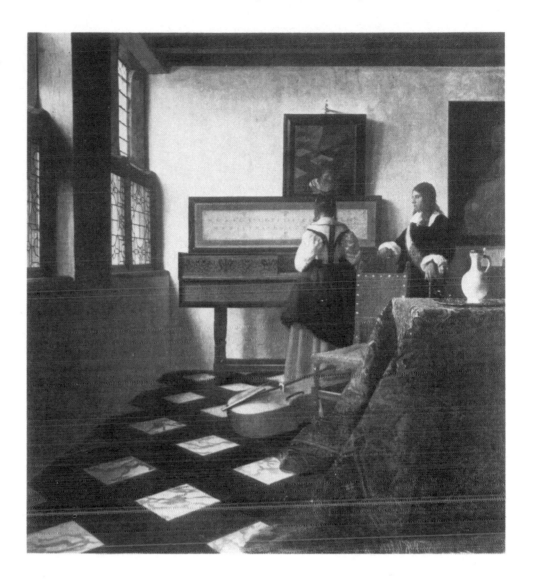

The influence of Vermeer is particularly noticeable in Whistler's work in a
painting begun late in 1858, *At the Piano* (Plates 10, 11). The subjects, Whistler's
half-sister and her daughter, must have been painted after one of his fairly frequent
trips across the Channel. Except in so far as such domestic genre subjects were
generally appealing to an English audience, there is, however, little of an English
influence apparent.

The colouring, clearly, does not come from the warm, blond tones of Vermeer,
but rather from the limited palettes of Hals or Rembrandt, beloved of Fantin. In this
it may be compared to the latter's *Two Sisters* which, together with his *Girl Reading*,
a *Self Portrait* and Whistler's *At the Piano*, was refused by the 1859 Salon. Legros,
Théodule Ribot and other friends were also rejected. Following the example of
Courbet at the Pavilion of Realism, though not, perhaps, with such magnificent
gesture, the group organized its own exhibition at the studio of a friend of Courbet,
François Bonvin, and titled it 'L'Atelier Flamand'.[13]

At the Piano is a quiet, intimate family group. Besides inspiration from Holland,
the influence of Jean-Baptiste Chardin, who was much admired by Bonvin, is also
discernible. And Bonvin himself was a painter of firmly organized domestic scenes of
similar nature. The subtle play with a limited tonal range is already masterly; the

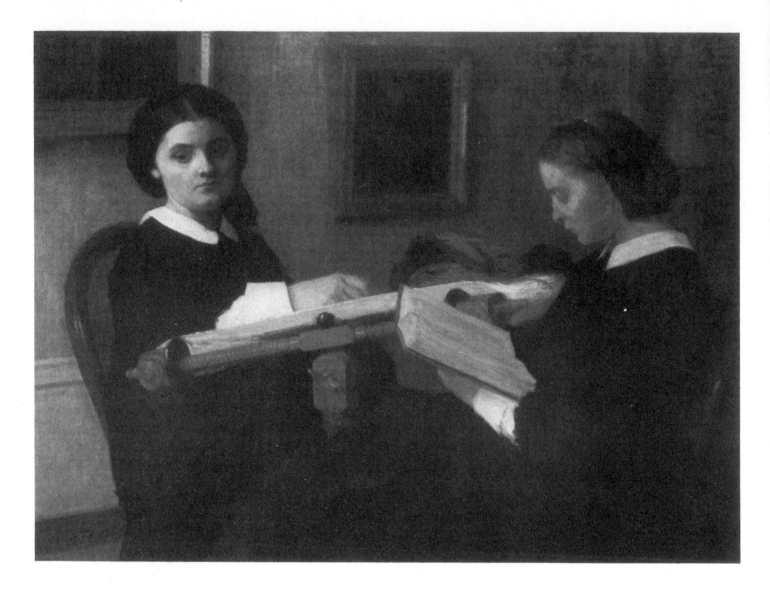

architectonic composition acutely considered, if a trifle obvious. The space of the canvas is flattened, the surface plane emphasized at constant intervals by the assertion of parallel rhythms. The calm, horizontal axis, typical of much of Whistler's work, is in contrast with the more casual, upright line of Fantin's *Two Sisters* (Plate 12).

Whistler paid frequent visits to England during these years, staying with his relatives in London. By May 1859 he had apparently determined to remain. *At the Piano* was accepted at the Royal Academy in 1860. Its purchase by John 'Spanish' Phillip, a painter of repute, and the praise it received from John Everett Millais, an artist whom Whistler admired, confirmed him in the supposition that England was full of promise for the young artist. He had as yet none of his subsequent disdain for the British.

Whistler often stayed with his brother-in-law, Seymour Haden. He also had a number of other friends and acquaintances, influential in their various ways. He resumed contact with those English students he had known in Paris: Edward Poynter, George du Maurier, Frederick Leighton and Thomas Armstrong. He also enjoyed the friendship and patronage of the wealthy Ionides family, Luke and Aleco having been Paris companions. His initial success at the Royal Academy; the

12 Henri Fantin-Latour, *The Two Sisters*, 1859, oil, 98.0 × 130.0 cm (38⅝ × 51⅛ in.). The St Louis Art Museum, Missouri.

welcome of new patrons—life must have appeared a pleasant contrast to the rather comfortless challenge of the bohemian existence he had pursued in Paris.

Paris associates were encouraged by Whistler to visit England, and were invited to stay with the Hadens. His two closest French friends, Fantin and Alphonse Legros, were among those who came. In Paris, late in 1858, these two, with Whistler, had formed themselves into the Société des Trois, whose constant search was for a new kind of painting to express their individuality, and their rejection of academic standards.[14] Fantin's first visit to London was in July 1859. The third in the trio, Legros, came to settle in 1863. Both received hospitality and support from Haden, and met potential patrons such as Alexander Ionides and the Edwin Edwardses.

It is in fact quite astonishing, in view of the rather insular attitudes which certainly seem to have characterized the official English art world, how many of Whistler's French contemporaries entertained notions of the rich possibilities awaiting them in London. It is true that Legros's decision to remain in England must have been dictated, at least in part, by the need to flee the debts left by his father on his death. He was probably also influenced by the example of Lecoq de Boisbaudran to become a teacher, and England must have seemed to offer the best opportunities.[15] Even as late as 1868, however, by which time Whistler was becoming somewhat disillusioned about his prospects, Edouard Manet, another French associate, wrote to Fantin that he felt it was about time he made some money: 'As, like you, I believe there is not much chance of doing anything in our stupid country, with its population of bureaucrats, I want to try and arrange for an exhibition in London next year.'[16]

Whistler submitted not only to the Royal Academy, but also, intermittently, to the Salon, although none of his paintings was accepted there until 1865. In contrast, he was consistently successful at the Royal Academy until the same year. In 1860 and 1861 he complemented his main exhibits, *At the Piano* and *La Mère Gérard*, with several graphic works. And in 1862, besides an etching of *Rotherhithe*, he showed the oil paintings the *Thames in Ice* and *Coast of Brittany: Alone with the Tide*.

The former (Plates 14, 15), also more specifically entitled *25th December 1860 on the Thames*, reveals Whistler in the very forefront of that movement in France which was developing a concern for the notation of light and atmosphere prevailing at a particular time of the day, the play of light upon an object, and a manner of direct and vigorous painting: themes the Impressionists were to pursue more consistently in the following years. The colour, close to Courbet, as was that of the early Impressionist palette, is cool, resonant and thickly applied in long dashing strokes. Whistler frequently visited France. His association with Paris and familiarity with the French *avant garde* hence continued uninterrupted. He maintained a regular correspondence with Fantin and also became friendly with Manet, whose *Guitarrero*, shown at the 1861 Salon, attracted the attention of the Société des Trois[17] (Plate 13).

The *Coast of Brittany*, painted in the autumn of 1861 and shown at the same Academy exhibition of 1862, also still makes clear reference to Courbet: the sharply outlined rocks, their planes accentuated by the direction of the brushstrokes, the vigorously painted waves in the background (Plate 16). Possibly there is also something of a deliberately Courbetesque naïve and untutored technique. However, the evocative addition to the title, *Alone with the Tide*, and the small, lone figure romantically dressed in national costume, augment the simple sentiment of its appeal and reveal Whistler to be fully aware of the contemporary English demand for anecdotal genre pieces.

The combined impact of the two environments with which Whistler was becoming familiar can again be identified in the *Harmony in Green and Rose: the*

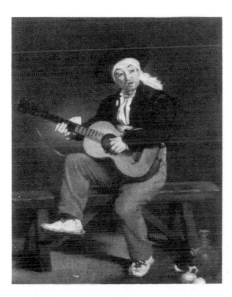

13 Edouard Manet, *Guitarrero*, 1860, oil, 147.3 × 114.3 cm (58 × 45 in.). The Metropolitan Museum of Art, New York; Gift of William Church Osborn, 1949.

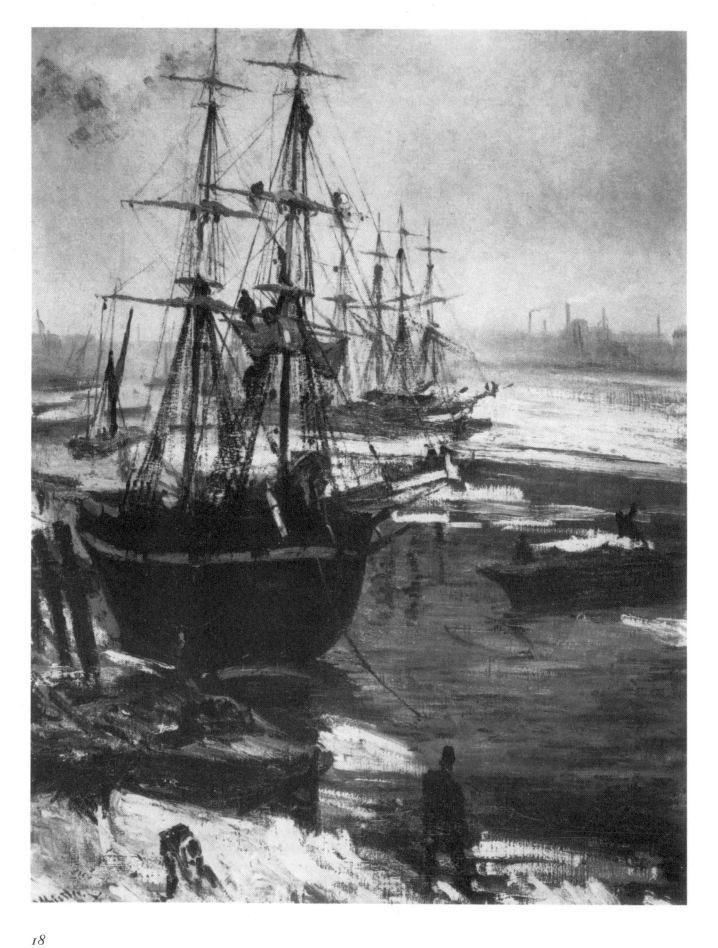

15 *Thames in Ice* (detail). Courtesy of The Smithsonian Institution, Freer Gallery of Art, Washington D.C.

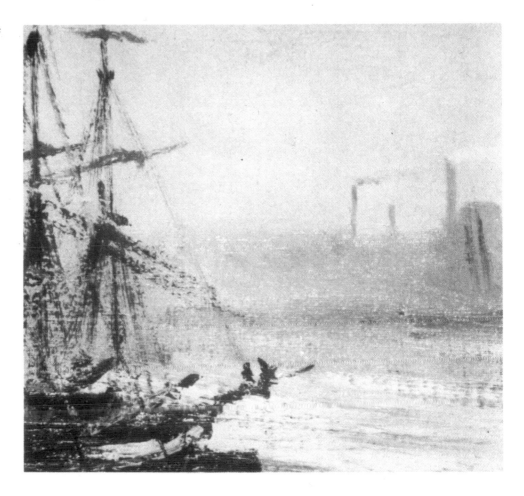

14 *Thames in Ice*, 1860, oil, 74.6 × 55.3 cm (29⅜ × 21¾ in.). Courtesy of The Smithsonian Institution, Freer Gallery of Art, Washington D.C.

Music Room, painted in 1860 (Colour Plate 3, p. 38). The richly applied paint and resonant contrasts stem mainly from Courbet; they also recall Manet. Fantin and his Dutch predecessors are manifest in the introduction of rectangular accessories to give the composition architectonic definition. At the same time this too has a subtitle, in this case the original title, *The Morning Call*, which again points to Whistler's awareness of English art and its demand for human relationships and anecdote.

In both the *Coast of Brittany* and the *Harmony in Green and Rose* there would seem to be evidence of yet another influence: that of Japan. The precise date for the appearance of this stimulus has been hotly debated.[18] It is necessary to differentiate here between *japonaiserie* and *japonisme*. Both these terms were in use by the 1870s, the former generally taken to indicate an interest in Japanese motifs because of their decorative, exotic or fantastic qualities; the latter describing the use of devices of composition, presentation and structure derived from Japanese works. It is clear that by 1864, in the series of figures in Japanese robes, such as the *Lange Lijzen of the Six Marks*, Whistler's fascination for the exotic qualities of Oriental artefacts falls into the category of *japonaiserie*. This has led some writers to doubt if Whistler could have responded in a more sophisticated way to problems of structure and form some years earlier. It cannot be doubted that there are other influences on these two paintings, as discussed above. Nonetheless, in the flat, black sweep of the figure in the *Music Room*, and the dramatic and unconventional spatial composition, and in the expanse of sand stretching before the incisively drawn rocks of the *Coast of Brittany*, the structural influence of Japanese prints is manifest, even if, as yet, fairly superficial. It certainly seems likely that Whistler would have been becoming aware of Japanese

16 *Coast of Brittany: Alone with the Tide*, 1861, oil, 87.2 × 116.7 cm (34⅜ × 46 in.). Courtesy of The Wadsworth Atheneum, Hartford, Connecticut; Gift of Susie Healy Camp in memory of William Arnold Healy.

prints by this date. Baudelaire's letter to Arsène Houssaye, written at the end of 1861, confirms that Japanese woodcuts were by then familiar to him and his circle.[19] There is also the claim by Whistler's friend Félix Bracquemond that he had discovered some Japanese woodcuts as early as 1856, two years after trading relations between the Orient and the West had been opened up.[20] In 1862 Japan participated for the first time in an international exhibition held in London. The same year saw the opening of La Porte Chinoise by Mme de Soye in Paris. This shop was frequented by many of Whistler's friends, Edouard Manet, James Tissot, Zacharie Astruc, Emile Zola, Edgar Degas and Henri Fantin-Latour, the last often being commissioned to purchase items for Whistler. Several collections of Oriental items were made, Whistler's being among the foremost.

Whistler, during the early 1860s, seems to have been searching for a more precise formula for his art than he had found in the bombastic declarations of Courbet. Perhaps this encouraged him to plan with Fantin an expedition to Madrid in 1862, particularly to see the paintings of Velazquez in the Prado. Whistler had for some time been fascinated by Velazquez. One of his earliest acquaintances, Frederick B. Miles, relates that during his earliest years in Paris the painter first modelled himself

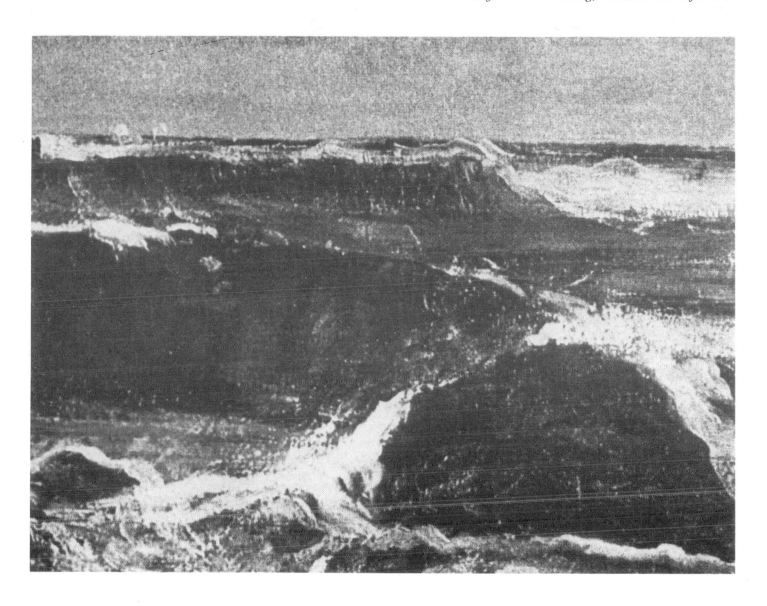

17 *Blue Wave, Biarritz* (detail), 1862, oil. Hill-Stead Museum, Farmington, Connecticut. See also Colour Plate 4, p. 39.

on Rembrandt but then discovered Velazquez, whom he considered still greater.[21] Now Fantin and Whistler intended to visit the Prado together; indeed so much were they in sympathy at this date that when Fantin was unable to accompany him Whistler declared that he would stand in for the latter's own eyes when looking at the paintings. However, the trip was not completed. Whistler got as far as crossing the frontier from Guéthary to Fontarabie, and in a letter to Fantin he expressed the astonishment he felt at the sudden change in atmosphere. But he ventured no farther. The visit was postponed in the belief that Fantin would be able to make the journey in the following year. In the event it was never accomplished. In 1866 Whistler wrote, 'Madrid, pas encore . . .'.

From this trip, however, resulted one finished picture, *Blue Wave, Biarritz* (Colour Plate 4, p. 39; Plate 17). This, with its massive breakers and the physical thickness of the paint itself, almost certainly owes a debt to Courbet. The latter had first painted the sea in 1854. His attention had usually been drawn by the vast stillness of the water and sky, and it is generally assumed that Whistler preceded Courbet in the depiction of broken waves. In 1859, however, Zacharie Astruc had discovered in Courbet's studio some sea studies which had been brought back from Courbet's 1854

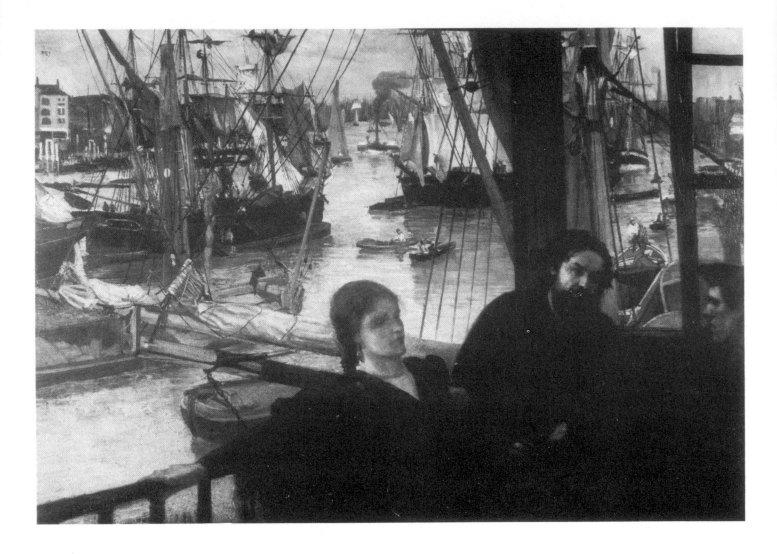

walking tour. His enthusiasm for these was immense:

> They express every hour of the day, all the strange changes of the sea, the liquid, tempestuous, profound sky, infinite as the sea . . . Here a few ships skimming like birds across the clear face of the water . . . again, the lighthouse battered by the waves . . . there a troop of wild white horses.[22]

He describes not only the calm, but all aspects of the sea as they had absorbed Courbet's attention. Even if Whistler had seen none of these studies, he was close enough to Astruc for it to seem very unlikely that he would have missed at least hearing about works that evoked such enthusiasm.

It was during this trip, however, that Whistler expressed, in a letter to Fantin, his growing dissatisfaction with *plein-air* painting. This undoubtedly resulted in part from the waning of Courbet's influence. In a very early letter to Fantin, written shortly after his removal to London, Whistler speaks in terms which clearly indicate that already he was trying to assert his independence of Courbet's influence, if not totally rejecting it. Describing a painting he had recently begun, he begs, 'Hush! Don't tell Courbet!' From the detailed description he gives of the painting, it is evident that he is referring to an early state of *Wapping*, a work which took three years, at least, to complete, only being shown at the Royal Academy in 1864 (Plate 18).

The problems this composition posed were obviously tremendous. The surface is

heavily worked and uneven. In the final state there are many details which have been altered since the days of its conception. Ultimately, however, the difficulties of imposing a strict architecture on a busy and unconfined outdoor scene did not prove insuperable. The control of the composition is firm, even dramatic, and only occasionally awkward. The web of intricate rigging elaborates the surface, asserting the flat plane. The group of figures sharply and diagonally intrudes into the foreground. There are contrasts of bold, rounded shapes and linear details; of thick, vigorous paint and the lucid treatment of the Thames; of low, subtle tone and touches of vivid colour.

The influence of England on Whistler was intensified by new and close contacts. During the summer of 1862, when he had for some time been a settled inmate of London, familiar with its society, Whistler met the English painter D. G. Rossetti. The two became close friends and Whistler was absorbed into the circle which included, among others, Algernon Swinburne and George Meredith. He embarked with enthusiasm upon the task of introducing Rossetti to his French friends and their interests. William Michael Rossetti recalled that it was through Whistler that he and his brother first became acquainted with Japanese art.[23] When Fantin visited London he was introduced to Rossetti and was shown around by him. On the latter's return visit to Paris Fantin put himself at Rossetti's disposal and accompanied him to the Louvre, the Luxembourg, and exhibitions of work by Delacroix, Manet and Courbet.

On Delacroix's death Fantin painted his *Homage*, which was shown at the 1864 Salon (Plate 19). Whistler and Legros were included, as well as Baudelaire, Manet, Champfleury, Bracquemond, Albert de Balleroy and Louis Cordier. Fantin took up Whistler's suggestion that Rossetti would also be pleased to be painted. 'Rossetti, too, has told me that he will be very proud to pose for you. He has a superb head and he is a great artist, you will like him a lot!'[24]

Rossetti, however, pleaded lack of time. From a letter to his mother, written during a brief visit to France later in the year, it is clear that, in private at least, his

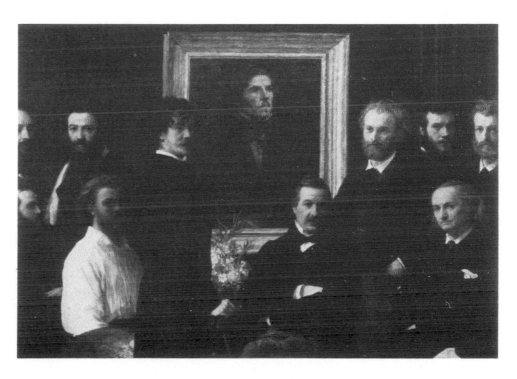

19 Henri Fantin-Latour, *Homage to Delacroix*, 1864, oil, 160.0 × 250.0 cm (63 × 98⅜ in.). The figure in the white shirt is Fantin himself, with Alphonse Legros standing behind him and Whistler standing to his immediate left, in front of the picture frame. Charles Baudelaire is sitting at the extreme right of the bottom row of the painting. To the right of the portrait of Delacroix (i.e. on the opposite side from Whistler) stands Edouard Manet, with Félix Bracquemond behind him. Louvre, Jeu de Paume, Paris; photo Musées Nationaux.

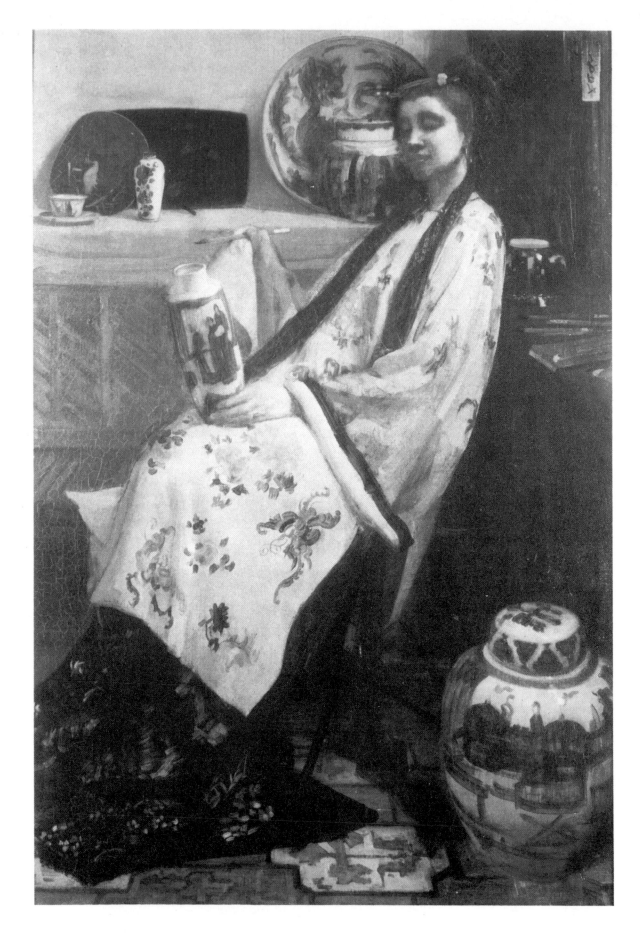

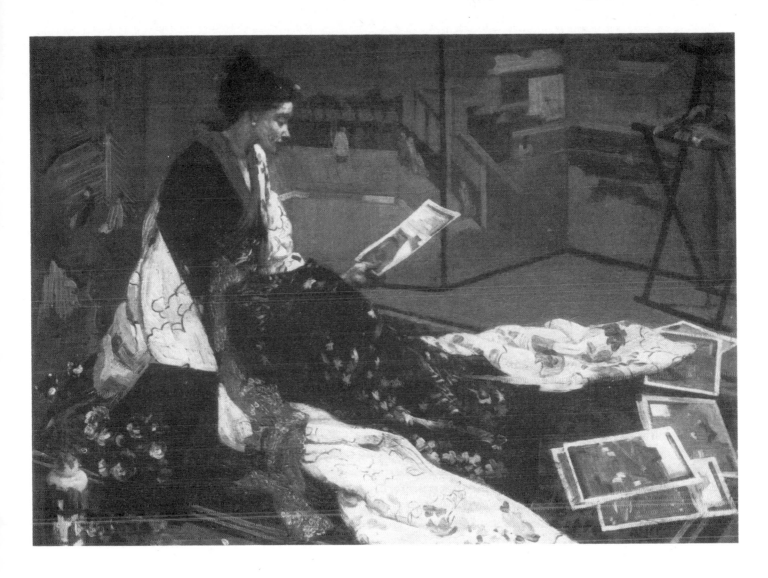

21 *Caprice in Purple and Gold No. 2: the Gold Screen*, 1864, oil on wood panel, 50.0 × 68.4 cm (19¾ × 27 in.). Courtesy of The Smithsonian Institution, Freer Gallery of Art, Washington D.C.

20 *Purple and Rose: Lange Lijzen of the Six Marks*, 1864, oil, 91.0 × 56.0 cm (35⅞ × 22⅛ in.). Philadelphia Museum of Art; John G. Johnson Collection.

opinion of the work of Whistler's French friends, when seen at close quarters, was not altogether complimentary:

> The new French school is simple putrescence and decomposition. There is a man named Manet (to whose studio I was taken by Fantin), whose pictures are, for the most part, mere scrawls, and who seems to be one of the lights of the school. Courbet, the head of it, is not much better.[25]

Swinburne is another figure whom Fantin would have liked to include in his painting, but felt unable to invite directly, doubtless deterred by his already rather awesome legend. Thus, despite some show of willingness, the two worlds did not ultimately come together in the painting.

Whistler clearly had difficulty in resolving the conflicting aims and ideas of the various sources to which he was looking at this time. He was developing closer ties with artists in England, while still maintaining those with his French friends. He was also still anxious to continue as a leading collector of Oriental and exotic artefacts.

At the Royal Academy of 1864 he was represented by the *Lange Lijzen of the Six Marks* (Plate 20), as well as by *Wapping*. The title of the former should perhaps be explained. The 'lange lijzen' is a Dutch phrase referring to the elongated figures on Chinese vases, which were much favoured by collectors in Holland. The 'six marks' refers to the signature and date marks on the vase. When writing to a friend, from

Chelsea in the February of 1864, Whistler's mother describes both the *Lange Lijzen* and some of her son's collection of Oriental items which inspired it. She also remarks, 'No wonder Jemie is not a rapid painter, for his conceptions are so nice, he takes out and puts in over and oft, until his genius is satisfied.'[26] Evidently in this painting Whistler was making no attempt at spontaneity, or at capturing the effects of a passing moment of time. The whole was simply intended as a realization of his ideas of Oriental luxury and exotic abundance. Despite the elaboration, however, the resonant, Rossetti-like colour of both this and the *Caprice in Purple and Gold No. 2: the Gold Screen* (Plate 21) is arranged on the canvas in a firmly co-ordinated succession of tonal areas, asserting the integrity and the constructed balance of the composition. The canvas is laced with repeated touches of the same hue; the rounded shapes of the figures are tautly and flatly related to the geometrically articulated background.

Whistler was in fact so absorbed by the romantic and legendary nature of the Orient that he begged Fantin that he might be painted in Chinese robes for the latter's *Homage to Truth: the Toast*, another group portrait, which was shown at the 1865 Salon. This work had a poor reception. The criticism it received from Paul Mantz serves to underline the confusing, dichotomous position in which Whistler now found himself:

> Fantin, having had the idea of uniting in an Homage to Truth the most recent converts to nature, has had the greatest difficulty in procuring some Realists, and since his painting could not remain empty he was obliged to grant places among the worshippers of the nude goddess, to Whistler, who lives in such close communion with the fantastic . . .[27]

After the robust nature of his early training Whistler must have found the concentration on a slow accumulation of luxurious accessories somewhat irksome. And although Japanese art long remained important to him, he soon abandoned his devotion to its decorative accessories. But the confusion of aims and methods brought about by his attempts at compromise between the very different art of two or even three countries still beset him. The 1860s continued to be years of experiment, sometimes of contradiction, and of a search for a formula by which he could combine the various threads of his interests.

2 The White Girl

There is one theme to which Whistler returned several times with renewed interest during the 1860s: that theme of simply composed female figures generally known as the 'White Girl' paintings. Through the early sixties, subjugated at times to the demands of realism, at times to those of the exotic, he had been developing a concern for the quality of the design of both form and colour. This concern gradually intensified during the latter years of the decade, and its progress is epitomized in the paintings which comprise his exploration of this particular subject.

In 1862, while on the abortive trip to Madrid, when Whistler was expressing to Fantin his dissatisfaction with *plein-air* painting, he returned his attention instead to a portrait of his mistress, Jo Heffernan, on which he had already been working for some time (Colour Plate 5, p. 42). He had begun the painting in Paris in 1861, describing it to George du Maurier early in 1862:

> . . . a woman in a beautiful white cambric dress, standing against a window which filters the light through a transparent white muslin curtain – but the figure receives a strong light from the right and therefore the picture, barring the red hair, is one gorgeous mass of brilliant white.[1]

The picture had first been exhibited in London in May 1862 at the Berners Street Gallery, under the unauthorized title of *The Woman in White*. Despite Whistler's express denial that his painting was remotely connected with the novel of that name, it is not too surprising, in the light of contemporary English attitudes, that it became inextricably involved: 'It is one of the most incomplete paintings we ever met with. A woman in a quaint morning dress of white, with her hair about her shoulders . . . The face is well done, but it is not that of Mr. Wilkie Collins' *Woman in White*.'[2]

In a letter written from Guéthary in 1862, Whistler mentioned to Fantin that on his return to London he planned to '. . . finish the *Grande Tamise* and the *Fille Blanche* for the Paris Salon'.[3] Doubtless it was this that prompted Fantin to remark to his patron Edwin Edwards on a side of Whistler's ambitions he had not previously recognized: his intense determination to be accepted in official circles. But Whistler, together with numerous others, was refused at the 1863 Salon. The news of this came to him while he was on his first visit to Amsterdam, with Legros. As in the previous year in London Jean Martinet offered his dealer's gallery to the 'Refusés' in Paris. But such was the pressure from the very large number who had not been accepted that an official Salon des Refusés was inaugurated: the *White Girl* was despatched.

If she had caused a mild stir in London, in Paris she aroused a furore. The painting, together with Manet's *Déjeuner sur l'Herbe* (Plate 22), proved to be the centre of attraction at the Salon. Whereas in England it had been understood in terms of illustration, the majority of French critics seem to have interpreted it as a poetic fantasy, a visionary painting. Fernand Desnoyers described it as 'A portrait of a spirit, of someone who's psychic. The face, the bearing, the figure, the colour, are strange. It is both simple and fantastic.'[4] The critics Thoré Bürger, Ernest Chesneau and Paul Mantz similarly found in the painting a sense of the mysterious, the strange. To precisely what extent these interpretations of the *White Girl* were born of their authors' environment, to what extent of the specific intentions of Whistler

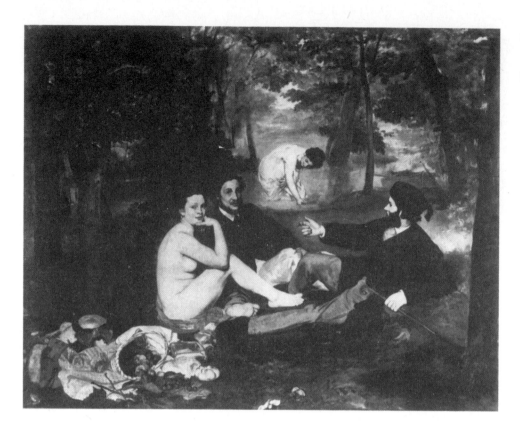

22 Edouard Manet, *Déjeuner sur l'Herbe*, 1863, oil, 211.1 × 269.9 cm (83⅛ × 106¼ in.). Louvre, Jeu de Paume, Paris; photo Musées Nationaux.

himself, it is difficult to determine. The latter was certainly familiar with Baudelaire, Gautier and even Poe at this time, and in these he could have found some inspiration for that combination of wistful beauty and strangeness which is conveyed by the painting. In 1862 Baudelaire had praised some etchings by Whistler on exhibition at Martinet's in Paris. In 1857 Baudelaire's *Fleurs du Mal* had first appeared; one of the poems was written to 'Une Blanche Fille aux Cheveux Roux'. This edition was dedicated to Gautier, whom he had met in 1849. The latter's collection of poems *Emaux et Camées*, first issued in 1852, included a 'Symphonie en Blanc Majeur'. That Whistler would have been familiar with these is almost certain. He might not have been a great reader, but he could scarcely have avoided encountering the work of poets so much admired by many of his circle. The extent of this admiration is implied in a record, from Antonin Proust, of Manet's reaction to a scene of demolition:

> Farther on house breakers stood out, white against a wall less white, which was collapsing under their blows, covering them in a cloud of dust. For a long time Manet remained absorbed in admiration of this scene. 'There you are,' he exclaimed, 'the Symphony in White Major, which Théophile Gautier speaks about.'[5]

Even in England, Whistler found among his friends Swinburne, one of the earliest admirers of Baudelaire.

From these French sources, then, Whistler could have gleaned inspiration for the enigmatic expressiveness of his figure. His manifest interest in the more painterly aspects of the work, the subtle relationships of colour, the robust material quality of the paint itself, all enhanced in this case by the simplicity of the composition and the directness of the title, were, of course, similarly the result of French training and environment.

23 John Everett Millais, *Eve of St Agnes*, 1863, oil, 118.1 × 154.9 cm (46½ × 61 in.). Reproduced by gracious permission of Her Majesty the Queen Mother.

The impact of English art is also evident. The *White Girl* had been begun before Whistler had met Rossetti; nonetheless a general Pre-Raphaelite influence is still possible, even had the painting not been reworked, as seems likely, after the return from Guéthary, during the winter of 1862–3. Millais, for example, was an artist Whistler certainly admired at this time. The rich, sensuous treatment he found in the *Eve of St Agnes* aroused his great enthusiasm (Plate 23).

An important French critic who did not read the *White Girl* simply as an exercise in spiritual mystery was Jules-Antoine Castagnary, who interpreted it in terms of the 'fallen woman' theme, the broken lily and the bear-skin rug acting out their appropriate symbolic parts. Certainly it seems undeniable that the mystic eroticism of Rossetti's work, as exemplified in *Fair Rosamund* (Plate 24), had made its impact.

By the 1870s Whistler was identified by many critics as a member, if only peripheral, of the Pre-Raphaelite group. For a time at least he was indeed impressed by the lush exoticism of Rossetti's art. It was in the 1860s that he devoted himself to that series of carefully composed single-figure portraits, elaborated with Oriental detail and accessories in all their rich profusion. In paintings such as the *Rose and Silver: 'la Princesse du Pays de la Porcelaine'*, the debt is not only to Japan (Colour Plate 6, p. 43). The richly costumed figure towering against a picturesque background; the psychological intensity; the sumptuous colour: all invoke Rossetti.

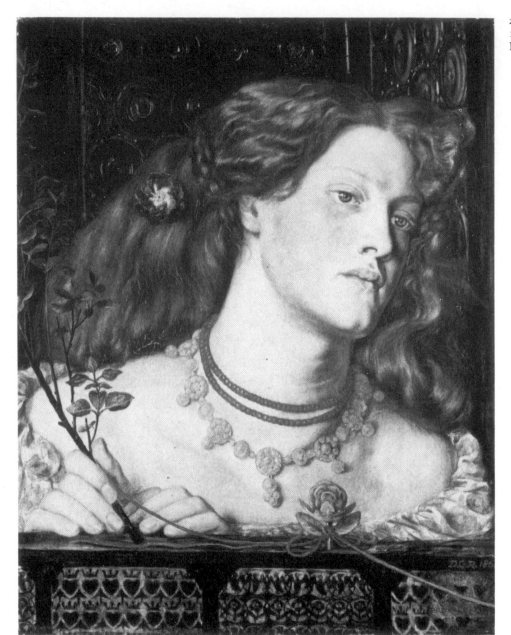

24 Dante Gabriel Rossetti, *Fair Rosamund*, 1861, oil, 52.1 × 41.9 cm (20½ × 16½ in.). National Museum of Wales, Cardiff.

Some of these same elements reappear in Whistler's pursuit of the 'White Girl' theme. In the winter of 1864 Jo posed for yet another painting of herself to be conceived as an arrangement in white, the *Little White Girl* (Colour Plate 1, p. 34).

This composition is organized around a series of contrasts. The soft, rounded forms of the figure are set against the strictly geometrical patterns of the architectural accessories. The paint is applied with brushy, transparent touches and dense, vigorous strokes; the colour is pale and quiet, laced through with repeated strong accents of red and blue. The whole is organized on a variety of spatial planes. The mirror not only serves to diversify and add to the spatial interest of the construction, but emphasizes by its reflection the enigmatic poetry expressed in the features (Plate 25). The effect remains fairly closed; the psychological and visual extent of the reflected space is confined by the nearest wall. The introverted intensity of sensation which emanates from the painting serves to underline the decisive nature of the steps Whistler was now taking away from Courbet's realism.

25 *Symphony in White No. 2: the Little White Girl* (detail), 1864, oil. Tate Gallery, London. See also Colour Plate 1, p. 34.

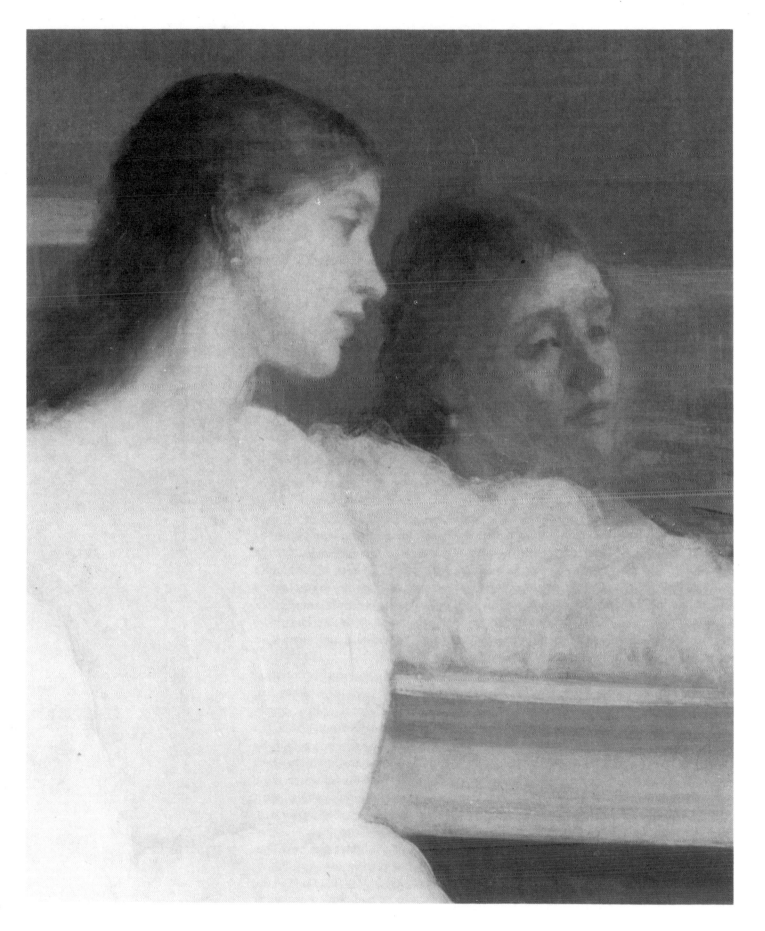

The *Little White Girl* was exhibited at the 1865 Royal Academy. Attached to the frame were some stanzas of a poem which had been dedicated to the painting by Swinburne:

Come snow, come wind or thunder
High up in air,
I watch my face, and wonder
At my bright hair;
Nought else exalts or grieves
The rose at heart that heaves
With love of her own leaves and lips that pair.[6]

The friendship and sympathy between these two artists was at this date very close. They made professions of admiration for each other's work. Swinburne even went so far as to write to John Ruskin enclosing the verses and maintaining that, though he had been told by Rossetti that they were better than the subject, 'Whatever merit my song may have, it is not so complete in beauty, in tenderness and significance, in exquisite execution and delicate strength, as Whistler's picture.'[7]

As this implies, it seems to have been Swinburne, far more than Rossetti, who apprehended and shared in the interests and ideas of Whistler. The love of a rhythmically patterned construction, the exploitation of a rich and sensuous quality in their media, characterize the work of both artists at around this time. Swinburne's admiration and respect for Whistler were such that he addressed the latter in his letters as 'mon père', and signed himself 'ton fils'. The two undoubtedly assisted and encouraged one another in the formation of theories in relation to their art.

Whistler continued to explore the theme of a painting arranged around a single colour. His *Symphony in White No. 3* was finished in 1867 (Colour Plate 2, p. 35). Once again, in contrast to some of his earlier works, it was obviously a picture which demanded much of his time, and deliberate thought, over at least two years. The main theme of the painting is boldly enunciated in the title, which asserts quite unambiguously Whistler's rejection of any anecdotal or didactic intention.

That a rich play with colour could be the theme of a painting evidently shocked and confused many contemporary critics. One of these, P. G. Hamerton, asserted in the *Saturday Review* that the picture could not justify its title, as several other colours were introduced. Whistler responded vigorously: 'Does he believe that a Symphony in F contains no other note, but shall be a continued repetition of F F F . . . Fool!'[8] Hamerton was, in fact, a fairly mild and moderate critic; he must have been moved to utter astonishment, have felt it a sign of whimsical aimlessness, to introduce so apparently irrelevant and pretentious a title.

It was indeed a radical step. To all appearances this painting was the continuation of a theme begun by the *White Girl* in 1861. In all three major variants Whistler had depicted female figures in relaxed, even languid, attitudes, against firmly constructed decorative backgrounds. The titles of the *White Girl* and the *Little White Girl* are unassuming; even so they carry overtones of sentiment which the critics were not slow to observe. By introducing a musical title and opus number, replacing the originally intended *Two Little White Girls*,[9] Whistler removes these intimations. The title no longer refers simply to the figures, but to the complete unit of the painting; not a figure painting with background accessories, but a cohesive, balanced and realized conception.

In about 1865 Whistler had been depressingly discouraged about his work. He had written to Fantin bemoaning his lack of assurance and progress. Gradually, however, he developed some confidence, and when writing in August 1865 of the *Symphony in White No. 3*, of which he enclosed a sketch, he had declared himself

26 Edgar Degas, *Mlle Fiocre in the Ballet from 'La Source'*, 1866–8, oil, 130.0 × 145.1 cm (51⅛ × 57⅛ in.). The Brooklyn Museum, New York; Gift of James H. Post, John T. Underwood and A. Augustus Healy.

pleased with his improvement, adding, 'Everything is becoming simpler day by day, and now I am above all preoccupied with composition.'[10]

The concern to research some definitive rules of composition which would produce a balanced and effective impact clearly was not that of Whistler alone; his letters to Fantin reveal it to be a mutual interest. And the sketch after the *Symphony in White No. 3* must have been discussed, to some extent at least, among his Paris friends, for it seems to have provided stimulus for Degas, who not only made a rapid copy of the composition, probably taken from this sketch, but adapted it for his own *Mlle Fiocre in the Ballet from 'La Source'*[11] (Plate 26).

In his introduction of musical titles Whistler was reflecting a very prevalent interest in the relationships which exist between the arts, particularly poetry, music and painting. It is clear, however, that his introduction of the title *Symphony in White* followed, rather than preceded, the conception of the painting itself. Whistler seems to have grasped at the terminology for its suggestions of lyricism and harmony; he was not attempting a rigorous exploration of the formal parallels between music and painting, but was indicating his concern to disentangle his particular medium from the expected narrative implications. Once he had found such a title it must have served to clarify his ideas and provide stimulus for the development of his researches into abstract form and organized rules of composition. There still remains a literary element, however, in the pensive charm of the girls in the *Symphony in White No. 3*.

The colouring and handling of the three *Symphonies in White* reveal a rapidly developing sensitivity and liveliness, and the facility and vigour shown in these

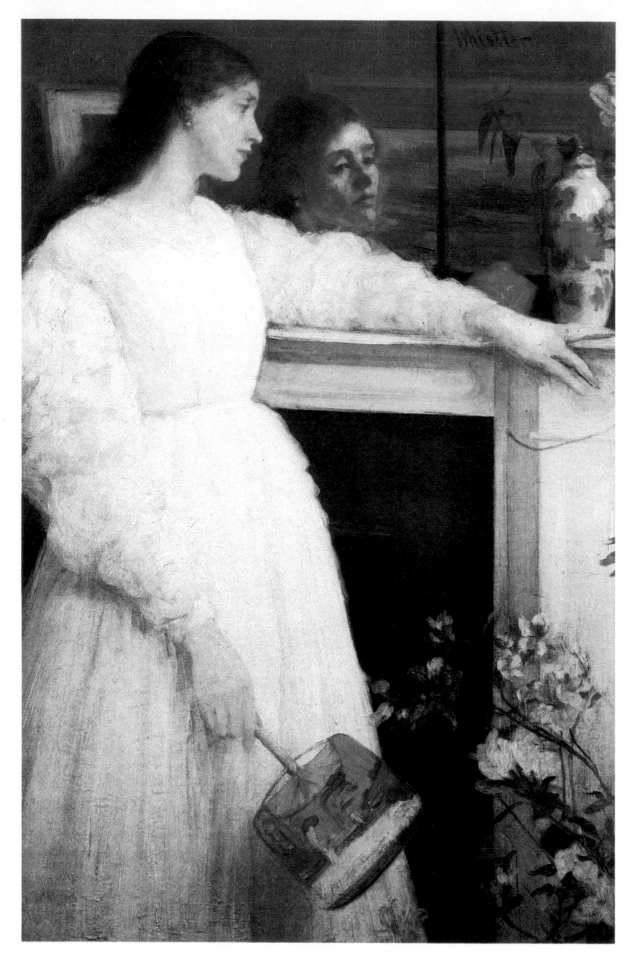

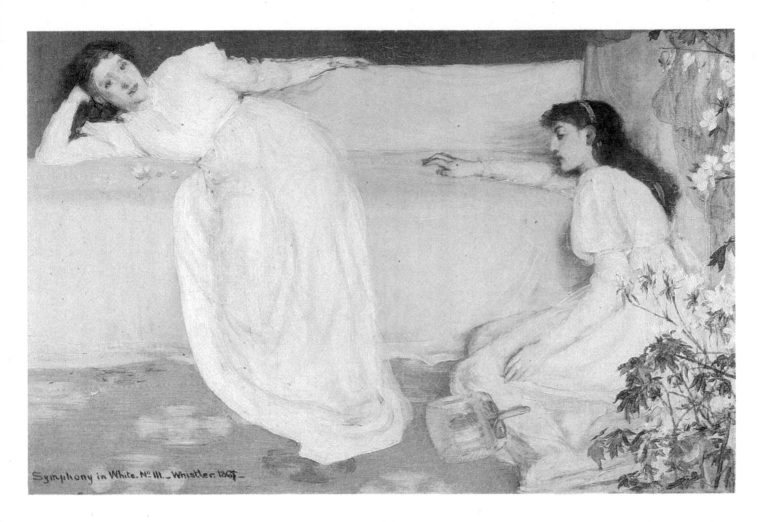

Colour 2 *Symphony in White No. 3*, 1867, oil, 52.0 × 76.5 cm (20½ × 30⅛ in.). Barber Institute of Fine Arts, University of Birmingham (U.K.).

Colour 1 *Symphony in White No. 2: the Little White Girl*, 1864, oil, 76.0 × 51.0 cm (29⅞ × 20¼ in.). Tate Gallery, London.

27 *Harmony in Blue and Silver: Trouville*, 1865, oil, 50.0 × 76.0 cm ($19\frac{5}{8}$ × $29\frac{7}{8}$ in.). Isabella Stewart Gardner Museum, Boston, Mass.

purely painterly attributes are reminders of Whistler's debt to his early Realist training. Towards the end of 1865, he had, in fact, joined Courbet at Trouville. The two painters had turned their attention to the Channel. Courbet wrote to his father of Whistler as 'an English pupil of mine'.[12] Though Whistler is unlikely to have accepted this view of the relationship, the two do appear to have shared a similar vision of the sea on this trip. In 1877, when Courbet, then an exile, wrote a letter to Whistler, he recalled their time together at Trouville: '. . . painting the sea with its fish, a dream of distant horizons'.[13]

One painting in particular, the *Harmony in Blue and Silver: Trouville*, where the vast, remote spaciousness is marked only by the stroke of a distant sail, and a figure, apparently Courbet, on the foreshore, clearly illustrates the extent to which Whistler was in sympathy with Courbet's approach (Plate 27). It compares very closely with Courbet's earlier work *Seashore at Palavas* of 1854 (Plate 28). Both have cool, restricted tones, a fine facture, a serene and limpid atmosphere. But Whistler's concern for the two-dimensional design of his work, emphasized by the thinly flowing parallel brushstrokes, the high horizon, is noticeably more pronounced.

Even if Courbet still had some justification for his claim to be mentor to Whistler, this was the last time any close contact occurred between them. Clearly, the year 1867 was a decisive time of change. In another letter written to Fantin this is again unmistakably revealed. After a word of regret for the death of Baudelaire which had taken place on 31 August, Whistler goes on to describe his present method of working,

28 Gustave Courbet, *Seashore at Palavas*, 1854, oil, 27.0 × 46.0 cm (10⅝ × 18⅛ in.). Musée Fabre, Montpellier; photo Claude O'Sughrue.

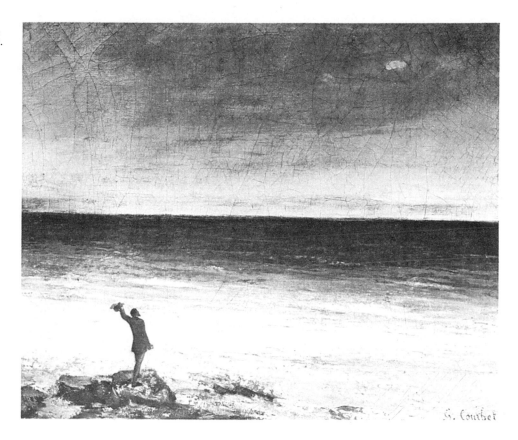

and to contrast it with that of earlier years:

> . . . I am now very demanding and exacting, very different from the time when I threw everything hastily on the canvas, expecting that instinct and beautiful colour would see me through. Oh! my dear Fantin, what an education I have given myself! or rather, what a terrible lack of education I feel![14]

It was in this same letter that Whistler made his explicit rejection of Courbet: 'I loathe Courbet's influence. The regret, rage, even hatred that I feel for it would astonish you.'

It is obvious that, despite his time with Courbet in 1865, Whistler had been moving away from the latter's circle of influence for some years, certainly since about 1863. But that does not explain this rather sudden, and undeniably violent, rejection of a painter who had at times been an important inspiration. Whistler might have been prompted by the fact that the acclaim he had at first received in London was now diminishing. English critics continued to denigrate what they considered the clumsiness and cursoriness of his execution; this in itself implies that they saw a connection between Whistler and some of the modern French painters, particularly Courbet, who had borne the brunt of so much similar criticism. In 1867 the latter had set up a one-man exhibition in Paris; opposite, another was organized by Manet. The work of both these was notorious still in many quarters. For Whistler, threatened by what was by now the unfamiliar and undesirable state of penury, any remote association with the radical French movement could not have been altogether welcome.

At the Royal Academy in 1865 Whistler had exhibited *Brown and Silver: Old Battersea Bridge*, *The Gold Screen* and the *Little White Girl*. In their reticent delicacy of touch and line all three seem to refer to that tradition of elegant, ordered painting which had been inherited by J. A. D. Ingres. And indeed Whistler now expressed a

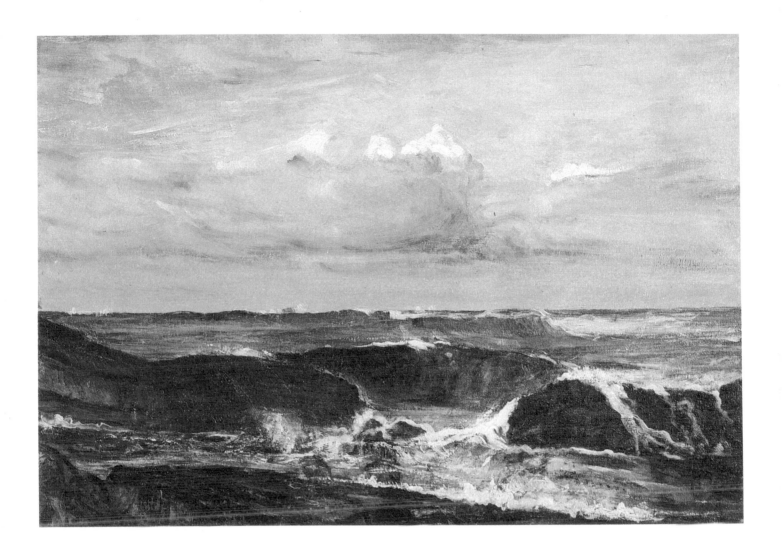

Colour 4 *Blue Wave, Biarritz*, 1862, oil, 62.2 × 86.4 cm (24½ × 34 in.). Hill-Stead Museum, Farmington, Connecticut.

Colour 3 *Harmony in Green and Rose: the Music Room*, 1860, oil, 95.5 × 70.8 cm (37⅝ × 27⅞ in.). Courtesy of The Smithsonian Institution, Freer Gallery of Art, Washington D.C.

wish that he had been guided by Ingres: 'Oh! I wish I'd been a pupil of Ingres!...
What a teacher he would have been! How sensibly he would have guided us!'[15] This
somewhat astonishing declaration cannot, of course, be taken simply at its face value.
Whistler makes it quite plain that 'It's not poor Courbet I reject, nor even his works.
I recognize his qualities as I always did.' About Ingres's work he is less than
enthusiastic: 'I'm not saying this from enthusiasm for his paintings... In fact I find
several of his canvases, which we've seen together, very questionable.' But of the
value of an education based on the strict and formal control of line and colour, such
as he might have received with Ingres, he has no doubts. And the exhibition of the
work of Ingres organized in Paris in 1867 must have confirmed him in this. He felt
that the attacking, spontaneous methods of Courbet had appealed to his vanity,
exercised his facility, at the expense of his intellect. Since the initial formation in
Paris of the Société des Trois, Whistler had been involved in the search for a style
which would specifically express his own personality and vision. Courbet himself
can, of course, be recognized as an influence which forcefully liberated the artist
from the necessity of following the schools. But the latter's boldness now appeared
too superficial, too anarchistic. Whistler felt that it was only with a thorough training
that he could be free of the problems imposed by an uncertain control of the
craftsmanly techniques of his trade, and progress to an exploration of a more
personal formula for his art.

Significantly, the idea of the Société des Trois reappeared at the fore of Whistler's
mind at this time. He and Legros had seriously quarrelled, and broken off all contact.
In 1865 Whistler proposed to Fantin a new member of the group, 'le jeune Moore'.

In the Royal Academy Exhibition of 1865 Albert Moore had shown *The Marble
Seat* (now lost), which, according to Moore's biographer, A. L. Baldry, was a
painting admired by Whistler. From this followed a close friendship between the
two, continuing, in some degree, until Moore's death in 1893.

Whistler must have first been attracted to *The Marble Seat* by its cool elegance and
ordered clarity. Perhaps he found in Moore's work the next best thing—in
England—to Ingres. To the Victorian eye it might also have recalled something of
the pensive charm of Botticelli, a painter beginning to be much admired in the circle
of friends which surrounded Whistler.[16] Moore and Whistler shared a concern for
the formal, balanced organization of a painting across the canvas. Moore's
Pomegranates, which was exhibited at the Royal Academy in 1866, reveals all the
qualities of abstract symphony for which he searched, without any hint of the dogma
or allegory more characteristic of some of the painter's earlier work (Plate 30).
Whistler found in Moore an example of the sweeter, more decadent side of
Hellenism, which he also admired in the elegant and graceful Tanagra statuettes
with which he was familiar[17] (Plate 29).

For the next three years Moore and Whistler worked together very closely. Indeed
by 1870 the latter felt that their styles had become too alike. He must have been
extremely concerned about this for he ultimately wrote to Moore suggesting that a
work of his own had inspired a rather too similar production from his colleague, a
move which, however tactfully carried out, must have borne with it some hazard for
the friendship. Whistler suggested the arbitration of the architect W. E. Nesfield,
whom Moore had first met in about 1858, and with whom he had worked on various
decorative schemes. With moderation and delicacy, as well as acute judgement,
Nesfield pronounced his conclusion: 'I strongly feel that you have seen and felt
Moore's spécialité in his female figures, method of clothing them and use of coloured
muslin, also his hard study of Greek work. Then Moore has thoroughly
appreciated and felt your mastery of painting in a light key.'[18]

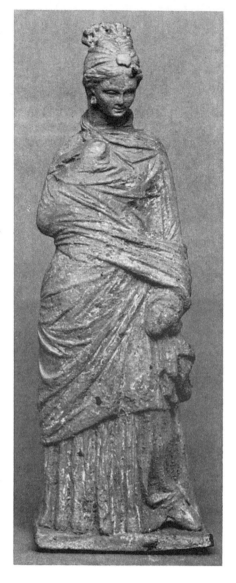

29 Terracotta statuette from Tanagra,
c. 300 B.C., 20.6 cm (8⅛ in.) high.
Reproduced by courtesy of the Trustees of
The British Museum, London.

30 Albert Moore, *Pomegranates*, 1866, oil,
25.4 × 35.6 cm (10 × 14 in.). Guildhall
Art Gallery, City of London.

Some of the paintings most characteristic of these years were described by
Swinburne in his review of 'Some Pictures of 1868'. Recurring throughout this
criticism one finds the use of musical terminology to describe aspects of various
paintings, most of which were exhibited at the Royal Academy, ranging from the
work of Legros to that of G. D. Leslie. Of Moore he writes, 'His painting is to artists
what the verse of Théophile Gautier is to poets; the faultless and secure expression
of an exclusive worship of things formally beautiful . . . The melody of colour, the
symphony of form is complete.'[19] Whistler he discusses among those who had 'not
submitted to the loose and slippery judgement of an Academy'. Besides mentioning
one 'great picture', which was not yet finished, Swinburne also refers to 'three
slighter works lately painted'. These he describes in some detail, almost wholly in
musical terms. He writes, 'In all these the main strings touched are certain varying
chords of blue and white, not without interludes of the bright and tender tones of
floral purple or red. . . .'

Two of the paintings discussed must be the *Variations in Blue and Green* and the
Symphony in White and Red (Plates 31, 32). Swinburne alludes to them as
compositions based on the harmony and opposition of a few colours. The figures are
drawn broadly and simply, the thin, liquid paint clearly revealing the passage of the
brush. The shapes are flat and sinuous, repeated across the surface at rhythmic
intervals.

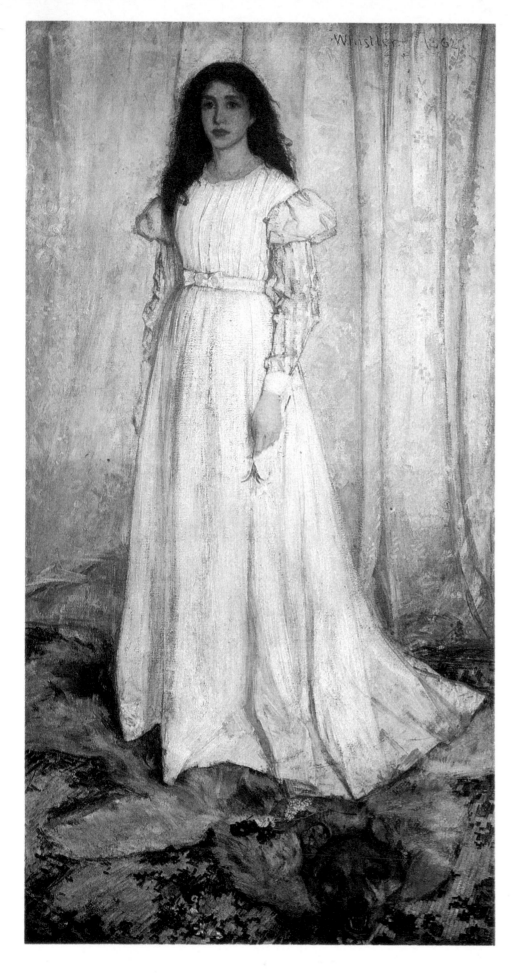

Colour 5 *Symphony in White No. 1 : the White Girl*, 1864, oil, 76.0 × 51.0 cm (29⅞ × 20¼ in.). National Gallery of Art, Washington D.C.; Harris Whittemore Collection.

Colour 6 *Rose and Silver: 'la Princesse
du Pays de la Porcelaine'*, 1864, oil,
199.2 × 114.8 cm (78¾ × 45¾ in.).
Courtesy of The Smithsonian
Institution, Freer Gallery of Art,
Washington D.C.

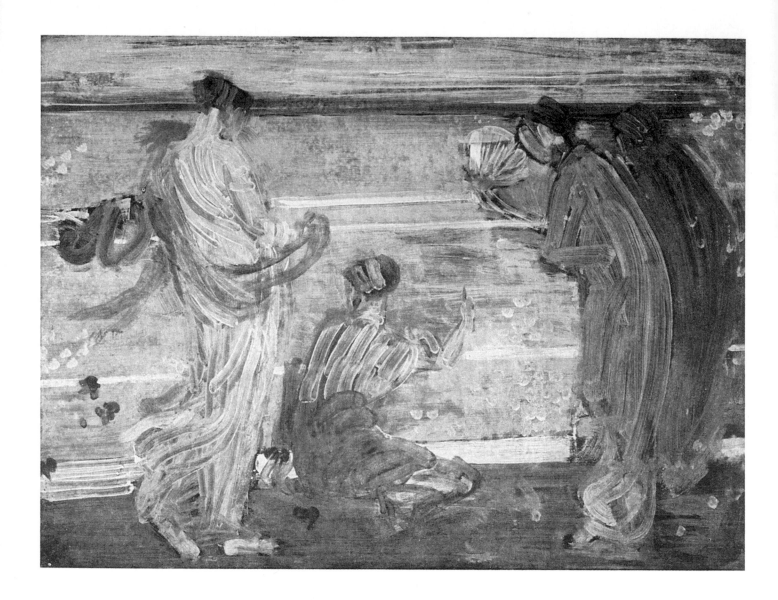

These two are taken from a group, known as the 'Six Projects', apparently executed as a decorative series for Frederick Leyland. The group is now in the Freer Gallery, Washington. They are all painted on board, mounted on wood panel, and are all of very similar dimensions. Not one appears to be finished.[20] There are hints of delicate, cursive movements of the brush, reminiscences of rich and subtle colour, but all are heavily, patchily worked, much scrubbed and belaboured. Evidently they were the witness to great frustration and self-searching. It was at this time that Whistler was writing to his cousin Thomas Winans, begging financial assistance and explaining that he was desperately anxious to 'perfect myself in certain knowledge that should overcome imperfections I found in my work'.

In this same letter he makes specific reference to a 'large picture of three figures, nearly life size, fully under way . . . everyone highly pleased with it except myself . . . I wiped it clean out, scraped it off the canvas and put it aside . . . now I expect shortly to begin it all over again . . . but with a certainty that will carry me through in one third the time.'[21] In the latter supposition he was, indeed, optimistic. The painting to which he refers must be the *Three Figures, Pink and Grey*, now in the Tate Gallery, and usually dated *c.* 1868 (Colour Plate 7, p. 46). A study for this, *The White*

31 *Variations in Blue and Green*, from 'Six Projects', *c.* 1868, oil on prepared Academy board mounted on wood panel, 46.9 × 61.8 cm (18½ × 24⅜ in.). Courtesy of The Smithsonian Institution, Freer Gallery of Art, Washington D.C.

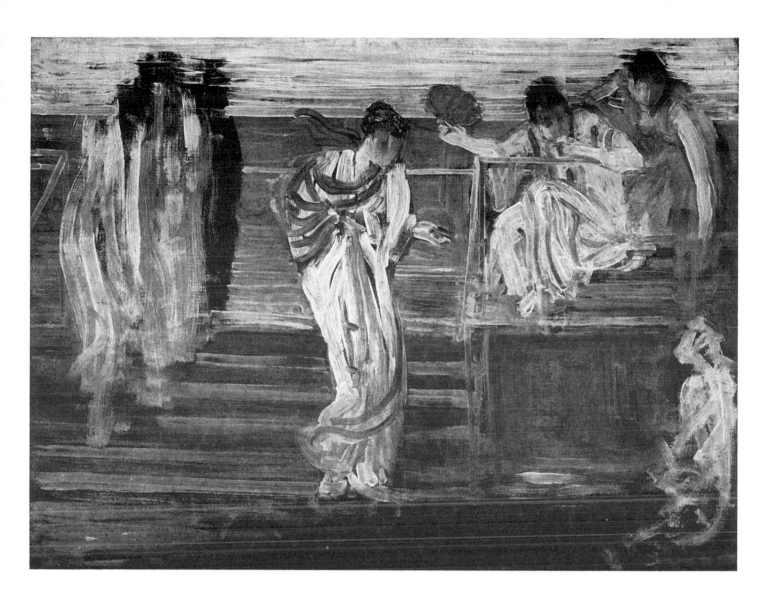

32 *Symphony in White and Red*, from 'Six Projects', *c.* 1863, oil on prepared Academy board mounted on wood panel, 46.8 × 61.9 cm (18⅜ × 24⅜ in.). Courtesy of The Smithsonian Institution, Freer Gallery of Art, Washington D.C.

Symphony or the *Symphony in White No. 4* (Plate 33), is possibly the 'sketch for the great picture' described by Swinburne in his appreciative review.[22] Numerous pastel, pen and ink, and one or two oil sketches also relate to it—the culmination of that theme on which he had been working since 1861, with the *White Girl*, and in which can be seen developing some of the essential ideas of his early career.

The *Three Figures, Pink and Grey* is a large, much-worked painting. The broad, descriptive brushstrokes of the study have been refined and leave little or no mark. The whole remains tentative, unfinished. In a letter to his patron Leyland, Whistler writes: 'You will be pleased to hear that, among other things, I am well at work on your large picture of the three girls, and that it is going on with ease and pleasure to myself.' The letter is undated, but can be assigned to about the middle of November 1872, for in that month Whistler held an exhibition of Nocturnes at the Dudley Gallery; an exhibition which, he remarked to Leyland, was a great success.[23]

As late as 1886 Malcolm Salaman recalls finding in Whistler's studio not the *Three Figures* specifically, but 'sketches of . . . several girls on the sea shore';[24] presumably paintings related to the 'Six Projects'. And despite the long years during which Whistler returned to this theme of figures set against a decorative background, he

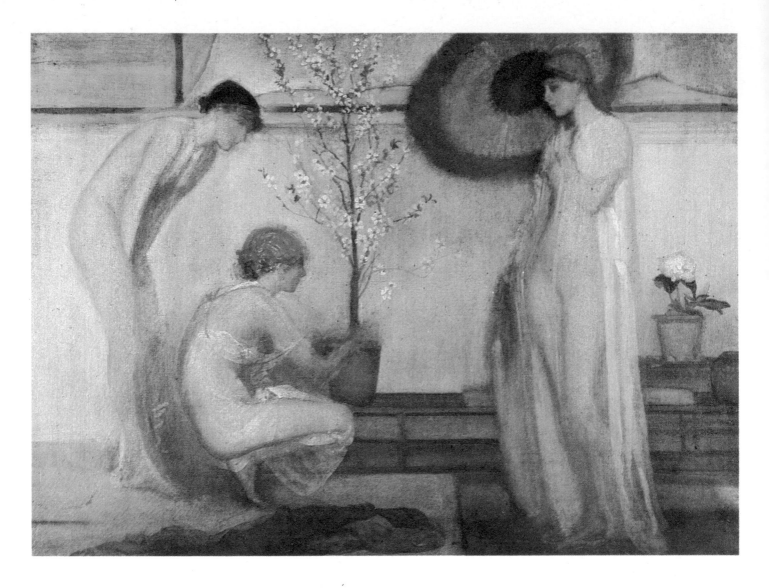

Colour 7 *Three Figures, Pink and Grey, c.* 1868, oil, 144.8 × 185.4 cm (57 × 73 in.). Tate Gallery, London.

Colour 8 *The Artist's Studio,* 1867–8, oil on wood panel, 62.9 × 47.6 cm (24¾ × 18¾ in.). Courtesy of The Art Institute of Chicago.

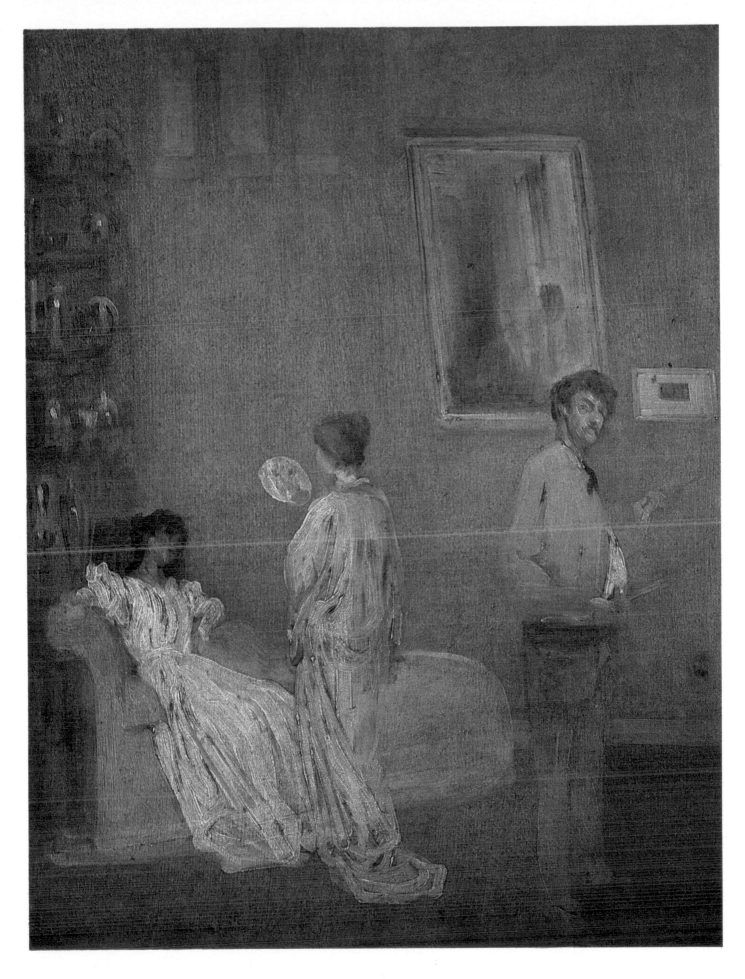

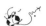

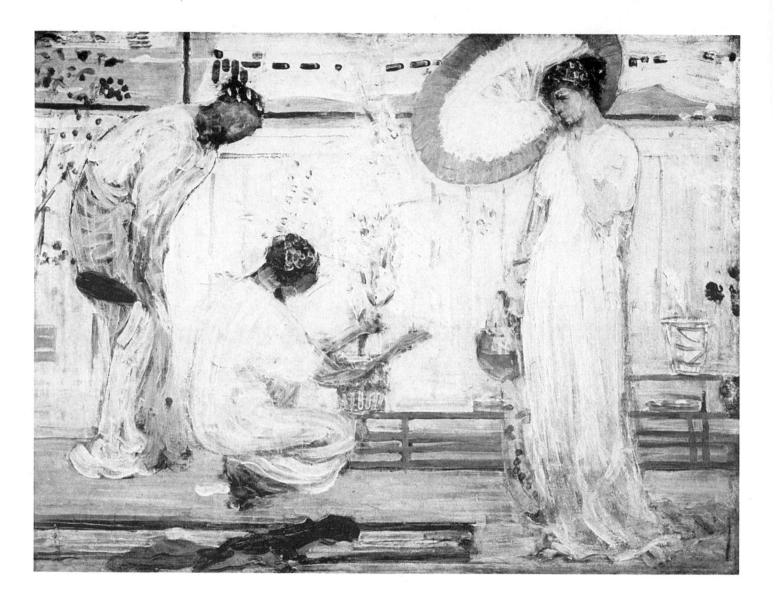

was never satisfied with it. He tried on several occasions to repurchase the *Three Figures* from Alfred Chapman, who had acquired it after it had passed through Dowdeswell's in 1891.

In these years Whistler's closest friend and confidant, apart from Albert Moore, was still Fantin. Yet another painting discussed in their correspondence reveals Whistler once again attempting a life-size realization of his ideas. The theme, of women posing on a balcony, had evidently been conceived as early as 1864, when Whistler's mother makes mention of it in a letter to a friend. In his diary for 1867 W. M. Rossetti remarks a 'picture of four Japanese women looking out on a water background . . . I think the unmitigated tint of the flooring should be gradated, but he does not seem to see it.'[25] From this description, particularly the reference to the strong, flat colour of the floor, one can assume that this was the picture shown at the Royal Academy in 1870, *Variations in Flesh Colour and Green: the Balcony* (Plate 34). The debt Whistler owed to the Japanese print is apparent: two woodcuts from a series he owned, showing life in a geisha house by Kiyonaga, are relied upon very heavily (Plate 35). There is also the interesting suggestion that large Japanese dolls in his possession at this time were used as models.[26] Though he undoubtedly used

33 *The White Symphony: Three Girls (Symphony in White No. 4)*, c. 1868, oil on prepared board mounted on wood panel, 46.4 × 61.6 cm (18¼ × 24¼ in.). Courtesy of The Smithsonian Institution, Freer Gallery of Art, Washington D.C.

34 *Variations in Flesh Colour and Green: the Balcony*, c. 1867–8, oil on wood panel, 61.4 × 48.8 cm (24⅛ × 19¼ in.). Courtesy of The Smithsonian Institution, Freer Gallery of Art, Washington D.C.

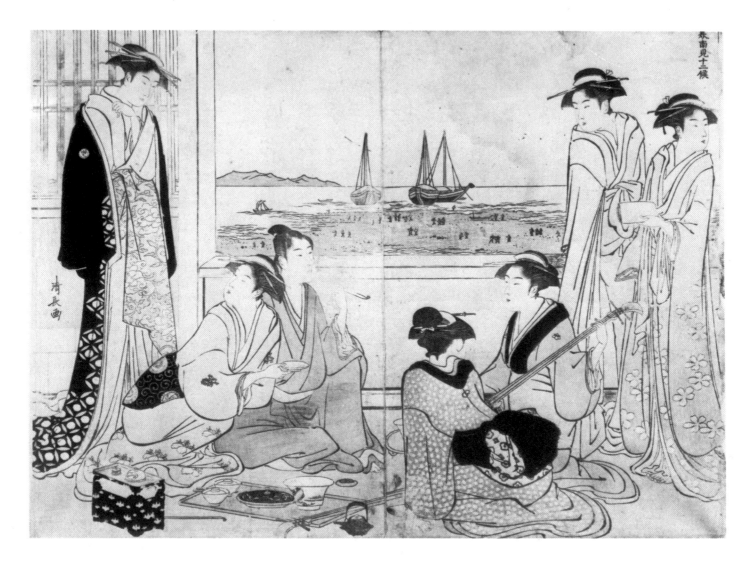

human models, the dolls he collected must have been something of a stimulus.

Like so much of his work at this time, the scheme he had to enlarge the painting never reached a conclusion. There is a sketch of the subject, squared up for translation and possible enlargement (Plate 36). There is also a watercolour sketch probably of an earlier date, an initial study. It is significant that one finds the squared sketch: it was not usually Whistler's custom to embark upon this sort of calculated preparation. He was evidently emulating his friend Moore, who invariably worked in this painstaking way. But Whistler had not been trained to cope with such academic rigours, nor to face the problems of composing several life-size figures. His mastery lay in quick response, and in his extraordinary sensitivity to materials. It was not until the 1880s that he began truly to realize this.

In the late 1860s he was clearly somewhat obsessed by the notion of producing a work on a large scale, a picture which could be the centre of an exhibition, which would embody the results of ten years' work and study. In a letter to Fantin he discusses yet another such: 'For the Salon I've got a reunion of all of us . . . It represents the interior of my studio, porcelain and all. You are there, and Moore, the white girl . . . and "La Japonaise".'[27] Once again a final version was never produced. There are two studies, both of which include Whistler and his two models in the studio (Colour Plate 8, p. 47). The success of Fantin's large group portraits, in which various representatives of his artistic environment are gathered together, must have

35 Torii Kiyonaga, *Youth and Courtesans*, from the series 'Twelve Months in the South', 18th century, colour woodcut, 36.0 × 51.0 cm (14⅛ × 20⅛ in.). Reproduced by courtesy of the Trustees of The British Museum, London.

36 Squared sketch for *The Balcony*, c. 1867, oil on wood panel, 61.0 × 48.2 cm (24 × 19 in.). Hunterian Art Gallery, University of Glasgow; Birnie Philip Bequest.

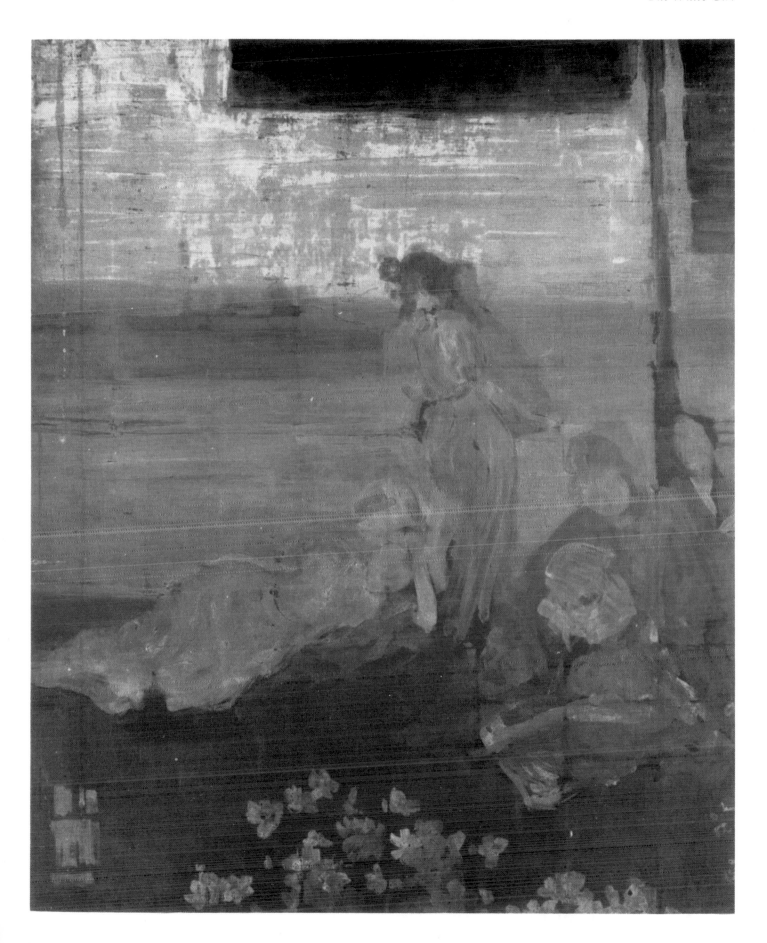

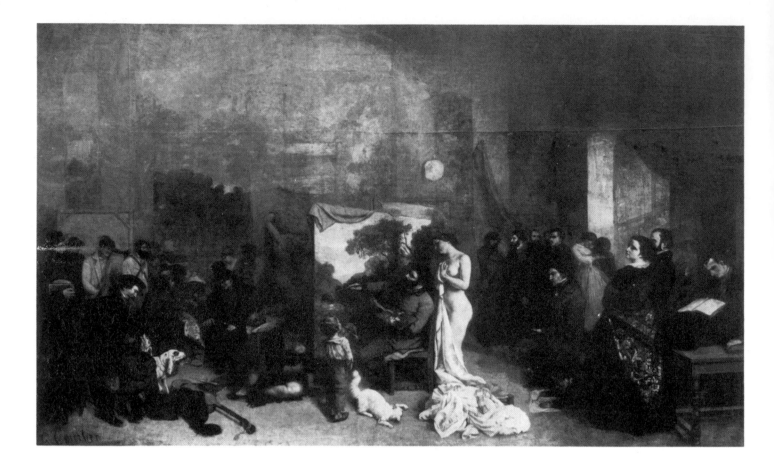

been an inspiration. Whistler's conception, however, is rather more personal than Fantin's, and rather more grandiose. It is, in fact, perhaps paradoxically, much closer to Courbet's *Studio*; a manifestation of the ingredients of the artist's own career and ideas of painting (Plate 37). But Courbet, more concerned with narrative than with the search for an absolute notion of formal design, completed his manifesto.

For Whistler this search, with which he had become increasingly preoccupied, resulted in the almost inevitable lack of faith in his own progress, precluding the completion of nearly all major paintings. Nevertheless, and despite the implications of the later *Studio* painting and the continuing fascination for exotic costume, he had established a break from both the immediate realism of Courbet and the poetic genre with which he had been impressed during the early years of the decade.

37 Gustave Courbet, *The Artist's Studio*, 1855, oil, 359 × 598 cm (141⅜ × 235⅜ in.). Louvre, Paris; photo Musées Nationaux.

3 The Nocturnes

The year 1866 is usually marked as that in which the first of Whistler's 'Nocturne' series of paintings appeared. This series has been treated in great detail, often to the exclusion of all else Whistlerian; the beginning and end of his career have been traced with almost sole reference to it. Without taking so extreme a stand one can nevertheless maintain that in the Nocturnes, on which Whistler worked for well over a decade, can be found evidence of the conception and development of many of those ideas and aims which he ultimately worked into a cohesive theoretical pattern to use as the basis for his painting.

Whistler seems to have used the term 'Nocturne' for those paintings which reveal his growing interest in two-dimensional arrangement. He frequently took for his subject a serene horizontal vista of the Thames and exploited the natural effect of oncoming twilight to simplify and confine both shape and range of hue. The early Nocturnes are mainly of the Thames. Indeed it seems to have been the constant presence of the flat expanses of the river which encouraged his interest in exploiting the two-dimensional elements of a composition; a concern already established by the impact of the Japanese print. The Nocturnes were not the realization of a sudden and arbitrary interest in the Thames at twilight, but the result of a developing sensitivity to nuances of tone and subtleties of form.

The Thames had always exercised a strong attraction for Whistler; it must have played an important part in his original plan to live and work in London. From the summer of the first year he spent in the city, after leaving Paris in 1859, he worked and lived near the water. After spending some time with the Hadens and with du Maurier, he seems to have moved to rooms in Wapping. The first of the many etchings of the waterside and its activities date from his earliest residence in the district (Plate 38), and in 1860 he began work on the major painting *Wapping*, finally exhibited at the Royal Academy in 1864.

All the spontaneous vigour of approach which he had absorbed in Paris came to the fore in his early treatment of the Thames. It seems likely that the extant paintings on the theme are the remnants of what was a far larger programme of work, much of which was probably discarded unfinished, or lost in later years. His dogged biographical sleuths the Pennells collected numerous faded photographs of paintings of water subjects, some of which I have been unable to trace.[1] The titles applied by Whistler were at no time very specific, and were often subject to change: the identification of exhibited works thus often proves impossible.

No problem exists with the dating of the *Last of Old Westminster*, shown at the Royal Academy in 1863 (Plates 39, 40). This is a work which has always attracted a good deal of attention, partly because of the fairly full account given by Arthur Severn of its execution. The Severn brothers were probably not aware of the consequences when they allowed Whistler to work on his painting from their apartment, which boasted bow windows over the river:

> He was a long time over the picture, sometimes coming only once a week, and we got rather tired of it. One day some friends came to see it. He stood it against a table in an upright position for them to see, it suddenly fell on its face, much to my brother's disgust, as he had just got a new carpet.[2]

38 *Rotherhithe* (K.66.II), from 'The Thames Set', 1860, etching 27.0 × 19.7 cm (10⅝ × 7¾ in.). Hunterian Art Gallery, University of Glasgow; McCallum Collection.

From Severn's description to Pennell the painting must represent the last stages in the building of the New Westminster Bridge. But this is more or less irrelevant: 'It was the piles, with their rich colour and delightful confusion that took his fancy, not the bridge, which hardly showed.' The scene is full of busy activity, though the strong diagonal of the bridge dominates and controls the composition and completely eliminates any hint of chaos. The bird's eye view reduces the figures to a pattern of vivid dots scattered among the complexities of the scaffolding. The far bank of the river, masked somewhat by a slight haze of fog, is simply naturalistic in form. The whole gives witness to an acute eye for visual detail, governed and controlled by a strong feeling for pictorial design. Whistler obviously painted this on the spot. However, the realistically and broadly detailed perspective, the simplicity

39 *Last of Old Westminster* (detail).
Courtesy of The Museum of Fine Arts,
Boston.

40 *Last of Old Westminster*, 1862, oil, 61.0
× 77.5 cm (24 × 30 in.). Courtesy of The
Museum of Fine Arts, Boston, Mass.;
Abraham Shuman Fund.

41 James Hedderly, photograph of the Thames at Chelsea, 1860s. Chelsea Public Library, London.

of the composition, and the subject itself, imply the possibility that he also looked to photography, either as a general inspiration or guideline, or as an aid to detail.

Although a fairly recent introduction, photography had become acceptable as a compositional aid and was used by artists on both sides of the Channel. It had acted as a stimulant to the appreciation of minor details, or of broad effects of movement, or was used simply to replace the more arduous and academic processes of preparatory study: acedemic studies which were, as the result of his Realist artistic upbringing, already almost invariably bypassed by Whistler. He relied more upon a spontaneous grasp of a scene, and on his visual memory, for compositions. But by the early 1860s, as witnessed by his rejection of Courbet, he was becoming increasingly aware of the possibilities more formal preparatory work could offer the strength of his designs, and increasingly dissatisfied with a hasty and immediate record. Photography may well have offered him some assistance.

The Thames riverside, with its picturesque barges, rivermen and light effects, had naturally attracted several gifted photographers, among them James Hedderly, who lived in Chelsea with his brother, Henry, and who worked around the area during the 1860s. In his own day his photographs of the area were already immensely popular. They reveal an intimate knowledge of the people, a love and respect for the buildings which surrounded him. The river front, before the Embankment was built; the residences of Chelsea characters, such as D. G. Rossetti and Thomas Carlyle; the shop fronts and street corners with which he was so familiar; all provided him with subjects for his camera.[3] No artist before him had revealed such a sympathy for the intimate, casual details, the poetry, the dramatic impact of commonplace vistas which Chelsea and its environs could afford.

Even if Whistler used none of these photographs specifically, and I have come across no evidence that he did, the series of paintings he executed of the riverside, with the foreground barges, sails rolled, the silhouetted shapes of the moving craft, and the buildings on the far shore, reveals a vision of the river which has much in common, in both mood and composition, with some of the photographs by Hedderly

42 Walter Greaves, *Barges, Lime Wharf, Chelsea*, etching, 17.8 × 30.2 cm (7 × 11⅞ in.). Chelsea Public Library, London.

(Plate 41). It seems very probable that Whistler was aware of these photographs and inspired by the combination of the poetic and the domestic which characterizes them. His assistant and pupil during these years, Walter Greaves, certainly did use a Hedderly photograph as the basis for one, at least, of his etchings, *Barges, Lime Wharf, Chelsea*[4] (Plate 42). There is an interesting note in Alan Cole's diary for December 1877, referring to a dinner during which Whistler was talking of photographs and painting.[5] And the *Battersea Reach* of 1863, over a decade earlier, a painting he later declared a favourite, is even articulated by a series of light/dark contrasts, similar to those of a sepia-toned photograph, and not by colour developments (Plate 43).

The complexities of detail and busy activity of the *Last of Old Westminster* seem to be gradually simplified in subsequent paintings of the riverside. Whereas *Wapping*, the *Thames in Ice*, even the *Coast of Brittany*, all water subjects to some extent, manifest an uneven finish, a vigorous attack, a variety of colour and detail, the *Brown and Silver: Old Battersea Bridge*, exhibited at the Royal Academy in 1865, is altogether quieter, more limited and subtle in tone, more akin to those paintings Whistler called Nocturnes (Plate 44). The size of the canvas is not significantly smaller than those used earlier. Nevertheless the strokes are apparently fewer and less worried, the paint more liquid, the facture altogether finer and smoother. The whole conception

43 *Battersea Reach*, *c.* 1863, oil, 51.0 × 76.0 cm (20⅛ × 29⅞ in.). Corcoran Gallery of Art, Washington D.C.; Bequest of James Parmelee.

is simply realized, painted, as it were, all in one go.

These paintings, and those executed in 1865 while Whistler was working at Trouville with Courbet, preface the development of what was to become an absorbing and at times almost exclusive interest in the light and form effects created by water, particularly the Thames, under the various shades of night.

In 1866 Whistler made his extraordinary voyage to South America, an experience which must have been very important in encouraging him in his appreciation of water and light effects. There is a strain of the ridiculous in Whistler's tale of this expedition. Doubtless he elaborated it for the faithful, somewhat gullible ears of the Pennells. The horseback retreat from the guns at Valparaiso, the encounter with the 'Marquis de Marmalade' on the return journey: all seem to hint at some magnificent private jest. There is no obvious reason why Whistler should have wanted to sail for Chile. He had not left to fight in the American Civil War, despite his great interest in that encounter. Yet, apparently prompted by the fact that after the war many Southerners, including his brother, Dr William Whistler, 'were knocking about London, hunting for something to do', a plan was made to 'go and help the Chilians and, I cannot say why, the Peruvians too . . . Some of these people came to me, as a West Point man, and asked me to join and it was all done in an afternoon.'[6]

Whatever the initial haste, the preparations for this journey were evidently lengthy. There is a detailed will, drawn up before the expedition, in which Whistler leaves everything to Jo. And in a letter of February 1866 Swinburne writes that he is

44 *Brown and Silver: Old Battersea Bridge*, Royal Academy 1865, oil, 63.5 × 76.2 cm (25 × 30 in.). Addison Gallery of American Art, Phillips Academy, Andover, Mass.

off to see 'the last of Whistler'; he implies that the journey had been spoken about to such an extent that he had almost ceased to believe in its ever taking place.[7] In February, however, Whistler embarked.

In 1866 Whistler would have been obliged to journey round the whole of South America in order to reach the North; the Panama Canal was not under construction until the 1880s. It is, in fact, likely that his initial plan was to visit the United States, though the fact that he seems never to have made the slightest reference to this in later years implies that he never reached the goal. Support for this theory can be found in Whistler's will, drawn up on his 'proceeding to America',[8] and in the above-mentioned Swinburne letter, where the poet remarks that Whistler 'really was off to California'. Similarly, Whistler made various odd jottings, in his passport, concerning the flora and fauna of California, that being the first State he might have reached in America. And from a note in the diary of William Michael Rossetti, it is clear that Whistler did venture beyond Valparaiso, at least as far as Lima.[9]

Whatever the details, William Michael noted that Whistler, during this

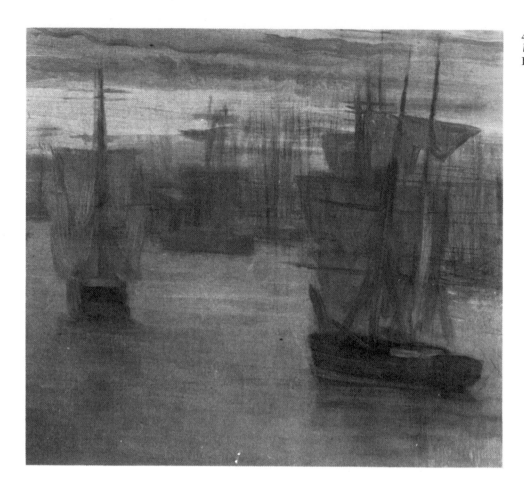

45 *Crepuscle in Flesh Colour and Green: Valparaiso* (detail), 1866, oil. Tate Gallery, London. See also Colour Plate 9, p. 67.

expedition, 'painted next to nothing'. From the letters he wrote to Fantin around this time, in which, incidentally, he seems to make no reference to his voyage whatsoever, he appears to be supremely preoccupied with the problems of his figure compositions, particularly the *Symphony in White No. 3* and the *Artist's Studio*. Of the seascapes which resulted from the trip, one, the *Crepuscle in Flesh Colour and Green: Valparaiso*, was shown at the French Gallery in London in January 1867 (Colour Plate 9, p. 67).

The ostensible subject of this painting is the fleets drawn up for battle at Valparaiso. It is evident, however, that the subject has little or nothing to do with the mood conveyed. The paint is not very thin but it is smoothly and liquidly applied, slight lips of paint including the horizontal movements of the brush. The colour is soft but resonant, the tonal gradations so subtle that there is little distinction between sky and sea. The ships, with their patterns of sails and rigging, are carefully spaced across the canvas. There is evidence, on the right of the painting, of a few lines of simple cross-hatching in charcoal (Plate 45); signs of the initial lay-in, and the keen attention which was paid to the balance of the design, rather than to the accuracy of the detail. The ultimate impression is one of calm serenity and a remote harmony: a manifest break from the principles of Realism with which Whistler had been imbued.

Another of the Valparaiso seascapes is the *Nocturne in Blue and Gold: Valparaiso*, one of the first in which the water is seen beneath the darkness of the sky, scattered with a few staccato touches of brilliant light (Colour Plate 13, p. 79; Plate 46). The paint in this is thinly applied over a dark ground, which has drowned the subtlety of handling, though something of its variety and delicacy can still be discerned. There is

46 *Nocturne in Blue and Gold: Valparaiso* (detail), 1866, oil. Courtesy of The Smithsonian Institution, Freer Gallery of Art, Washington D.C. See also Colour Plate 13, p. 79.

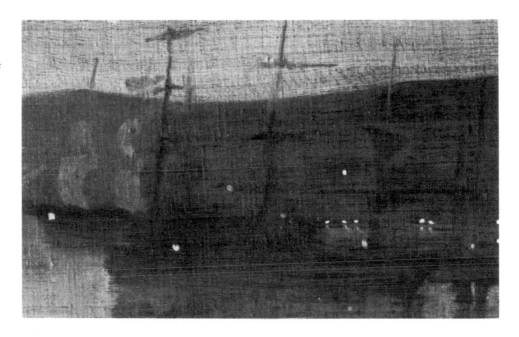

little or no draughtsmanship; the canvas is articulated by subtle tonal developments, from which emerge the briefly defined silhouettes of figures and ships. In neither of these paintings is there a precise sense of time or place. All the animation of the canvases is found in the activity of the brush and variety of tone, rather than in much reference to the natural scenes they purport to convey.

Both of these canvases, particularly the former, suggest a fairly mature reaction to a theme already much appreciated. It has usually been assumed that Whistler's Nocturnes began with the Valparaiso trip. There is no easy way of dating the works, and certainly he exhibited most of these paintings in the 1870s. But it is clear that Whistler had a great interest in water subjects some years before the voyage of 1866. During his absence, Jo had written to his solicitor and friend, Anderson Rose, of 'sea views' then at Rossetti's.[10] The fact that she mentions several indicates that Whistler was already concentrating on the development of the theme rather than simply producing individual paintings. The cool, smooth *Brown and Silver: Old Battersea Bridge* had been on show at the Royal Academy in 1865. And there are other extant paintings sharing the refinement, the limited range of flat colour associated with the series of Nocturnes, which must have been executed if not before, then very shortly after, the Valparaiso trip. There is, for example, the large painting *The Ocean*, now in the Frick Collection, New York (Plate 47).

William Michael Rossetti, in writing of Whistler's housewarming in February 1867, remarked 'two or three sea pieces' which were new to him; 'one, on which he particularly lays stress, larger than the others, a very grey, unbroken sea'.[11] It seems possible that this refers to *The Ocean*. It is certainly a relatively large painting, measuring 79·5 × 99·0 cm (31 × 39 in.). And, from the thick, smooth handling of the sea, the impasto surge of the wave at the lower corner, the vigorous detailing of the pier nosing in at left, and the rather awkward intrusion of decorative foliage along the lower edge, it can scarcely have been painted later than this. It appears more ungainly than other Nocturnes in which a similar device of decorative Japanese foliage is introduced: the *Nocturne in Blue and Silver No. 1*, or the *Nocturne in Blue and Silver: Cremorne Lights*.

The former is dated 1877 by the Fogg Museum, Cambridge, Massachusetts (Plate 48). It was exhibited at the Grosvenor Gallery in that year, and was subsequently

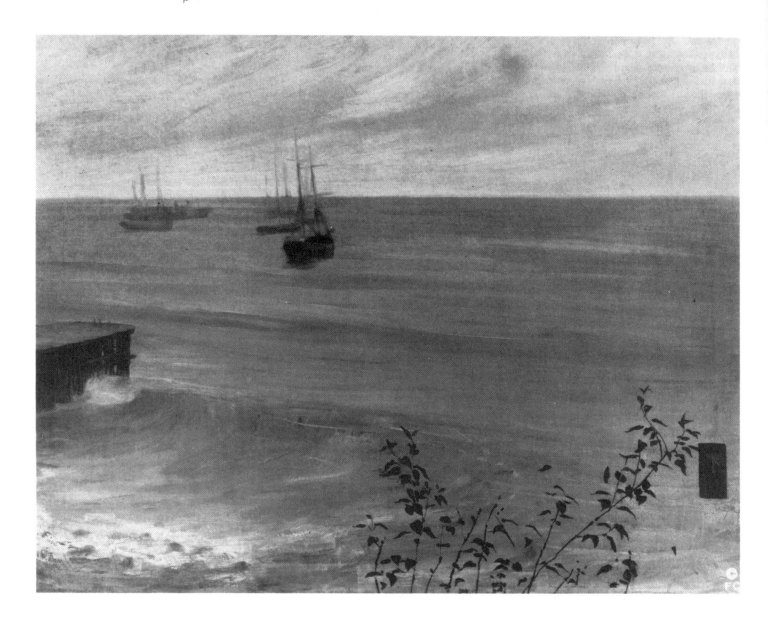

47 *Symphony in Grey and Green: the Ocean*, c. 1866, oil, 79.5 × 99.0 cm (31 × 39 in.). Copyright The Frick Collection, New York.

produced at the Ruskin trial. In a letter in the Fogg it is asserted, however, that the painting was in the Leyland collection before the trial, and since it seems unlikely that Leyland purchased it at the height of his quarrel with Whistler, it was probably acquired earlier in the 1870s.

The latter painting, *Cremorne Lights*, dated 1872, manifests a similar expanse of flat water and sky, similar Japanese elements in the signature motif and delicately intrusive foliage (Colour Plate 10, p. 70). There is a greater refinement and confidence about this painting, which seems to indicate that it was executed later than the *Blue and Silver No. 1*. This would place the Fogg painting as early as 1871–2. The paint of *Cremorne Lights* is smooth and liquid, cool in tone, horizontally brushed to reveal a slight indication of a previous piece of work; a piece which has the appearance of one of the swiftly drawn figures allied to the 'Six Projects' of the later 1860s (Plate 49).

The decorative silhouette formed by the far bank of the Thames is a motif often repeated, with almost exactly the same emphasis and detail, in several Nocturnes. One such is the *Blue and Gold*, which is now in the York City Art Gallery (Plate

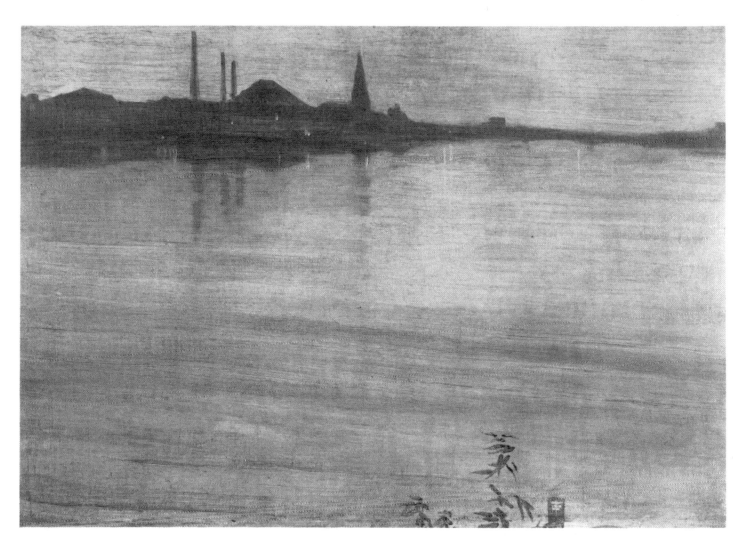

48 *Nocturne in Blue and Silver No. 1*,
c. 1871–2, oil, 43.2 × 59.1 cm (17 ×
23¼ in.). Fogg Art Museum, Harvard
University, Cambridge, Mass.; Grenville
L. Winthrop Bequest.

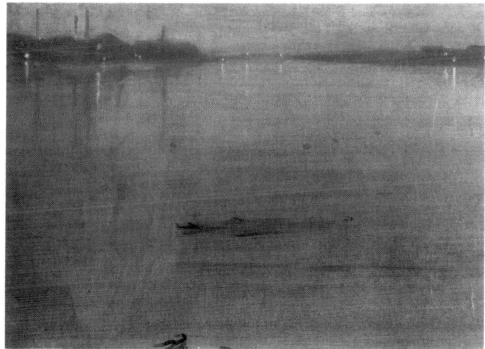

49 *Nocturne in Blue and Silver: Cremorne
Lights* (detail), 1872, oil. Tate Gallery,
London. See also Colour Plate 10, p. 70.

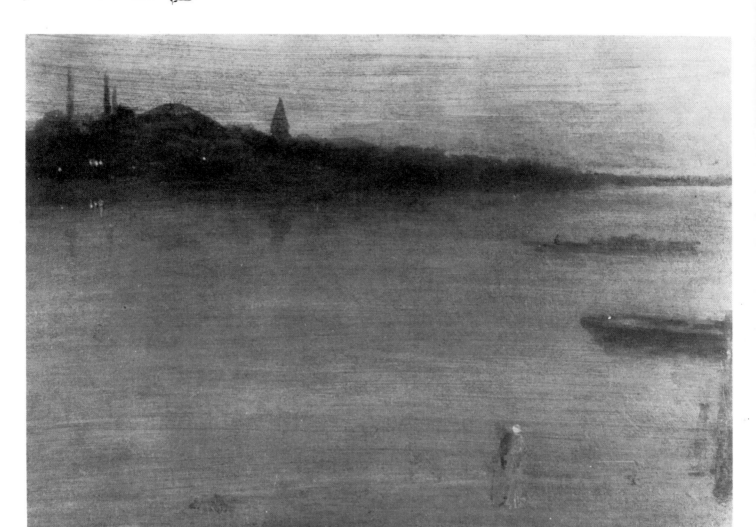

50). Though smaller than the two just discussed, the proportions are directly comparable, and possibly date this, too, to the very early 1870s, or even the late 1860s. It does now appear rather heavily worked, however, and it is probable that it was touched up at a later date by Walter Greaves, the elder of the two brothers, boatbuilders, who met Whistler in about 1863 and became his devoted pupils.

50 *Nocturne in Blue and Gold*, c. 1868–72, oil, 30.5 × 45.7 cm (12 × 18 in.). This painting was probably also worked on by Walter Greaves. City Art Gallery, York.

The Pennells, who dutifully tracked down most of Whistler's one-time associates, abstracted from Walter Greaves much talk of the 'early days', including accounts of Whistler's methods of study on the many occasions, particularly at night, when the Greaveses rowed Whistler out on the river.[12] He apparently sketched on brown paper with black and white chalk, although in later years he seems to have relied increasingly on his memory, and on verbal accounts of details of shape and colour as an aid to memory. When it came to the ultimate painting, Walter Greaves gives slightly more detail; it must be recalled, however, that he was interviewed by the Pennells after Whistler's death, and after a separation of over twenty years, so there is no indication of any of the slow chronological development of these techniques. Greaves particularly recalled the very liquid medium which Whistler applied to absorbent canvas, over a ground of red, lead grey or 'warm black', or, perhaps, to a mahogany panel. The colours were all studied and mixed beforehand, there being very few pure tones, and applied with brushes which had been reshaped. The medium was sometimes so wet that it could be floated around the canvas as it lay on the floor, or dripped as it was left to dry outside.[13] These years were full of experiment. Whistler

searched for the precise tone, the exact amount of absorbency in a canvas, the appropriate colour for the ground, and tried to organize all before embarking on a painting.

His increasing consciousness of the precise ends towards which he was working was asserted in the generic title, 'Nocturne'. The title first appeared in the exhibition at the Dudley Gallery in November 1872; that being the last year he exhibited at the Royal Academy and the first to witness his general use of musical titles. The name was evidently suggested to him by his friend and patron the wealthy shipping magnate Frederick Leyland, with whom he kept in close correspondence whether the latter was in London or on his estate, Speke Hall, near Liverpool.

> I say, I can't thank you too much for the name 'Nocturne', as the title for my Moonlights. You have no idea what an irritation it proves to the critics, and consequent pleasure to me; besides, it is really so charming, and does so poetically say all I want to say, and no more than I wish! The pictures at the Dudley are a great success. . . .[14]

The significance of this statement, apart from its revelation of Whistler's opinion of the critics, lies in the clear enunciation of his desire to be precise in his expression; to convey the message of a painting with all fulness and clarity in the title. To plan to do this implies a firm consciousness of the specific nature of what he was attempting to state, and a growing assurance in the means of realizing his intention. This is confirmed by a letter to an old family friend, George Lucas, dated January 1873, in which he discusses some of his works, apparently on show at Durand Ruel's: 'They are not merely canvases having interest in themselves alone, but are intended to indicate slightly, "to those whom it may concern", something of my theory in art. The science of colour and picture pattern as I have worked it out for myself during these years.'[15] This seems to be one of the first occasions on which Whistler speaks with real confidence about the science of painting. He appears to be assured in his letters of this period of the progress he is making in the formalization and rationalization of his theories in relation to his art; a confidence echoed in the proliferation of titles abstracted from musical terminology.

The musical titles are the most direct and public expression of his concept of painting. His first work to be shown with such a frankly abstract title was the *Symphony in White No. 3*. But the notion that a chosen chord of colour should be the base from which to develop a pictorial theme can be found at the very beginning of Whistler's career, and is sometimes consciously expressed in the titles, in the *Blue Wave* and the *White Girl*, for example.

The first painting to attract the attention of the British public, *At the Piano*, already manifests this control of key. Undoubtedly, as discussed earlier, some of the inspiration for this must have come from Holland, particularly Vermeer. Another of the sources already mentioned as influential on Whistler's ideas is the stream of artefacts issuing from Japan. Both Dutch and Japanese art were important in developing Whistler's inherent feeling not just for composition of line, but also for orchestration of tone. He was convinced that the fundamental nature of a painting was concerned with the materials used in its creation, rather than with the edifying or entertaining aspects of its excuse, the subject. The artist should 'treat a flower as his key, not as his model'.

It was this conviction that led to the use of musical titles. And, although painterly sources can clearly be found for the concept of thematic colour, it is—perhaps paradoxically—literary sources which seem even more important, and which most certainly inspired the expressive nomenclature.

It has been seen that not only Whistler but also Swinburne in his criticisms, the

Essays and Studies for example, introduced musical terms as the most fitting and lucid way of describing various paintings. But this was not just a passing whim or affectation of the Whistler circle. Analogies with music had been invoked in the first half of the century, when discussion raged over the differences between the Romantic painter and the Classical, the relative value of colour and line. Delacroix, for example, upbraided the critics for their endless arguments 'over the primacy of drawing against colour, as to whether melody should take precedence over harmony, and whether composition is the first of qualities'.[16]

Still in this context, reiterating the parallel, Théophile Gautier wrote in 1856, 'Design is like the melody, colour the harmony; if you will allow this comparison borrowed from another art.'[17]

Among the many other associated ideas conjured in Baudelaire's *Fleurs du Mal*, one finds the emphatic repetition of parallels drawn between the concepts of night, darkness, music, poetry and passion. One poem, 'Correspondances', asserts the links between music, colours, sounds and perfumes. Another has some lines which seem evocations in poetry of the Nocturnes Whistler painted:

Voici venir le temps où vibrant sur sa tige
Chaque fleur s'évapore ainsi qu'un encensoir
Les sons et les parfums tournent dans l'air du soir
Valse mélancolique et langoureux vertige.[18]

It was through the translation of Baudelaire that French audiences became familiar with Edgar Allan Poe, for whom Whistler had sympathy as a fellow countryman as well as an artist. Poe's work had first appeared in France as early as November 1845, in a translation of the 'Gold Bug' in the *Revue Brittanique*. 'Mesmeric Revelations' was the first of Poe's stories to be translated and annotated by Baudelaire, in 1848, while the bulk of his work was published in French between about 1852 and 1865. Baudelaire felt he had discovered in Poe an artist whose ideas had developed along lines parallel to his own. Poe's concept of Beauty as the supreme aim of the artist seems to depend on the expression of something ethereal and esoteric, beyond the ordinary pleasures and tastes of man; a mystic sensation which must be evoked. And it was in music, the most abstract art, that he found this most easily attainable: 'It is in music, perhaps, that the soul most nearly attains the great end for which, when inspired by the poetic sentiment, it struggles—the creation of supernal beauty.'[19] Hence, 'the idea without music is prose from its very definiteness.'[20]

Whistler and his English friends were certainly very much aware of the work of these writers. Swinburne, particularly, made frequent references to Gautier, Baudelaire and Poe, and in 1873 he composed some 'Memorial Verses on the Death of Théophile Gautier', published in the *Fortnightly Review*.

In England itself one finds in the elegant writing of Walter Pater further discussion of the relationship between music and the several other arts. Like Poe he considers that in art alone, in what Poe calls 'the contemplation of beauty', is it possible to attain the 'supreme elevation or excitement of the soul';[21] in Pater's words, 'a quickened, multiplied consciousness'. Pater concludes, 'All art constantly aspires towards the condition of music. For while in all other kinds of art it is possible to distinguish the matter from the form, and the understanding can always make this distinction, yet it is the constant effort of art to obliterate it.'[22]

Pater's publications certainly aroused the interest of the Rossetti circle in London. Swinburne actually felt, and probably rightly, that Pater had been somewhat influenced by his own writing: as he wrote to Rossetti in 1869, 'I liked Pater's article on Leonardo very much. I confess I did fancy there was a little spice of my style, as you say, but much good stuff of his own, and much of interest.'[23]

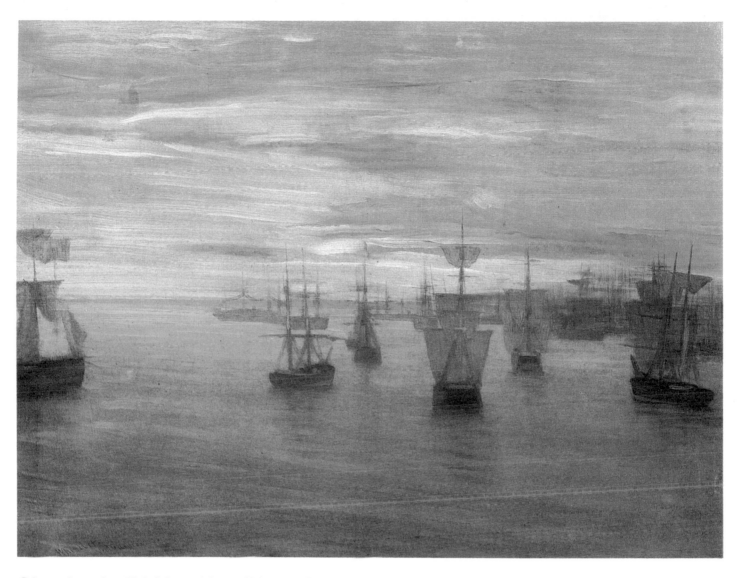

Colour 9 *Crepuscle in Flesh Colour and Green: Valparaiso*, 1866, oil, 57.2 × 75.5 cm (22½ × 29¾ in.). Tate Gallery, London.

It is worth noting that not only was painting, and its appreciation, influenced by the terminology and techniques of music, but music, too, or the work of some musicians, was affected by painting, particularly Whistler's painting. Claude Debussy, of course, is most notable in this context. He undoubtedly admired Whistler, and the two worked together in May 1893, with Stéphane Mallarmé and Henri de Régnier, on the first Parisian production of the symbolic drama by Count Maurice Maeterlinck *Pelléas and Mélisande*. In comparing the work of the two, Théodore Duret wrote,

> Whistler's Nocturnes leave the motif vague, enveloped in atmosphere or shadow which has its own value and itself becomes the theme of the painting; similarly in Debussy's Nocturnes the melody or musical motif remains enveloped in a mysterious and continuous harmony.[24]

Duret also compares Whistler's Nocturnes to 'fragments of Wagnerian music'.

Emmanuel Chabrier, a great friend of Manet, uses pictorial metaphors to describe the way he worked: 'If the only colours I could use were grey pearl and canary yellow with their various shades . . .' Significantly, he introduces tones peculiar not only to the palette of Manet, but also to that of Whistler. He concludes his discussion with a Whistlerian choice of highlight: '. . . well, no, I should not find them enough . . . Let's have a little red, Good God!'[25]

Clearly, there were precedents for Whistler's interest in the parallels between music and painting. He could not have avoided being deeply influenced and even directed by the ideas of writers so much admired by so many of his contemporaries. His understanding of their work might not have been so deep and subtle as that of Swinburne, perhaps. He was not, after all, himself a poet. But, in terms of his own medium, he explored and clarified the implications of this relationship between the arts. His titles served to reiterate, to underline constantly, those principles of painting which he developed: principles of abstraction which, though receiving encouragement from many sources, were fundamentally personal. Throughout his mature career he remained convinced of the sentiments expressed in 1878 in one of his earliest attacks, 'The Red Rag'.

> Art should be independent of all clap-trap—should stand alone, and appeal to the artistic sense of eye or ear, without confounding this with emotions entirely foreign to it, as devotion, pity, love, patriotism and the like. All these have no kind of concern with it, and that is why I insist on calling my works 'arrangements' and 'harmonies'.

In June 1874 Whistler held his first one-man exhibition, at the Flemish Gallery, 48 Pall Mall. Beneath every painting a musical title was systematically applied. That they were intended to suggest the general aims which lay behind the picture, rather than the specific nature of an experiment in parallels between notes of music and colour, becomes apparent in the sometimes fairly loose way he would apply these titles. In the winter exhibition at the Dudley Gallery, in October 1875, for example, he showed a *Blue and Gold No. 3*. This is perhaps that painting now known in the Freer Gallery, Washington, as *Blue and Silver: Battersea Reach*; on the back there is, in Whistler's hand, the former title (Plate 51). The *Nocturne in Blue and Gold: Westminster* was exhibited also as *Grey and Gold* and *Blue and Silver*. After Whistler's death Bernhard Sickert, not an unsympathetic critic, wrote to the Pennells giving many alternatives to the titles they had published. To Sickert this raised the question of whether Whistler's motives for introducing such nomenclature were truly serious and considered, or whether 'the analogy attempted by him between music and painting falls to pieces'.[26]

But this question arises from a misconception. True, the occasional and

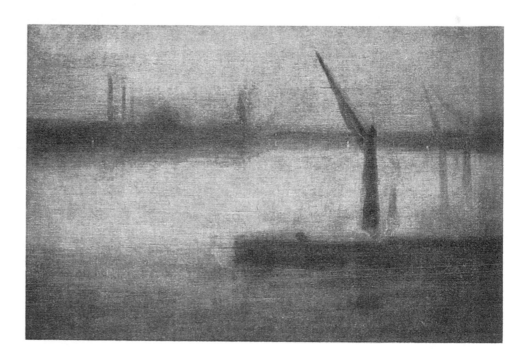

51 *Blue and Silver: Battersea Reach,*
c. 1874, oil, 49.9 × 76.5 cm (19⅝ ×
30⅛ in.). Courtesy of The Smithsonian
Institution, Freer Gallery of Art,
Washington D.C.

apparently casual changes of title are sometimes disconcerting, and they would seem
to represent a certain carelessness. No piece of music could be called, at will, a
'Symphony' in one of several different keys. But Whistler was not attempting such
an utterly rigorous parallel with musical technique. He was not confusing one art
with another. And it is perfectly feasible that a painting, particularly one of his low-
toned Nocturnes, could at a different time and in a different environment have a title
applied to it more satisfactory even than the original.[27] Whistler was never careless
over his colour themes:

> I observe that many journals have thought proper to inform the 'curious reader'
> . . . that the 'peculiar titles of my pictures' . . . were suggested to me by one of my
> 'boon companions' when I had 'in my off hand way, *hastily* given life to one of my
> peculiar creations'.
>
> But 'candour compels me to confess' that . . . these creations are the result of
> much earnest study and deep thought. Each of them represents, to me at least, a
> problem laboriously solved, and their peculiar titles suggest as much. . . .[28]

Nocturne in Blue and Gold: Old Battersea Bridge, which is one of the most well
known of Whistler's Nocturnes, seems also to have been called *Blue and Silver*[29]
(Colour Plate 12, p. 78). Painted on fairly rough-grained and very absorbent
canvas, the brushmarks of this work are totally dissolved, just as the details of the
scene are submerged in the all-enveloping simplicity of hue. The blue of water,
horizon and sky actually comprises a wide variety of tones, subtly gradated to create
an atmospheric, monochromatic effect. Even the touches of bright lights scattered
along the bank are applied with a light hand and fluid paint. The design is boldly
enunciated, the strong vertical of the bridge asserting the flatness of the picture plane
and contrasting with the softer, more elusive horizontals.

The familiar sights of the reaches of the Thames provided the theme for the
majority of Whistler's Nocturnes. These were generally wide, unpeopled vistas, but
he did paint a series of that popular place of entertainment the pleasure gardens at
Cremorne. The excitement and gaiety of this spot is manifest in all the versions
Whistler executed. The *Cremorne Gardens No. 2,* full of fashionable and active
figures, parallels, to some extent, the 'modern life' paintings of his French associates

overleaf
Colour 10 *Nocturne in Blue and Silver:*
Cremorne Lights, 1872, oil, 49.5 × 74.0 cm
(19½ × 29⅛ in.). Tate Gallery, London.

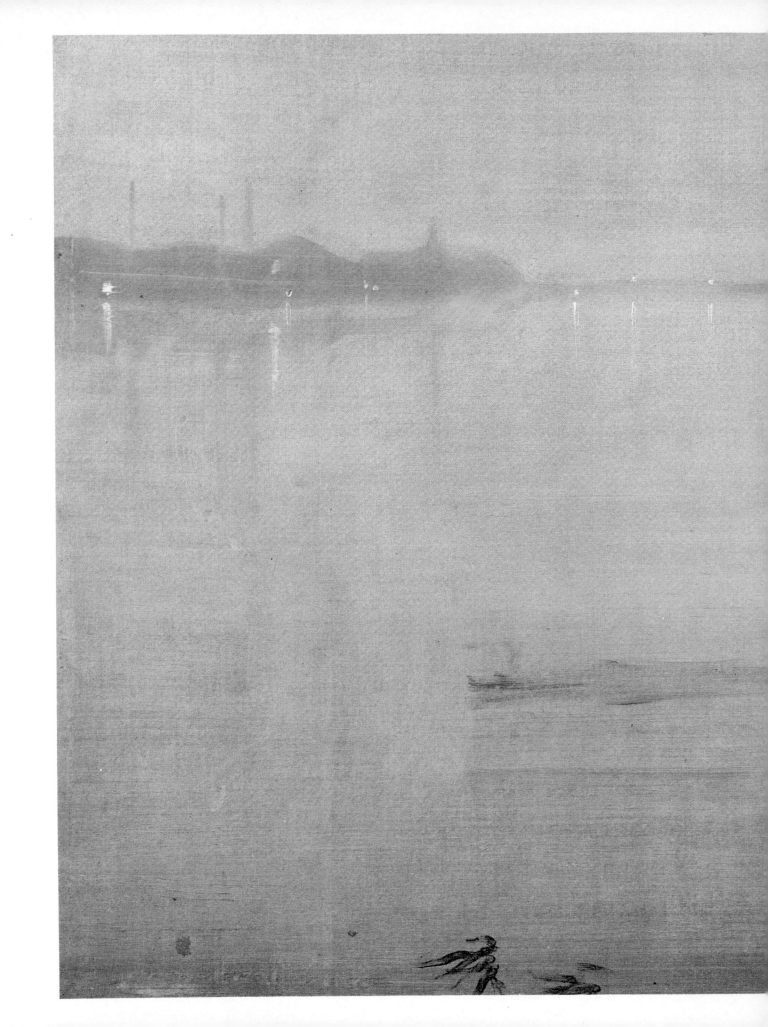

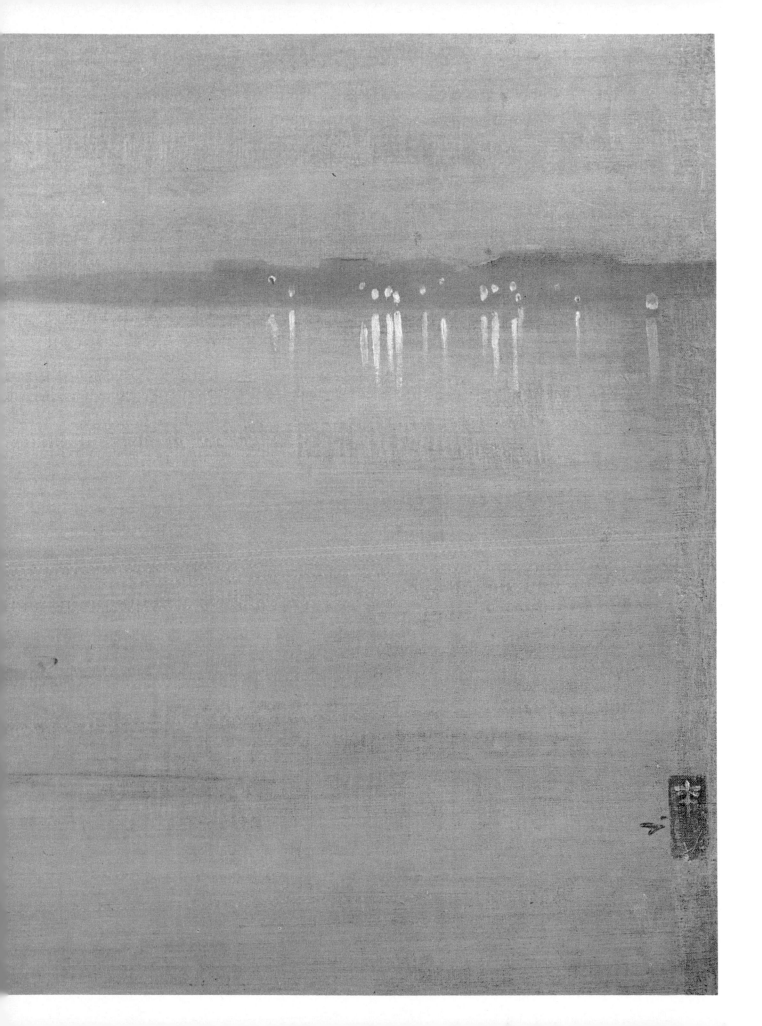

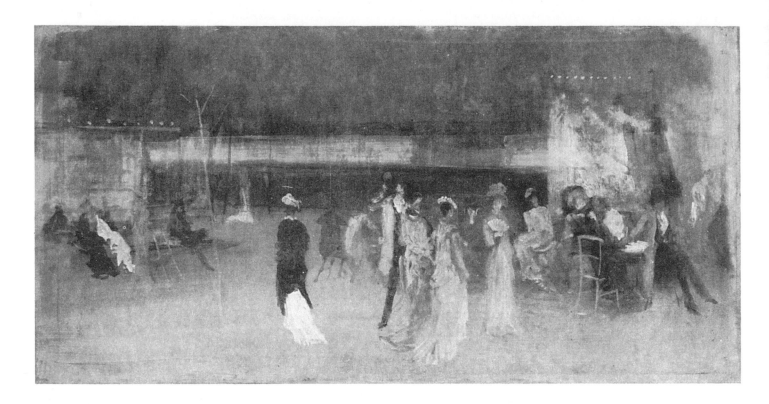

52 *Cremorne Gardens No. 2*, *c.* 1875, oil,
68.5 × 135.5 cm (27 × 53⅜ in.).
Metropolitan Museum of Art, New York;
Kennedy Fund.

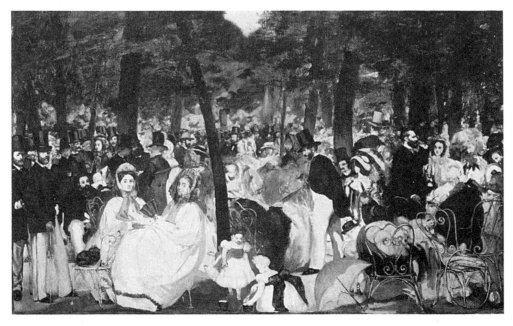

53 Edouard Manet, *Music in the Tuileries*,
c. 1860, oil, 76.2 × 118.1 cm (30 ×
46½ in.). Reproduced by courtesy of the
Trustees, The National Gallery, London.

Manet and Tissot, with whom he was in close contact during the early 1870s[30]
(Plates 52, 53). Two technically much more fascinating pictures of Cremorne have
both been the subject of much discussion: the *Nocturne in Black and Gold: the
Firewheel*, and the *Nocturne in Black and Gold: the Falling Rocket*, of *c.* 1874. It was
the latter which directly precipitated the Whistler *v.* Ruskin trial of 1878 (Plate 74).
The former, perhaps even more daring in its execution, was probably painted at a
slightly later date (Colour Plate 11, p. 74).

In this the touch of the brush is throughout delicate, light and controlled. There is
no wildness, no violent attack, no heavy impasto. The warm, bright tones of the

54 *Battersea Reach from Lindsey Houses,*
c. 1871, oil, 50.2 × 75.7 cm (19¾ ×
29¾ in.). Hunterian Art Gallery, University
of Glasgow; Birnie Philip Bequest.

55 *Cremorne Gardens No. 1*, with frame,
c. 1874–5, oil, 49.5 × 76.2 cm (19½ ×
30 in.). Fogg Art Museum, Harvard
University, Cambridge, Mass.; Grenville
L. Winthrop Bequest.

lights emerge from the still warm but sombre darkness; the paint is so transparent
that it creates an effect of the permeating atmosphere. The flat, horizontal emphasis
typical of so many of his compositions is still apparent, but its starkness is alleviated
by the play of the subtly arranged spurts of light. A few figures are briefly indicated,
yet with no attempt at naturalistic form; they simply provide the necessary colour
accents. The dynamism of the canvas stems mainly from the brilliant bursts of
golden light of the Cathcrine Wheel. The optical effect of the falling sparks creating
vertical streaks of light is conveyed by the shoots of paint, obviously, and
astonishingly, quite deliberately dripped down the surface. The whole invokes a

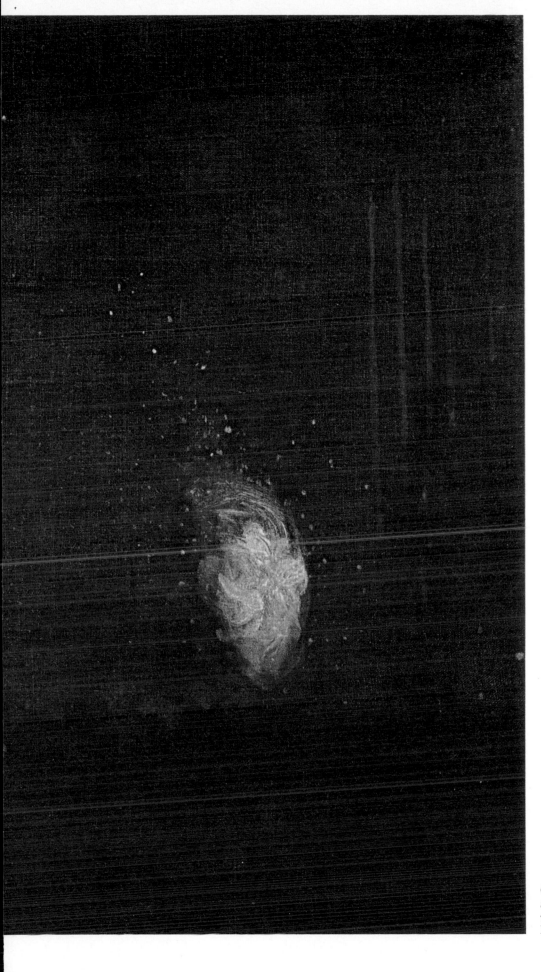

Colour 11 *Nocturne in Black and Gold:
the Firewheel, c.* 1874, oil, 53.5 ×
75.5 cm (21 × 29¾ in.). Tate Gallery,
London.

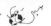

56 *The Firewheel* (copy of the painting of *c.* 1874–5, Colour Plate 11, p. 74), 1893, watercolour, 9.5 × 15.5 cm (3¾ × 6⅛ in.). Hunterian Art Gallery, University of Glasgow; Birnie Philip Bequest.

feeling of gaiety, brilliance and movement, through a masterly control of the medium, which eliminates violence of colour, paintwork or form, but creates on the canvas an intrinsic excitement. It is interesting to compare the painting with a watercolour copy of it made in 1893 (Plate 56). This is fascinating in its adventure into almost total abstraction; the subject is now the life of the paint itself.

These extraordinary Nocturnes, not surprisingly, aroused much remark. There was much unthinking ridicule, and furious attack, such as that which occasioned the Ruskin trial. There was also, however, another type of criticism: considered, thoughtful, but still unfavourable. This does deserve some examination. J. Meier-Graefe, for example, in his lengthy study of modern art, saw Whistler's effects as increasingly weak and facile from the early 1870s. He interpreted the Nocturnes as uncontrolled, bathed in vapour to eliminate difficulties. One painting he describes as a 'tasteful colouristic schema'.[31] George Moore, in the same book in which he obviously enjoys the Cremorne *Firewheel* Nocturne, describes others as the 'outcome of a highly strung, bloodless nature, whetted on the whetstone of its own weakness to an exasperated sense of volatile colour and evanescent light'.[32]

It is undoubtedly significant that these similar criticisms were penned around the turn of the century, a time when Whistler was identified with the Symbolists and Decadents, and others who appeared often self-consciously highly strung and morbidly refined in their sensitivity; and it must be admitted that there are paintings among the Nocturnes which do leave one dissatisfied, even irritated. There are those, such as one or two painted at Cremorne Gardens, that appear 'left off', rather than finished, though some of this must be owing to the darkening colour which in time has subsumed the minute delicacies of tone and subtleties of form (Plate 55).[33] That group of paintings where exotically costumed figures lounge on the Thames Embankment often appears mannered or immature (Plate 54). Yet the best Nocturnes survive such criticism. Whistler's sympathy with his materials, and his ability to exploit these sensuously, simplifying the form and rationalizing his own reactions, is revealed in all its fulness and vitality in such startling and exciting paintings as the two Cremorne firework Nocturnes.

4 The Artist in Society

Cremorne Gardens, already referred to as the inspiration for several of Whistler's Nocturnes, doubtless attracted him not only by its light displays, but also by the brilliant array of fashionables gathered there nightly. From his earliest student days in Paris, Whistler had devoted much of his time to social mixing, both with his group of 'no shirt' friends, and with others better connected.

On his arrival in London he had been welcomed by Seymour Haden, his brother-in-law, who even while Whistler was still in Paris had tried to interest influential patrons in his work. Once in London he had been successfully received at the Royal Academy, had found important patrons among the exclusive Greek community, and discovered himself in a position to encourage his less fortunate French friends to visit London and improve their lot.

The circle of friends that surrounded Rossetti, and which Whistler joined in 1862, may have been somewhat unorthodox, but it was not uncouth. It included not only artists, but also writers of the seriousness of W. M. Rossetti and George Meredith, and even a solicitor of standing, J. Anderson Rose.

Quite evidently, almost from the start, the appeal to Whistler of bohemian living extended only in so far as it provided a contrast to a setting of more comfortable social refinement. And this, of course, must have contributed to his consciously evolved theories as to the position the artist ought to take in the society which surrounded him.

For Whistler, the artist should concern himself not simply with the isolated production of a work of art, but with the quality of his whole environment and mode of living. If a refined, sensitive, carefully composed painting were to be produced, it could only be done by an artist in whose everyday life these qualities were reflected.

Whistler made several different homes in London and on each occasion devoted considerable time and attention to the arrangement of the rooms, their colour, light and general layout. Initially, in the early 1860s, his taste was inspired by the collections of Oriental artefacts, and then of Dutch blue and white china, which he assiduously gathered together. His mother, who came to live with him in the winter of 1863, wrote to a friend of her son's 'artistic abode . . . ornamented by a very rare collection of Japanese and Chinese' china.[1]

When, on his return from Valparaiso at the end of 1866, Whistler moved to 2 Lindsay Row, the interior decoration was closely observed by his friends. W. M. Rossetti, invited to the housewarming, noted, 'There are some fine old fixtures as doors, fireplaces, etc., and Whistler has got-up the rooms with many delightful Japanesisms, etc. Saw for the first time his pagoda cabinet.'[2] Alan Cole, while remarking Whistler's house to be full of light, rather more tersely describes 'Jimmy's absurdities with pieces of Liberty silks on the floor' and flights of Japanese fans on the ceiling.[3]

As a background to these 'Japanesisms', the overall hue of the rooms was invariably simple, usually light. Walter Greaves describes the dining room at No. 2 as blue, with darker blue dado and doors; the studio, quiet and sombre in grey and black; and the drawing room, painted at the last minute before the housewarming, in tones of flesh colour, yellow and white.[4]

overleaf
Colour 12 *Nocturne in Blue and Gold: Old Battersea Bridge*, c. 1873, oil, 66.6 × 50.2 cm (26¼ × 19¾ in.). Tate Gallery, London.

Colour 13 *Nocturne in Blue and Gold: Valparaiso*, 1866, oil, 75.6 × 50.1 cm (29¾ × 19¾ in.). Courtesy of The Smithsonian Institution, Freer Gallery of Art, Washington D.C.

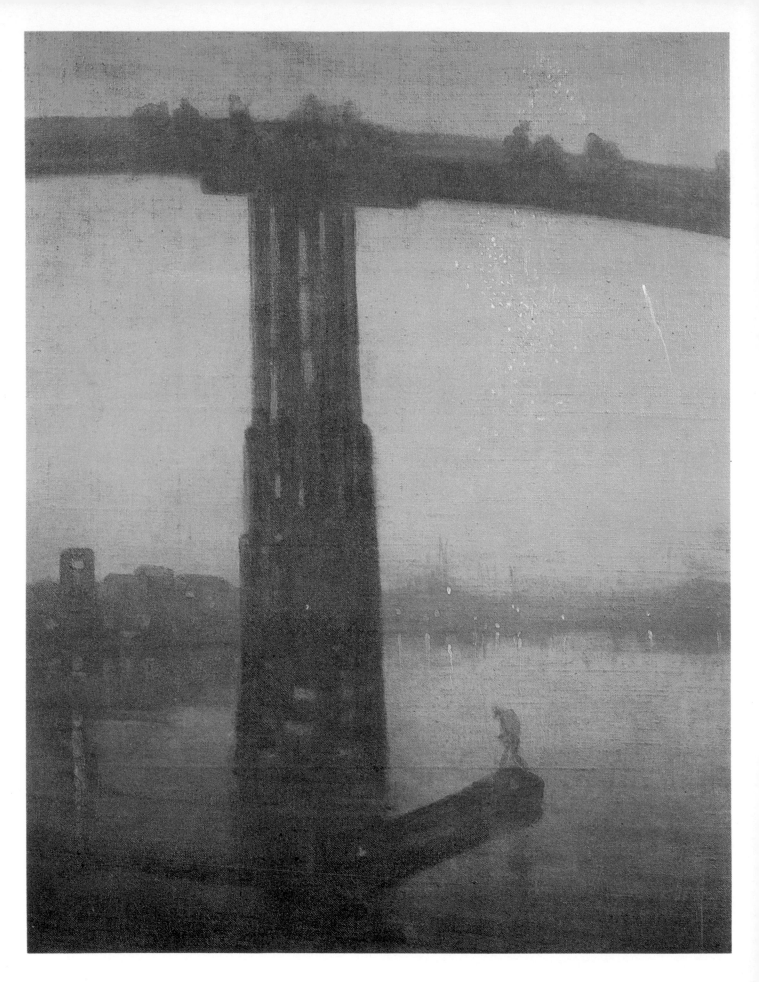

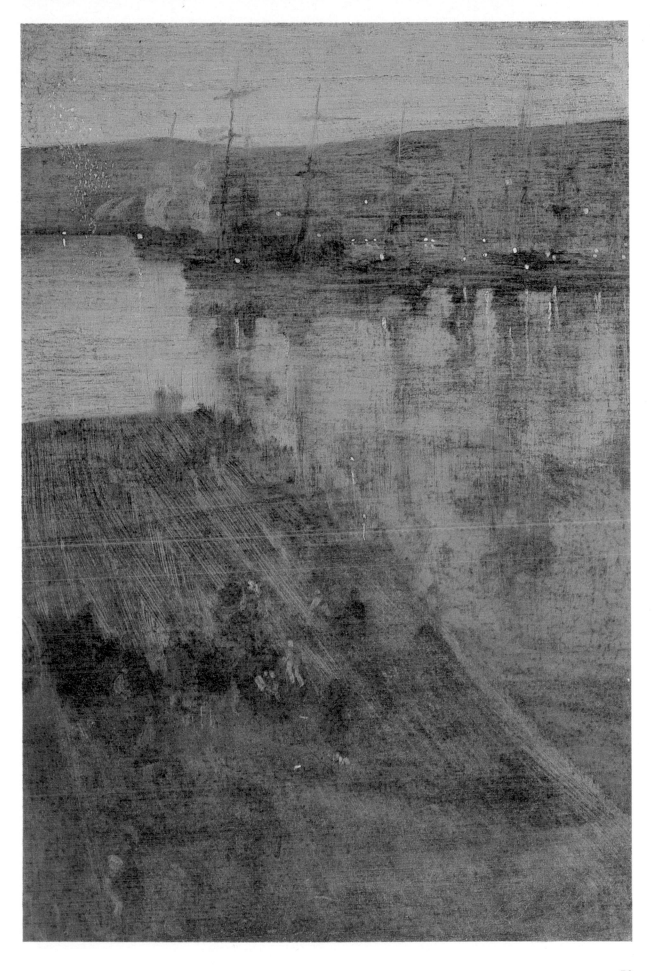

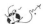

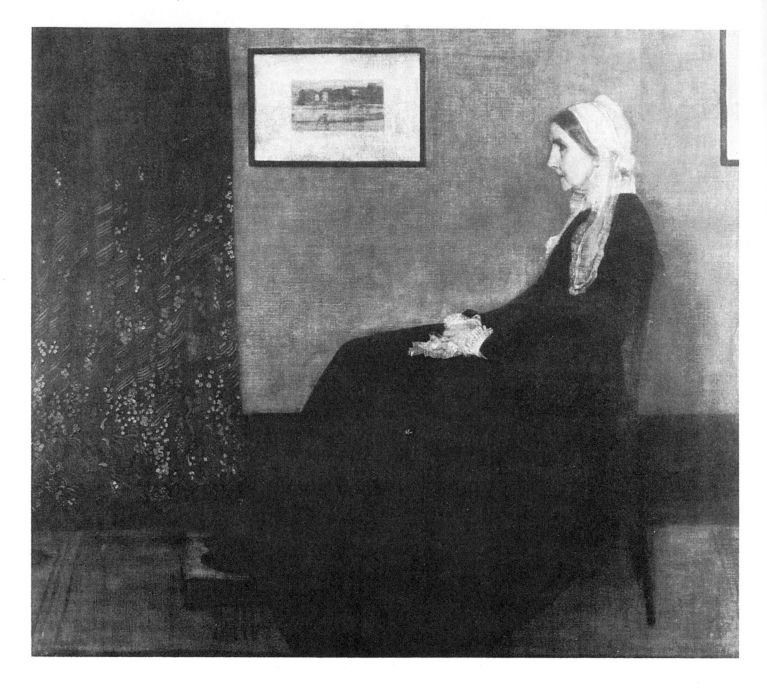

It was in this coolly coloured studio that Whistler painted *Arrangement in Grey and Black No. 1: the Artist's Mother* (Plate 57). The figure is shown in profile, the body a simple, flat shape, held tautly in place by the lines of curtain, skirting and picture frames. The narrow and sombre range of hue, the severe simplicity of composition, combine with the slight rounding of the shoulders and drooping of the head to convey an impression of an ageing woman still strict and dignified. Writing probably of an earlier state of this work to Fantin in 1867, Whistler once again makes it quite clear that he feels increasingly assured of his ability to produce an art of strict linear control and tonal exactitude: 'I think I have just about understood the science of colour, and have reduced it to a system.'[5] His systematic approach is made explicit in the title 'Arrangement', under which the portrait was exhibited at the Royal Academy in 1872. And it was against this approach that much criticism was raised for many years. In a chatty and slightly scathing article in the *Edinburgh Review*, for

57 *Arrangement in Grey and Black No. 1: the Artist's Mother*, 1872, oil, 145.0 × 164.0 cm ($57\frac{7}{8}$ × $64\frac{5}{8}$ in.). Louvre, Paris; photo Musées Nationaux.

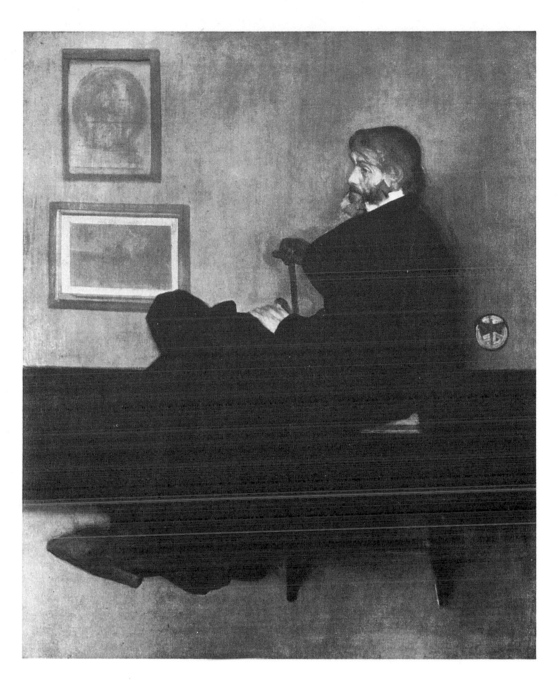

58 *Arrangement in Grey and Black No. 2:*
Thomas Carlyle, 1872–3, oil, 171.0 ×
143.5 cm (67⅜ × 56½ in.). Glasgow Art
Gallery.

example, a writer declares, 'Decoration has (in part) driven out life.'[6]

Much the same sort of attack was mounted against the *Arrangement in Grey and*
Black No. 2: Thomas Carlyle (Plate 58). *Carlyle* was slightly more heavily worked
than the *Mother*; this painting nevertheless manifests the same restrained simplicity
of arrangement, the same sparing elegance of line. The solid, flat, black masses of
coat and hat are heightened by the flash of white at the neck, and the decorative notes
of the circular print and butterfly motif. And, as with all his most successful
portraits, Whistler has captured some most expressive elements of his sitter's
personality: 'It is a portrait which penetrates to the thoughts beneath the outer
appearance.'[7]

Accustomed to contemporary portraiture in which every conceivable accessory
might be introduced to give grandeur, or add information about the circumstances of
a sitter, and every detail of appearance might be flattered and elaborated, many

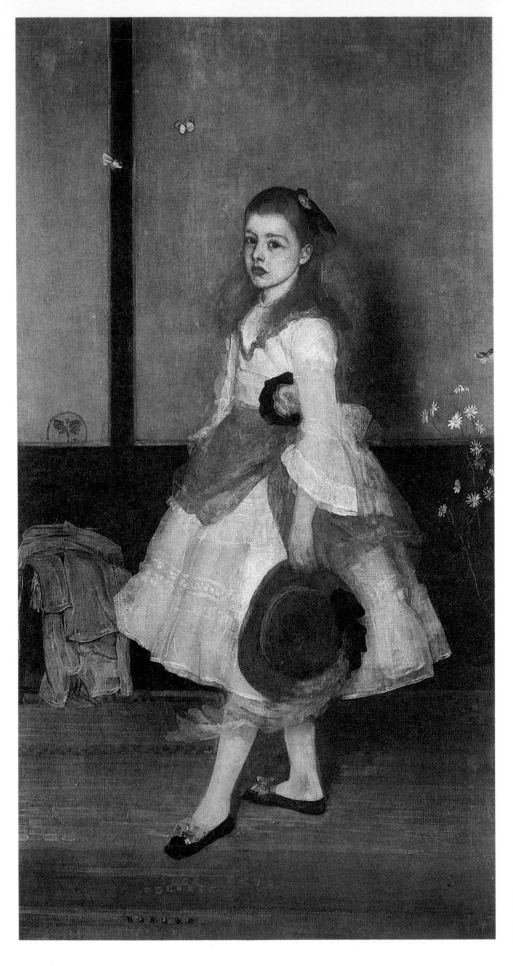

Colour 14 *Harmony in Grey and Green: Miss Cicely Alexander*, 1873, oil, 218.4 × 99.0 cm (86 × 39 in.). Tate Gallery, London.

59 *Harmony in Grey and Green: Miss Cicely Alexander* (detail). Tate Gallery, London.

critics failed to appreciate this indefinable flavour of the personality which Whistler could catch. It is possible to see in the languorous ease of the portraits of Jo not necessarily her own character, but the overtones of Rossetti's poetic dream of woman. Yet in the *Mother, Carlyle*, and even more in the later portraits, there is little or none of this somewhat literary artifice, but rather a much simpler insight into character: the severe and sincere matriarch, or the tired and ageing intellectual. That Whistler did retain some interest in his sitters as individuals should be recalled, in order to balance and highlight his indisputably greater concern for the disposition of colour and line across a canvas.

It seems to be clearly indicated by the considerable number of commissions he received for portraits that he was an accepted figure among some elements, at least, of fashionable society at this time. Before *Carlyle* was finished he had embarked upon portraits of members of both the Alexander and the Leyland families, some of which were exhibited in Whistler's first one-man show at the Flemish Gallery, Pall Mall, in 1874.

Harmony in Grey and Green: Miss Cicely Alexander, begun probably in the first half of 1873, was the only Alexander portrait to be finished (Colour Plate 14, p. 82;

Plate 59). Even this took about seventy sittings. Though there is nothing laboured about the final portrait, it was being continually rubbed out and repainted; if Whistler were not absolutely satisfied with one area, it must go. He wished to achieve a simple, fresh spontaneity; a realization on canvas of the arrangement he had planned in his mind.

There are one or two sketches relating to the portrait, including a pastel and a study of the head, but the search for a happily resolved composition must have been conducted by Whistler mainly in his mind, before he approached the final canvas. This is confirmed by Cicely Alexander herself. She wrote to the Pennells that, after visiting the family, Whistler determined to begin with the 'light arrangement'; that is, Cicely, and not her dark-haired sister.[8] Having thus established the main tonality of the picture, he went on to elaborate the detail. He supervised the making and laundering of Cicely's costume, and evidently arranged her position against his grey studio wall with exactitude. The Pennells' own description of the harmony achieved cannot be surpassed: 'the colours which bind all this arrangement together, which play all through it, are green and gold . . . like . . . threads in tapestry.'[9]

There is an unfinished portrait of Cicely's sister, May Alexander, but this appears uncertain and timid beside the *Cicely* (Plate 60). It was apparently painted in the Alexanders' home and not in Whistler's studio, and perhaps this explains the lack of ease and directness. A more successful work, exhibiting the critically exact approach of *Cicely*, is the portrait of Mrs Leyland, again painted in 1873 and exhibited at the Flemish Gallery in 1874 (Colour Plate 16, p. 132).

This *Symphony in Flesh Colour and Pink* is another painting not quite finished. It does reveal rather heavy working around the shoulders and sides; but this does not detract from the monumental sweep of the figure as it rises up the large canvas. It is dominated by delicate, cool grey-green and pink tones, highlighted by the rich warm brown of hair, and rosettes scattered over the dress. The elegant simplicity of the figure is decorated with tiny, gay touches of flowers intruding at the side, and patterns on the mat, both of which also appear in the *Cicely Alexander*.

All the portraits of this time obviously result from a concentrated effort to produce a formal, theoretical system which could set the pattern for figure arrangements. Nearly all are set against a plain ground, articulated only by a dado or a skirting board. Decorative details, such as the dainty floral intrusions, add a note of lightness, but they are not essential and were gradually abandoned. The essential nature of each painting lay in its structural balance and simplicity. The details of each individual harmony had to be subordinated to the whole.

The same feeling for structural integrity which characterizes the portraits is typical of Whistler's approach to the whole range of his work. For many of his patrons he also executed, or suggested, interior decorations, on which he lavished as much detailed care and attention as on the exhibition portraits.

Some of his own furniture, of Oriental inspiration, may have been exotic but it was, nevertheless, mainly simple in form, and fairly scantily distributed. This feeling for essential simplicity had doubtless been bred in the Paris studios, where economy had been imposed. It must now have been encouraged by E. W. Godwin, whom Whistler seems to have met in the early 1860s. From about 1860 the former had studied the art of Japan. Besides being an architect of note, he had become increasingly interested in the whole field of interior decoration. His early wallpapers, designed for Jeffrey and Co., comprise sunflowers, birds in flight, interlaced bamboo: all Japanese motifs. As early as 1862, his income assured by his success in the competition for Northampton Town Hall, he had acquired a reputation for eccentricity by taking new rooms in Portland Square, Bristol, painting them in plain

60 *Miss A. M. Alexander*, 1873, oil, 192.4 × 101.6 cm (75¾ × 40 in.). Tate Gallery, London.

colours, hanging Japanese prints and laying Persian rugs on the bare floors. It seems undoubted that Godwin was an important influence on Whistler's sense of interior design, ridding him of his more elaborate flights of decorative fancy and encouraging him to work towards a frank structural simplicity. Whistler and Godwin together showed a stand at the Paris Universal Exhibition in 1878 (Plate 61). The signboard of the stand declares that the 'Decorations, Harmony in Yellow and Gold' were designed and painted by Whistler, the china lent by Liberty, Regent Street, while the furniture was designed by Godwin and executed by William Watt. It was at this time that Godwin and Whistler were planning the furniture which should go into the latter's own White House, designed for him by Godwin; the Paris display was a trial run. The White House, with its simple, even playful, asymmetry, was in radical contrast to those more stolid and elaborate red brick villas then becoming fashionable. So radical was it, in fact, that Godwin was obliged by the local authorities to impose a few decorative motifs before they would grant permission for its construction[10] (Plate 62).

When William Alexander bought Aubrey House in Campden Hill, Kensington in 1873, he was beleaguered by Whistler with suggestions for its decoration. These he seems to have readily received, although not many were actually adopted. There is an indication that Whistler, at about the same time, decorated a room for his solicitor, Anderson Rose, but nothing now is known of this scheme. Aubrey House remains the best example of Whistler's plans for a patron in the early seventies.

He submitted not merely colour schemes and decorations for the individual rooms, but also sketches of appropriate furniture (Plate 63). In a sketch for the dining room he portrays three chairs, radically simple in their use of four apparently

61 Stand at the Paris Universal Exhibition of 1878. Cabinet and fireplace designed by E. W. Godwin, executed by William Watt. China lent by Liberty's of Regent Street, London. Decorations (*Harmony in Yellow and Gold*) by Whistler. Crown Copyright; Victoria and Albert Museum, London.

62 E. W. Godwin, Front elevation of house at Tite Street, pen and ink with wash, 31.8 × 45.1 cm (12½ × 17¾ in.). Hunterian Art Gallery, University of Glasgow; Birnie Philip Bequest.

63 Sketch for furniture at Aubrey House,
c. 1873. From a photograph in The
Library of Congress, Washington D.C.;
Pennell Collection.

unmoulded struts for the back, and elegant in their proportions. For the sideboard Whistler again removes all elaboration typical of contemporary design. The whole is a carefully proportioned, functional piece of furniture, comprising a cupboard and shelf space on which the collection of china could be displayed.

The plans for the colour schemes of Alexander's house are similarly simple. This was only one year before William Morris bought out his partners in the firm of Morris, Marshall, Faulkner & Co., and was firmly embarked upon his career as a designer of, among other things, wallpapers of dazzling pattern and colour. In contrast, in his sketches for the decoration of the dining room, executed on a few small sheets of brown paper, Whistler created an arrangement of rhythmically spaced horizontal lines, signifying the dado, the main wall, and the frieze (Plate 64). The colour theme is built up from a range of subtly different tones of blue and gold, creating an abstractly harmonious composition of line and colour.

The most famous of all Whistler's decorative schemes is, of course, the Peacock Room, executed for his friend and patron F. R. Leyland, at 49 Princes Gate, in 1876–7 (Plates 65, 66). No other commission seems to have absorbed so much of his attention; no other now poses so many problems.

It seems that Whistler was initially asked to do some work on the panels of the staircase. He painted these to imitate aventurine lacquer, and decorated them with small floral patterns of pale pink and white. At the same time Thomas Jeckyll, for whom Whistler later declared his friendship and admiration, was occupied with the planning of the dining room, at one end of which was to hang Whistler's '*Princesse du Pays de la Porcelaine*'. Somewhat dissatisfied with the colour of the leather with which Jeckyll had panelled the room, feeling that it clashed with his painting, Whistler obtained the permission of Leyland, then at Speke Hall, to alter the hue of the embossed flowers. The plan soon escalated until the whole room was being modified and redecorated.

The Peacock Room occupied all Whistler's time and thoughts for several months, with the Greaves brothers as busy assistants. The window panel and the opposite wall portray the peacocks in their full glory; the subsidiary decoration around the room is based on the breast and tail feathers of the bird. The theme of peacocks is in

64 Colour scheme for decoration of
Aubrey House, *c*. 1873, watercolour on
brown paper, 15.1 × 10.1 cm (6 × 4 in.).
Hunterian Art Gallery, University of
Glasgow; Birnie Philip Bequest.

the Japanese tradition, and it was not only Whistler who re-used it at this time. As early as 1867 his friend Godwin had employed the peacock theme in the wall decoration of the major apartments of Dromore, the castle he built near Pallaskenny, Ireland, for the Earl of Limerick. Albert Moore planned a peacock frieze for a wall decoration commissioned in 1872 by A. F. Lehman, for his house at 15 Berkeley Square. In the 1860s Rossetti had, of course, among his various exotic animals, owned a peacock. And there is an amusing tale of Henry Irving, in the early 1870s, utilizing the current fascination for this fashionable bird when, as Hamlet, he shouted 'Peacock!' to Ophelia, then carrying a fan of those decorative feathers; the audience was said to be greatly appreciative.[11]

Whistler is said to have broached the peacock as a theme for decoration in Alexander's house on Campden Hill. It must have been fairly well established in his mind, for there are very few sketches for the Leyland room; and the smaller of these seem to have been executed as late as the 1880s to illustrate the scheme, of which he was always proud, to his admirers.

The Peacock Room now appears heavy and over-decorated. Much of this is undoubtedly owing to the architectural details originally installed by Jeckyll. The overall colour scheme is simply blue and gold, the gold leaf being left to tarnish a little before varnishing to remove any crude brassiness. But whatever the delicacies

65 The Peacock Room, 1876–7. Courtesy of The Smithsonian Institution, Freer Gallery of Art, Washington D.C.

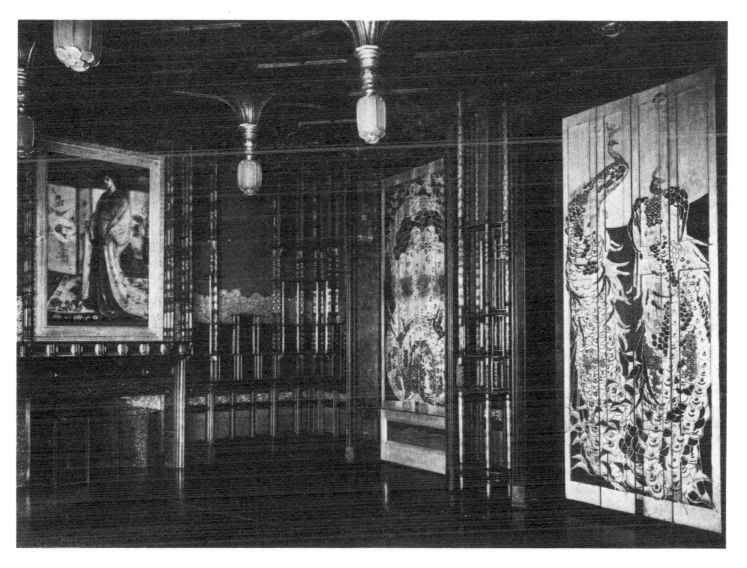

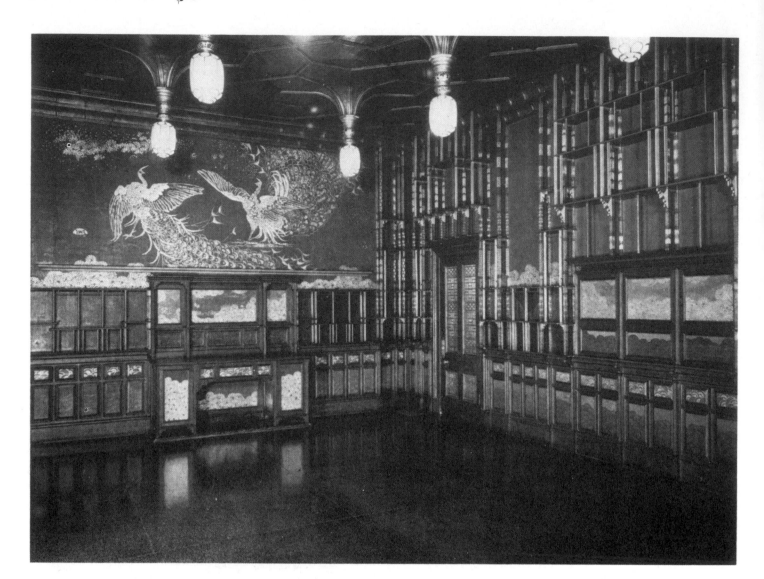

66 The Peacock Room, 1876–7. Courtesy of The Smithsonian Institution, Freer Gallery of Art, Washington D.C.

of detail, the whole now lacks subtlety, and that elegant simplicity which one usually associates with Whistler's decorative schemes. Whistler's impetus towards an elaborate scheme of decoration must have been encouraged by the plans he had drawn up for the Central Gallery at South Kensington, in 1873. Henry Cole had asked him to execute a mosaic panel, and for this he designed a figure richly robed in Japanese costume and carrying a parasol (Plate 67). The Pennells emphasize the fact that, though this scheme was never brought to a conclusion, Whistler was always anxious to carry out some great plan of this nature. Perhaps the frustration experienced at not being given the opportunity explains, in some measure, the Peacock Room. Nonetheless, when considering Whistler as an interior decorator, discussing those elements of simplicity, delicacy and lightness which seem to preface so much of twentieth-century design, it is as well to bear in mind the Peacock Room, a room which carries with it connotations of the rich, exotic claustrophobia which now seem characteristic of Victorian planning, a room which Whistler at no time rejected.

While Whistler was desperately busy with his decorations, his patron, Leyland, remained at Speke Hall. There were letters passing between them already revealing some disagreement about money, but the two seem to have continued on fairly

above

67 Design for a mosaic panel for the South Kensington Museum, *c.* 1873, pastel on brown paper, 28.0 × 17.5 cm (11 × 6⅞ in.). Private collection; photo Sotheby's.

right

68 *The Gold Scab* (or *Eruption in Frilthy Lucre*) (caricature of F. R. Leyland), 1879, oil, 186.7 × 139.7 cm (73½ × 55 in.). Reproduced by permission of The Fine Arts Museums of San Francisco; Gift of Mrs Alma de Bretteville Spreckels.

amicable terms. What really upset Leyland was the fact that Whistler insisted on showing his work to as many people as possible, issuing invitations for them to visit Leyland's home. Leyland reacted strongly. He wrote to Whistler of complaints he had received from the housemaid, that she found herself prevented from preparing for the Leylands' return from Liverpool. Whistler was asked to refrain from issuing further invitations. The final clash erupted over Leyland's refusal to pay more than a thousand pounds of the two thousand guineas demanded by Whistler. In July 1877 Leyland forbade Whistler his house, and, on hearing that his wife had been seen at Lord's Cricket Ground with the artist, declared that if he were to be found again with a member of his family, he would 'publicly horsewhip' the painter.[12]

This break was something of a disaster for Whistler.[13] He lost one of his most generous and sympathetic patrons. He was soon to be forced into bankruptcy. And any subsequent access to the Peacock Room became impossible. In 1892

Leyland died. The house and its contents were auctioned. The *Princesse* went to the Scottish dealer Alex Reid, while the Peacock Room remained in the house. It was visited by the American collector Charles L. Freer in 1902, sold to him in 1904, and re-erected in his gallery, together with the '*Princesse*', acquired the year before.

Despite the controversy, however, and the consequent bad publicity, Whistler does seem to have been involved, by 1879, in several further schemes for interior decoration. It is a piece of good fortune that Whistler was from time to time obliged to write down the most specific instructions for his decorative schemes. These give a fascinating insight not only into his attitude towards design but also into his approach to the preparation of the materials for all his creative work. Whistler did not make a distinction of quality between the 'fine' and the 'applied' arts. This he states quite specifically in a letter to the critic Théodore Duret, with whom he became very friendly in the eighties: 'For you know that I attach just as much importance to my interior decorations as to my paintings.'[14] The attention Whistler paid to the precise tone of every element which would go towards creating the whole decorative effect was minute. In exactly the same way as he devoted himself to the mixing of each individual tone which was to make up an 'arrangement' on canvas, so too were the colours to be applied to an interior individually mixed, the effect of each hue being precisely calculated in relation to its neighbour. Accompanying one watercolour sketch for some part of a decorative scheme, executed probably about 1885–6, there are detailed instructions for the mixing of colours: 'Distemper. First one coat of light grey (made of simple whitewash and a little ivory black—not the vegetable black of the trade—with a very little yellow ochre) over ceiling and walls strongly sized.'[15]

Whistler's furniture and colour schemes demanded from him an exactitude of attention which automatically meant that his patrons tended to be rich. His reputation—or notoriety—as an *avant-garde* artist meant that they were usually also in the van of fashion. Yet it is also true that Whistler's influence had the effect of simplifying general taste in decoration. His elegantly functional furniture could be easily mass produced. Indeed, the designs of his friend Godwin were specifically intended to be machine made. Whistler's simplification, however, was by no means the result merely of casting off superficial decoration, or even of functional thinking in relation to the mass market and appropriate production systems. Whistler, perhaps despite himself, retained what was basically a Ruskinian devotion to nicety of finish, elegance, and a notion of the superiority, not of fine as opposed to applied arts, but of the artist as opposed to the common man. Nevertheless, that common man, for whatever reason, was moved to emulation. By 1882 Walter Hamilton was able to refer to an article in the '*Burlington* for July last' entitled 'A Plea for Aestheticism':

> The human eye may now repose upon the neutral tints of his (Mr. Philistine Jones') carpets and walls. He has even a dado, and blue china may be espied in nooks and corners; he has eschewed gilt and his pictures and ornaments no longer excite in you iconoclastic desires, he has ceased to care for stucco.[16]

Whistler, meanwhile, continued to address his attention to fashionable society. Just as his lecture audiences of the eighties were specifically selected and invited, and the apprentices of his late years represented the chosen few, so the revelation of the logic behind his decorative schemes was reserved only for those whose own personal taste and refinement might enable them to comprehend and sympathize. Lady 'Archie' Campbell, for many years a close friend of Whistler's, clearly related to the Pennells the 'fundamental principles of decorative art with which Whistler impressed me'.[17] These depended upon the application of 'scientific methods in the

69 Drawing for *A Catalogue of Blue and White Nankin. Porcelain forming the Collection of Sir Henry Thompson*, 1878, brush and wash and pen and ink, 21.2 × 16.2 cm (8⅜ × 6⅜ in.). Glasgow Art Gallery.

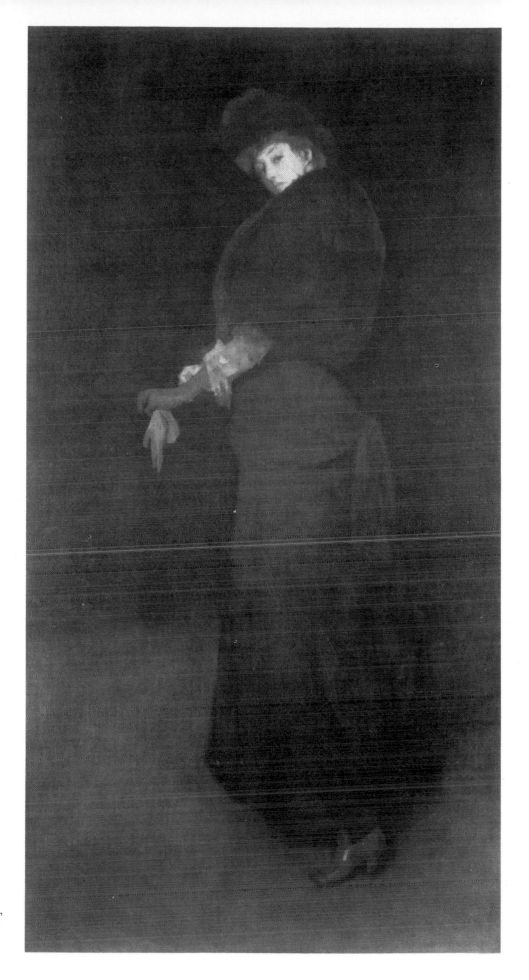

70 *Arrangement in Black: the Lady in a
Yellow Buskin (Lady Archibald Campbell)*,
1883–4, oil on canvas, 21.3 × 10.9 cm (8¾
× 4¼ in.). Philadelphia Museum of Art;
The W. P. Wilstach Collection.

treatment of all decorative work'. Here again Whistler introduces a reference to the parallel scientific principles which controlled the production of a musical work: 'He contended that what the knowledge of a fundamental base has done for music, a similarly demonstrable method must do for painting.'

It was in the early 1880s that Whistler was occupied with many studies and portraits of Lady Archibald Campbell. Besides the *Lady in a Yellow Buskin* (Plate 70), which he exhibited at the Grosvenor in the summer of 1884, he also painted one which he called *The Grey Lady*, to which he is probably referring in a letter to Duret of late 1881: '... tomorrow I have a sitting for the portrait of the fine lady in grey which you saw me begin.'[18]

It must have been at this time that Whistler imparted to Lady Archie the ideas upon which she based both an essay, 'Rainbow Music, a treatise on the Philosophy of Harmony in Colour Grouping', and the decoration of a room, taking the colour of the 'Heliotes' shell as a theme. Indeed Lady Archie seems to have regarded herself as a pupil of Whistler. And she clearly voices in 'Rainbow Music' ideas which Whistler had been developing for a decade.[19]

The Pennells make much of the lack of appeal Whistler's painting had for prospective important sitters. Of the 1880s, when, according to Cole, Whistler planned to paint at his studio in Tite Street 'all the fashionables',[20] the Pennells remark, 'The carriages brought the expected crowds, but not the sitters.'[21] In fact it seems that Whistler's share of the market was not insubstantial, even in the 1870s. It was undoubtedly attracted at least as much by his public character as by his private art, but it patronized him nevertheless.

During the 1870s Whistler had gradually severed his connections with the hustle of the Paris of his student days. The letters to Fantin ceased. He seems to have made no response to a letter from Courbet of February 1877 begging financial assistance. By the early eighties his French contacts were, on the whole, more refined and fashionable: men such as Mallarmé, Manet and Duret. During the 1870s Whistler did little travelling abroad; rather, he immersed himself in the social life of London, occasionally making sorties to outposts of culture, such as the Leylands' Speke Hall. But this does not, for one moment, imply that Whistler was setting himself up in the sort of bourgeois establishment which, for example, surrounded Millais. Whistler's concept of the artist in society was that he should not be a shopkeeper, selling successfully or otherwise. Rather he should be a leader, working with those who might understand something of the theories which lie behind his work. These people were usually wealthy—those who were able to dedicate the time and attention demanded by Whistler of his sitters. But 'philistine' they could not be. And those like Leyland who—however justifiably—in the last resort considered their social comforts of more importance than their artistic honour, were rejected and scorned by Whistler.

5 *The Red Rag and the Ruskin Trial*

It would not be fair, despite Pennell, to characterize all the Press reviews of Whistler's work in the 1860s and 1870s as derogatory. In 1873, for example, the *Art Journal* expressed its opinion of the artist's position in a note on the exhibition at the Dudley Gallery of the *Variations, Pink and Grey*: 'The style of this artist is now sufficiently well known by visitors to the Dudley, and the extraordinary merit of his work is widely recognized.'[1]

There had been, nevertheless, a good deal of scathing criticism and ridicule. And from 1862 onwards Whistler sharpened his pen and entered the fray, his first attack being aimed at the *Athenæum*, which had published an article misapprehending the intentions behind his *White Girl*, exhibited in the newly opened Berners Street Gallery. Many of the barbed letters printed over the subsequent years in various journals were reproduced—often with a touch of extra sharpening—in *The Gentle Art of Making Enemies*, published in 1890. Whistler's whole literary output was not insubstantial, and certainly did much to publicize both his paintings and his character—not always to his own benefit.

Of far more significance than the letters, though many of these are very expressive, are some of the longer essays published as the result of more extended and serious thought, some of which also appear in *The Gentle Art*.

The first pamphlet, printed privately by Thomas Way in 1877, was on the Peacock Room. This was distributed among various shops, including Liberty's, and certainly must have contributed to Leyland's ultimate fury at the number of visitors intruding on the privacy of his home. In the following year 'The Red Rag' appeared.[2] This was Whistler's first truly significant article, embodying some of the theories and ideas on which he had been working, with the most conscious deliberation, for so many years.

The theme of the essay is a discussion of fundamental attributes of the artist: an understanding of the inherent properties of his materials, the exploitation, and the expression of these in his work, reflected in his titles. He makes clear his scorn of those artists who have misunderstood or deliberately modified these fundamental aims; those who decorate their work with attractive frills of anecdote and sentiment to sweeten it for the public. He illustrates the core of his argument with reference to his *Nocturne in Grey and Gold: Chelsea Snow* (Plate 71): 'I care nothing for the past, present or future of the black figure, placed there because the black was wanted at that spot. All that I know is that my combination of grey and gold is the basis of the picture.' This painting does, indeed, reveal a remarkable play with subtle nuances of tone extracted from the limited ranges of one low chord. The paint is thin, almost immaterial in places; there might be a feeling of tentative uncertainty but for the precision of the accents of colour, the sudden, quick passages which intersperse the slow movements of the brush. It is usually dated 1878, but it was probably one of three paintings shown at the Dudley Gallery at the end of 1872, the first works to be publicly exhibited under the title 'Nocturne'.[3] This must have been one of the reasons Whistler here introduced the painting to illustrate his argument; also, it was a work with which he was particularly pleased. It was shown at the Grosvenor Gallery in 1878, the year after Ruskin's abusive attack, and a year in which he felt it vital that he should 'appear well' at that gallery.

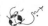

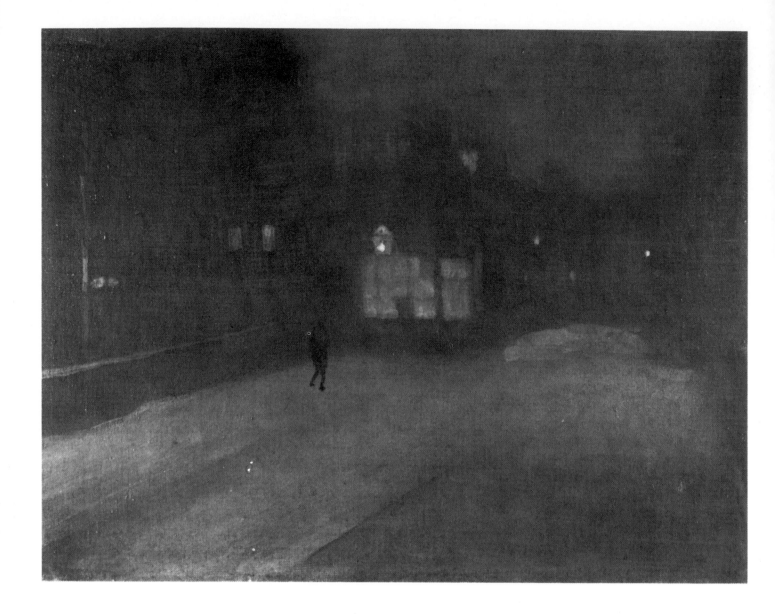

It was not only Ruskin who ridiculed Whistler in 1877. The French comedy *La Cigale* by Henri Meilhac and Ludovic Halévy[4] had been adapted for an English audience by John Hollingshead, and was presented at the Gaiety Theatre in December of that year as *The Grasshopper*. Here, criticism of Whistler's work took the form of a gorgeous joke. The character of Marignan, hero of *La Cigale*, became Pygmalion Flippit, not an 'Intentionist' as in the French version, which parodied Impressionism, but, more ambiguously, 'An Artist of the Future'.[5]

The play opens with Flippit and his 'friend and unworthy pupil', Adonis Stipple, setting off for a day of sketching. Flippit is working on a 'harmony in grey', *The New Forest in a Mist*. The characterization of Whistler is clearly built up. There is reference to Flippit's vanity, and his 'Hyperion curls'. A painting is carelessly knocked on to a palette. The hero reacts: 'I don't know, though . . . I think it looks all the better for it.' He continues, 'Like my great master, Whistler, I see things in a peculiar way, and I paint them as I see them. For instance, I see you a violet colour, and if I painted your portrait now I should paint it violet.'

It seems that Whistler himself initially did not object to the dialogue of the play.

71 *Nocturne in Grey and Gold: Chelsea Snow*, c. 1872, oil, 44.5 × 61.0 cm (17½ × 24 in.). Courtesy of The Fogg Art Museum, Harvard University, Cambridge, Mass.; Grenville L. Winthrop Bequest.

And in his memoirs Hollingshead states that Carlo Pellegrini's caricature of Whistler, used in the production, was painted 'with the celebrated artist's consent'.[6] The extraordinary thing is that this play was put on after Ruskin's virulent criticism of paintings exhibited by Whistler at the Grosvenor Gallery in May 1877. However, the trial, in which the artist sued the critic for libel, did not take place until November 1878. Then it progressed almost as if it were based on the farcical *Grasshopper*: one incident in the play, for example, was a staged presentation to a prospective buyer of a *Dual Harmony in Red and Blue*, which could be interpreted either as an ocean with sunset, or, the other way up, as the Sahara beneath the sky.

Through the 1870s Whistler had continued to exhibit at small private galleries — the *Falling Rocket* itself was shown at the Dudley Gallery, London, in October 1875 without causing any stir. The institution of the Grosvenor Gallery by Sir Coutts Lindsay seemed to provide a more significant outlet. All the artists exhibited by invitation only; as early as March 1876 Alan Cole noted in his diary that Whistler 'was in great excitement over Sir Coutts Lindsay's gallery for pictures — very select exhibition . . .'.[7]

In the opening show in May 1877 Whistler included seven major works; clearly he had retained his excitement over the exhibition, for he rarely showed such a large group together. Among others invited were Rossetti, Edward Burne-Jones and Walter Crane, all considered somewhat *avant-garde*, and the more popularly respectable Millais, George Watts, Lawrence Alma-Tadema and Edward Poynter.

In the exhibition Whistler showed the portrait of Carlyle, which was submitted too late to be included in the catalogue; the *Fur Jacket*, under the title *Harmony in Amber and Black* (Plate 72); and Irving as Philip II of Spain, as an *Arrangement in Black No. 3* (Plate 73).[8] There were also four Nocturnes, one of which became the centre of the ensuing controversy: the *Nocturne in Black and Gold: the Falling Rocket* (Plate 74). This brilliant twilight scene at Cremorne Gardens afforded Whistler an opportunity to manipulate paint and canvas in a way which the restrictions of portraiture did not allow. The atmosphere is hazy. A few ruffled touches suffice to indicate the figures. The burning displays, reflected in the water, explode in a blaze of sparks, pinpointed by delicate spots of colour. The consistency of the paint varies from fluid blurs to thick, sharp jabs, the tone from dark warmth to startling brilliance.

The gaiety, ease and spontaneity with which this was painted is manifest, and it is not difficult to accept Whistler's statement that it was executed in only a couple of days.

This was in reply to a question put by the Attorney-General in the Ruskin trial. From its tone it is clear that the expected reply would, for him and for most of the public, imply a lack of industry, effort and, consequently, of worth. It was evidently Ruskin's conviction that Whistler's effort did not justify the asking price of two hundred guineas. And, as Ruskin's criticism was characterized by a 'dogmatic and prophetic conviction of being able to set the world right by his own individual insight and judgement',[9] he did not hesitate to express this opinion in the strongest possible terms. His letter in *Fors Clavigera* has been frequently quoted. The most virulent section perhaps deserves repetition: '. . . the ill educated conceit of the artist so nearly approaches the aspect of wilful imposture. I have seen and heard much of cockney impudence before now, but never expected to hear a coxcomb ask two hundred guineas for flinging a pot of paint into the public's face.'[10]

Whistler, at the trial, maintained that Ruskin's powerful criticism had hindered him from selling his work as he had done previously. Yet this was quite probably brought about as much by his lack of interest in anything other than the Peacock

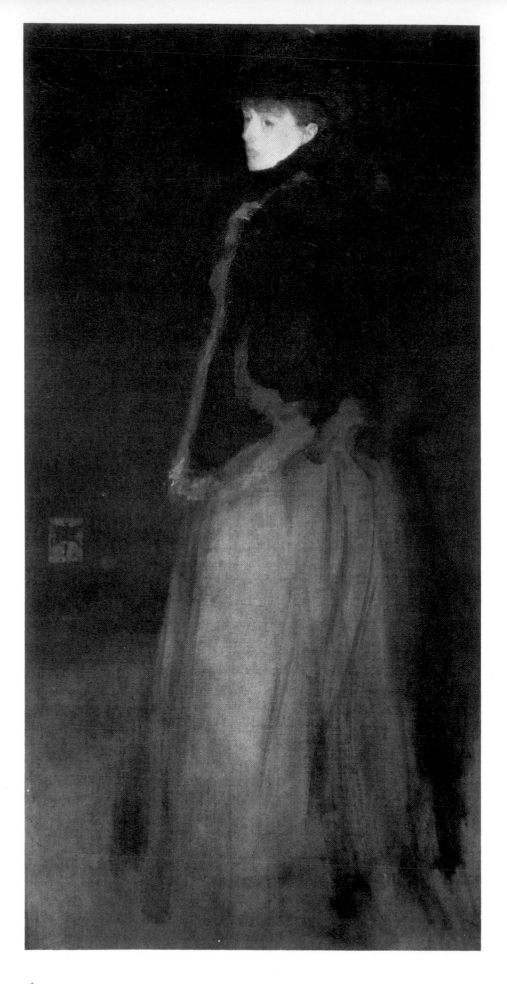

72 *Arrangement in Black and Brown: the Fur Jacket*, c. 1876, oil, 194.0 × 92.7 cm (76⅜ × 36½ in.). Worcester Art Museum, Mass.

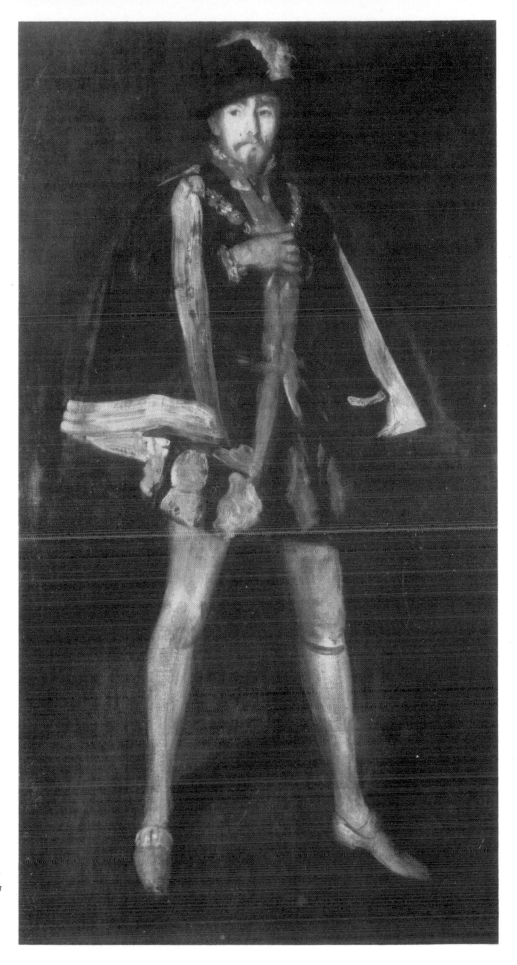

73 *Arrangement in Black No. 3: Sir Henry Irving in the Character of Philip II of Spain in Tennyson's 'Queen Mary'*, (begun 1876), reworked *c.* 1885, oil, 215.2 × 108.6 cm (84$\frac{3}{4}$ × 42$\frac{3}{4}$ in.). Metropolitan Museum of Art, New York; Rogers Fund, 1910.

Room for a good part of 1876–7, and the unsuccessful conclusion to that episode, as by anything else. Ruskin's criticism had been printed in a magazine intended for working men; not the sort of public that would have been considering buying a painting by Whistler, even had Ruskin's review been favourable. Its impact would probably have died very shortly, or have been indistinguishable from that of the whole body of critical opinion.[11] Nevertheless, Whistler took him to court. It seems most likely that the main motive for this was less the financial problems he was undoubtedly suffering than the desire, expressed over a decade earlier, to 'have it out' with this power in the land, 'face to face'.[12] Ruskin was the epitome of the influential establishment critic and it was as a representative of that large body of writers which had plagued Whistler for years that arms were raised against him.

Ruskin was, indeed, an inordinately powerful critic. It was not so much the content as the tenor of his criticism which inspired such confidence. It is not really possible to find in his writings a solid, undeviating line of argument. That is part of his greatness—the very fact that he could present apparently contradictory statements with such passionate conviction that artists of fundamentally differing attitudes could call upon him for support. By examining the whole of Ruskin's often self-contradictory writings it is even quite possible to find some statements almost as trenchant as Whistler's in their concern for abstract qualities. It would hardly be fair to ignore these. In *The Stones of Venice*, for example, he declared, 'We are to remember, in the first place, that the arrangement of colours and tones is in art analogous to the composition of music and entirely independent of the representation of facts.'[13] And there are other passages advocating a poetic form of abstraction. These are few, however, and they seem, in practice, to have been little more than the expression of a passing, probably impulsive, whim. The main tenor of his arguments is more truly expressed in his insistence that, 'lovely as the drawing is, you would like far better to see the real place . . . this is the true sign of the greatest art—. . . to make itself poor and unnoticed; but so to exalt and set forth its theme that you may be fain to see the theme instead of it.'[14] Whistler's Nocturnes often seem to work in the opposite way. Having seen one of his enigmatic, lyrical interpretations of the Thames riverside, the twilight scene itself can only be viewed through that artist's eyes.

In a fairly general way one can observe in Ruskin's critical writings—opening with the dramatic defence of Turner in the first volume of *Modern Painters*, published in 1848, and continuing for another forty years—a gradual drying up of the youthful ardour which enabled him to see merit in very different fields of art and even excuse some failures if he felt they were the result of a sincere attempt. He does seem to have become more of a didactic, moralizing critic with age. But this view of Ruskin can only be accepted with hindsight, with the benefit of historical perspective. It was probably not apparent to his contemporaries. What is important, in trying to comprehend the reasons Whistler took Ruskin to court, is to ascertain the light in which his criticism was viewed at the time, and the impact it had on Whistler and his associates.

Ruskin, of course, was one of the first critics to champion the Pre-Raphaelite Brotherhood, and this naturally created a reciprocal sympathy for him in the minds of Rossetti, Millais and Holman Hunt. He seems to have maintained a particularly close friendship with Rossetti, and his understanding of the work of the PRB depended largely on Rossetti's own ideas. In writing on the Brotherhood in 1851 Ruskin promotes imagination, invention, poetical power, and the love of ideal beauty as the 'highest and noblest' gifts of the group.[15] He reflects Rossetti's literary bias when he declares that a 'poet on canvas is exactly the same species of creature as a

74 *Nocturne in Black and Gold: the Falling Rocket*, c. 1874, oil on wood panel, 60.3 × 46.6 cm (23¾ × 18⅜ in.). Courtesy of The Detroit Institute of Arts; Purchase The Dexter M. Ferry Jr Fund.

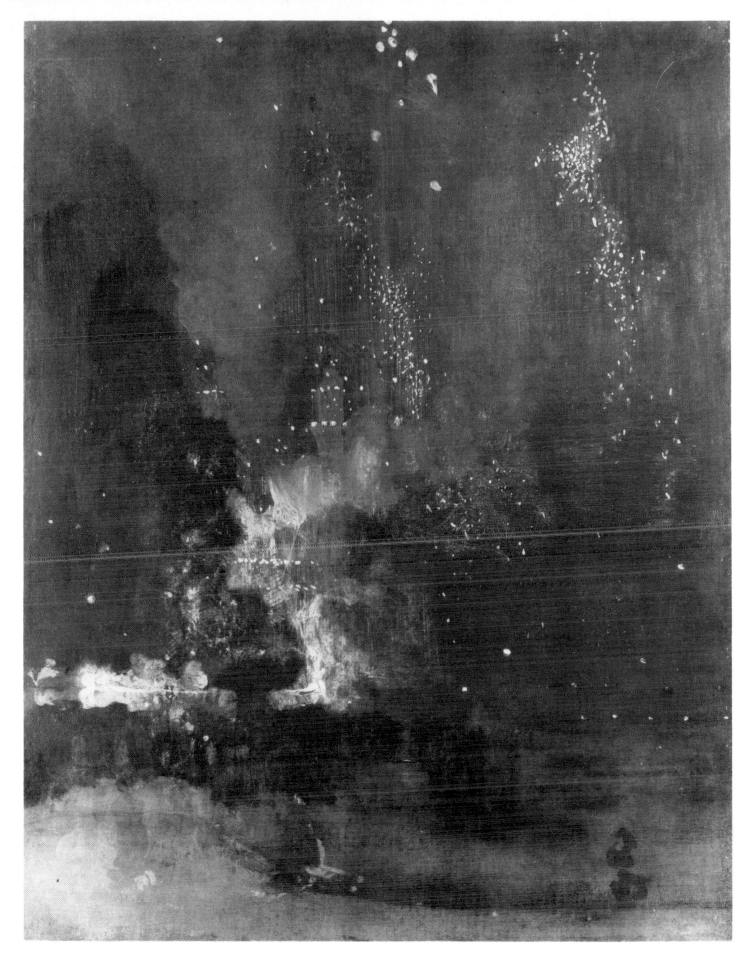

poet in song.' William Michael Rossetti sums up the situation precisely:

> Ruskin was the literary champion of the movement, and his utterances were currently accepted as representing the aims of the artists, so that Pre-Raphaelitism in the field of productive art and Ruskinism in that of criticism, passed with most people as nearly convertible terms. This contributed powerfully to make the Pre-Raphaelites what they soon became—fashionable in the world of dilettantism; but it fostered at the same time various misconceptions as to the true facts of the case.[16]

When Swinburne joined the Rossetti household, and Whistler became a friend of this clique, Rossetti's own belief in Ruskin's power of understanding, and in his literary merit, must have been conveyed to his associates. As late as 1873, some years after Ruskin had dismissed Rossetti in a not particularly kindly fashion, the latter could still write to Ford Madox Brown, 'I do not call John Ruskin's work criticism, but rather brilliant poetic rhapsody.'[17] It can certainly be argued that many of the artistic beliefs of Whistler and his associates stemmed directly from Ruskin, in particular from his ability to create an atmosphere of poetic richness with his writing. It was Ruskin's idealistic devotion to art that impressed the members of the group and conditioned their attitude towards their own work.

Whistler, however, was never a central member of this circle. Absorbed into the group by means of his friendship and sympathy, particularly for Swinburne, in the mid 1860s, Whistler obviously came under the influence of Rossetti, and, temporarily, approached his work with something of the latter's love of literary content and poetic enigma. At that date there is no reason to think that he questioned the general admiration he found within his circle for the writing of Ruskin. The first hint of any considered dissension appears in the letter written by Swinburne in 1865. This was the period in which Whistler was beginning to question all the influences he had hitherto accepted. He rejected these with vigour, but not with venom; he still had hopes of succeeding by the officially acceptable route of the Royal Academy. It was a time when he was examining in detail some of his own theories concerning his art and was anxious to renounce the literary, romantic content. He could not have failed to become aware that although within the Rossetti circle, largely as the result of personal contact, the influence of Ruskin was towards an art that, while literary, was at once both passionate and refined; outside that circle, in the minds of the general public and lesser critics, the impact of Ruskin was to create a demand for detailed anecdotal or didactic naturalism. In his memoir of Ruskin, Arthur Severn recounts that in the 1870s the great man, when before a painting,

> must go near and see what it was all about. Quite a badly painted picture would interest him if there was a letter being pushed under a door or a pretty girl looking rather sorry or anything unusual. While on the other hand a picture with little or no subject but with tones and colours exquisitely true in relation and well painted, he might pass unnoticed. . . .[18]

It was this side of Ruskin that was popularly known. It was this aspect that was taken up by lesser critics as justification for their own judgements.

Critical attacks on Whistler were now numerous; indeed, the artist seems to have enjoyed the fray. But he must have felt that, in order to attain much serious attention, he would have to attack and succeed in undermining the credibility of the high priest of Victorian criticism. The trial, however, was a great mistake. Ruskin, having suffered a mental breakdown, was unable to attend. In his place stood a rather embarrassed Burne-Jones, W. P. Frith and the Ruskinian critic Tom Taylor. 'The trial was a tiresome and unfortunate business of no interest to the lawyers, but of great interest to the public, the court being packed to overflowing.'[19] And to this

crowd Whistler evidently gave a not inconsiderable performance. Even taking into account the gloss and exaggeration which undoubtedly tinges the *Gentle Art* account, his display would have done justice to Reginald Bunthorne in Gilbert and Sullivan's *Patience*. And one must take ironic delight in noting that Whistler breakfasted with Gilbert on the opening day of the trial.[20]

The position of many of the witnesses at this trial was somewhat ambiguous. All three major witnesses for Ruskin had at some time expressed some favourable opinion, even if modified, of Whistler's work. Burne-Jones voiced his admiration during the trial, particularly of the colour of the *Nocturne in Blue and Gold: Old Battersea Bridge*. But he did not consider the painting to be finished. Frith and Tom Taylor were harsher in their opinions, but even they declared that Whistler had at one time had some ability, apparently wasted. A bone of contention for these people was, inevitably, the question of 'finish'. This term covered a variety of different interpretations. The common public regarded it simply as the means by which all trace of the brushstroke had been eliminated, and as much naturalistic detail as possible presented to the eye. Some comments in periodicals during the trial make this clear. 'Some of the figures the artist exhibits as Harmonies are mere strokes of the brush,' declared the *Scotsman*, while the critic of *Knowledge* described, 'Some smears of colour such as a painter might make in wiping his brushes on canvas'.[21] Burne-Jones's attitude was far more complex. One cannot help but believe that it was less the lack of detailed finish that disturbed him than the lack of reverence, or spiritual finish. He had some admiration and loyalty in his feelings towards both Ruskin and Whistler. He was obviously in an awkward position, and one can only admire the honesty with which he tried to deal with the situation. Fundamentally, however, he shared Ruskin's deep conviction that all great art was ultimately expressive of some form of religious praise. The theme of this argument might be summed up in Ruskin's words: 'The art of man is the expression of his rational and disciplined delight in the forms and laws of the creation of which he forms a part.'[22] Ruskin even rejected much Dutch and Flemish art—source of great enjoyment and stimulus for Whistler—because its highly elaborate detail was the result of mere 'petty skill', 'bred in the fumes of the taverns of the North', rather than the 'empyrean air' of Assisi or Cadore.[23]

On Whistler's side during the trial were W. M. Rossetti, Albert Moore and W. G. Wills. The first, together with Burne-Jones and Whistler himself, made it almost a family party. Like Burne-Jones, Rossetti obviously felt the awkwardness of his situation, and he, too, prevaricated somewhat when giving his evidence. He felt obliged to declare that the *Falling Rocket* was not a picture he admired, though he conceded it to be a valuable work of art. The other two witnesses were unconditional in their praise.

But it was undoubtedly Whistler himself who was the star of the show. Here he was obliged to gather his ideas together and formulate his theories in a concrete way. He was no longer just chatting to friends, or even compiling a brief explanatory note to include in an exhibition catalogue. He had begun the process of clarifying and assessing his ideas in 'The Red Rag'. Now he was faced with an opponent of redoubtable influence and ability. His definition of a Nocturne is the trenchantly expressed result of much critical examination of his aims and ideas:

> I have perhaps meant rather to indicate an artistic interest alone in the work, divesting the picture from any outside sort of interest which might have been otherwise attached to it. It is an arrangement of line, form and colour first, and I make use of any incident of it, which shall bring about a symmetrical result. Among my works are some night pieces, and I have chosen the word Nocturne

because it generalizes and simplifies the whole set of them.[24]

The lack of finish upset not only Burne-Jones and Ruskin, but also judge, jury and public at the trial. As well as this they were puzzled by the apparent lack of theme, the lack of any story which could be translated into words, the lack of any reference to beautiful or morally uplifting incident. The judge could not refrain from worrying about the figures isolated on top of Old Battersea Bridge in the *Nocturne in Blue and Gold*. The Attorney-General desired to know the 'peculiar beauty' of the *Falling Rocket*. But Whistler frankly divested his paintings of any outside sort of interest. The *Battersea Bridge* he called 'a certain harmony of colour', the *Falling Rocket* an 'artistic arrangement'. He utterly rejected the notion that they should simply be a vehicle for conveying represented fact, or spiritual exhortation.

The result of the trial is notorious. Whistler's farthing damages merely confirmed the farcical nature of the whole episode. The popular critics of *Punch*, the *World* and other such journals found in it plenty of ammunition. There were a few congratulatory or sympathetic notices, but these were vastly outnumbered. The wealthy Ruskin, as the Pennells noted with disgust, had a subscription account opened for him and his costs paid. Whistler was not so fortunate. The expense of the trial proved insurmountable. He was made bankrupt.

But these financial consequences were not ultimately the most significant. Ruskin evidently had exerted himself to work out his theories of art for his solicitors. Like Whistler, Ruskin regarded the trial as a battleground, and prepared himself accordingly. 'It's nuts and nectar to me, the notion of having to answer for myself in court, and the whole thing will enable me to assert some principles of art economy which I've never got into the public's head by writing; but may get sent all over the world vividly in a newspaper report or two.'[25]

From papers found by the Pennells, it seems that Ruskin was apparently proposing to publish an article about the trial. Under the title 'My own article on Whistler', notes were found among the manuscripts at Brantwood after Ruskin's death.[26] But this did not materialize.

Ruskin's plan to publish a document expounding his ideas concerning this trial was shared by his antagonist. Whistler's first pamphlet of any size, and the first to be published with the characteristic brown paper covers, was that entitled 'Whistler *v.* Ruskin: Art and Art Critics' (Plate 75). It appeared in December 1878, very shortly after the close of the trial. 'An Englishman, left in the lurch as Whistler was in 1878 would probably have eaten his heart in a proud silence and waited for better days.'[27] But, not having the benefit of that particular type of Victorian stoicism, Whistler rushed to the attack, trenchantly expressing his contempt for the art critic and the philistine public for which he catered. That public thoroughly enjoyed the spectacle. The trial had entertained them for some weeks; the pamphlet was an appropriate finale. In December 1878 the *World* announced that 'Mr. Whistler's "Arrangement in Brown Paper" has gone through three editions in a week, and a fourth is now ready.'

The account of the Ruskin trial Whistler gives in his pamphlet is a fair and amusing one. The episode had been, as we have seen, something of a farce. This was not, however, the only skirmish.

Ruskin was not a facile critic. The difficulties of classifying his work have already been indicated. Yet he was extraordinarily influential; for Whistler it was necessary to make some detailed study of the man's work in order to comprehend and combat this influence. He prepared notes on Ruskin not just for the trial but on numerous occasions over at least two decades.

In Whistler's library there was a copy of Ruskin's *Notes on Some of the Principal*

75 'Whistler v. Ruskin: Art and Art Critics', cover of pamphlet published December 1878. University of Glasgow, Library; Special Collections.

Pictures at the R.A. 1875.[28] Whistler obviously perused these notes, and has made his reactions very apparent, scattering Ruskin's critiques with exclamations, observations and underlinings.

In a very lengthy passage Ruskin discusses the *Babylonian Marriage Market* by E. Long, referring to the parallel to be found between this biblical story and the carnal and material passions of modern life. Whistler's comment is cryptic: '!!!!—John Ruskin, Professor of Fine Art—Amazing.' To Ruskin's note that he had marked a couple of pictures which interested him 'for reasons scarcely worth printing', Whistler's response is inevitable: 'Too true! too true!' His resentment that this man should be in a position of such influence is manifest.

Ruskin's moralizing tone when discussing James Collinson's *Sunday Afternoon* again aroused the painter's ire:

Rembrandt's bad bricklayer's work, with all the mortar sticking out at the edges may be pardonable in a Dutchman sure of his colours, but *it is always licentious*; and in these days, when the first object of manufacture is to produce articles that won't last, if the mortar cracks, where are we!

The whole is drawn to a conclusion by Whistler: 'THE END—of drivelling immodesty.'

Some of these margin remarks, in their content and style, indicate that he might have gone through the *Notes* when preparing his case against Ruskin for the trial. But they might equally well—and perhaps more likely—have been made at the date the booklet was published, in 1875. If so they would serve to underline Whistler's preoccupation with this critic and help to explain why he took him to court in 1878.

With the outcome of the trial Ruskin had certainly suffered a setback. Even with his tremendous influence, which had held sway for over twenty-five years, he had been challenged in a British court and had suffered the ignominy of defeat, though it be only in name. He had felt obliged to resign his post as the Slade Professor at Oxford, writing to Dean Liddell, 'I cannot hold a chair from which I have no power of expressing judgement without being taxed for it in British law.'[29] Despite all this, however, Ruskin had not been routed. His influence scarcely waned. The general public and mediocre critics depended on their superficial Ruskinian notions of those precepts by which one should judge a painting, and continued to express distaste for and incomprehension of Whistler's work. Both for the 1890 *The Gentle Art of Making Enemies* and for the 1892 catalogue of the exhibition at the Goupil Gallery, 'Nocturnes, Marines and Chevalet Pieces', Whistler prepared a further attack on these Ruskinian forces.

There are several quotations, taken particularly from *Modern Painters*, in both book and catalogue. Whistler and D. C. Thomson collaborated closely over the preparation of the important retrospective exhibition, and in many letters which passed between the two there are references to Ruskin and his opinions. In March 1892 Thomson makes the first mention of *Modern Painters*, a volume of which he plans to send to Whistler the following day.[30] The latter seems to have received four volumes of the book, with many suggestions from Thomson of relevant quotations which might have been suitable either as introductory notes to the catalogue or as remarks to place beside particular pictures. One memorable quotation which Whistler extracted from the tomes is to be found among the miscellaneous papers pertaining to him at Glasgow University, marked with the single word 'Reflection!' and the most expressive of butterflies. Ruskin had concluded that, were it not for the Divine Hand determining that granite should be speckled and marble white, huge Egyptian figures would have been 'oppressive to the sight as cliffs of snow' and 'Venus de Medicis would have looked like some exquisitely graceful species of

frog.'[31] The logic of the argument does, indeed, call for some reflection.

In both *The Gentle Art* and the 1892 catalogue other critics came under scornful attack. But there is no evidence that any were so carefully scrutinized. In a letter to Whistler D. C. Thomson makes an acute assessment of Ruskin's position and in so doing he clearly indicates part of the reason for the scrutiny, the reason for Whistler's insistent determination to challenge and expose the errors in the teachings of a man for whom he had once had some sympathy: '. . . Ruskin and Whistler really started with the same ideas, Whistler has kept faithful to them and Ruskin went in for Pre-Raphaelitism, Mr. Frith and all that superficial stuff.'[32]

Ruskin's writings still aroused considerable admiration, particularly in Paris, even in the 1890s. His aesthetic crusade undoubtedly had contributed something to the Symbolist ideal. Numerous articles were published on him by Robert de la Sizeranne. Two books, *The Bible of Amiens* and *Sesame and Lilies*, were translated into French by Marcel Proust.[33] It seems that Proust, despite a great admiration for Whistler,[34] only met him on one occasion towards the very end of the painter's life. And on that occasion the two discussed the merits of Ruskin. Whistler declared that the latter 'knew nothing about pictures'. Proust was aware that nevertheless, 'in his ramblings about them he drew marvellous pictures of his own to be loved for themselves.'[35] Thus Proust explains the power and continued influence of Ruskin; as he also explains Whistler's preoccupation with this single critic.

6 Venice and London

In September 1879 Whistler and Maud Franklin, who had taken Jo's place as mistress and model, left for Venice. The pressure of bankruptcy thus finally brought to fruition plans that had long been laid.[1] At the instigation of Ernest Brown, Whistler had been equipped by the Fine Art Society with a commission to produce a series of etchings. There were delays and some disagreement, the result of the conflicting interests of the commercial gallery and the scrupulous artist, who wished to refine and conserve his plates 'like old wine'.[2] In November 1880 Whistler returned to London with not only the initially commissioned set of twelve plates, shown in December, but also etchings, pastels and paintings sufficient for two other exhibitions at the Fine Art Society in the early 1880s.

Venice itself had, of course, long been recognized as a picturesque haunt for the artist and traveller. And it cannot be doubted that Ruskin had endowed it with an extra vivid charm and romantic attraction. Proust, for example, described his visit to the city: '. . . we went about Venice in a gondola listening to [Ruskin's] predication at the water's edge, landing at each of the temples that seemed to rise from the sea, proferring the object of his description and image of his very thought, imparting light to his books. . . .'[3]

Whistler, however, tended to prefer the less popular corners of the city, though he viewed them with no less reverence and delight. One of the numerous young artists by whom he now found himself surrounded was Harper Pennington, who described to the Pennells Whistler's habit of leading him off to 'look at some Nocturnes that he was studying or memorizing, and then he would show me how he went about to paint it, in the daytime . . . he set down in colour some effect he loved from the natural thing in front of us.'[4]

The admiration and recognition Whistler had first received among Venice artists was a herald to the growing significance of his position in London after his return. In Venice, for the first time, Whistler had consciously behaved as a teacher, a guide toward his admirers. Several of these were directly influenced by his work. Frank Duveneck and Otto Bacher, for example, both produced remarkably Whistlerian etchings. The work of the former was, in fact, mistaken for Whistler's, even by Seymour Haden, when it was shown in London in 1881. And it is worth recalling that many of these artists subsequently left Venice, perhaps for Germany, France or the United States, and thus spread some aspects at least of Whistler's teaching. Duveneck, a great admirer of 'the master', opened a school in Florence on leaving Venice in 1880, before returning to his native United States the following year. There he taught students at the University of Cincinnati, emphasizing the importance of a painterly brushstroke and a subtle tonal palette.

Whistler's first exhibition on his return to London comprised the twelve Venice etchings shown at the Fine Art Society in December (Plate 94). They were, on the whole, poorly received, there being the usual criticisms of lack of finish and slightness of size and execution. Ernest Brown, ever a good friend to Whistler, took the set to the United States and there they raised a slightly more enthusiastic response. The adverse criticism in London was not, however, unanimous. The writer in the *Globe* for example considered the works 'greatly in advance of his former

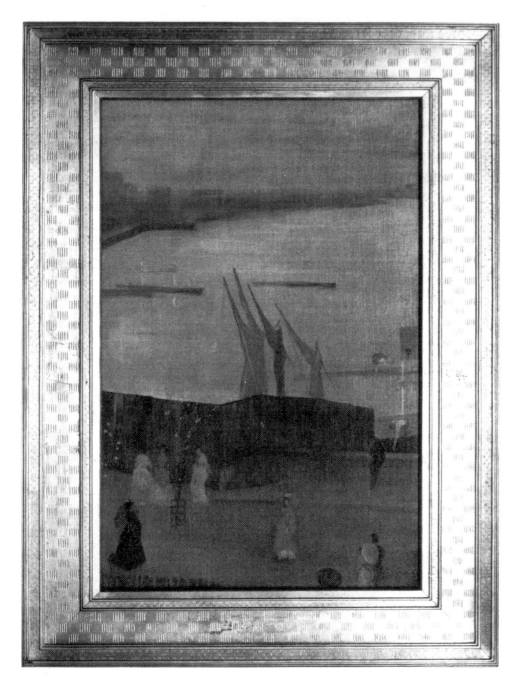

76 *Variations in Pink and Grey: Chelsea*, with frame, *c.* 1871, oil, 62.7 × 40.5 cm (24⅝ × 16 in.). Courtesy of The Smithsonian Institution, Freer Gallery of Art, Washington D.C.

productions of the kind . . . as regards beauty of tone and perfect balance of light and shade [they] could scarcely be surpassed.'[5] In the *Daily News* Whistler's 'strength . . . swiftness and certainty' of execution was admired, and his etchings described as 'a series of little masterpieces which please as much as music pleases, or flowers'.[6]

This latter impression must have been enhanced by the manner of presentation. From very early years Whistler had been concerned with the way in which his works were framed and displayed. He could, in fact, have found some of the inspiration for this in the book that in his student days had stimulated his imagination, Murger's *Scènes de la Vie Bohème*. Here Murger not only writes of a musician who composes a symphony on the 'Influence of Blue in the Arts', but also of a painter who mounts his work in specially designed 'key pattern' frames.

77 *Nocturne in Blue and Gold: Old Battersea Bridge*, detail of frame. Tate Gallery, London.

Very early in 1873 Whistler was writing to George Lucas of an exhibition of his works at Durand Ruel's: 'You will notice that my frames I have designed as carefully as my pictures—and thus they form as important a part as any of the rest of the work—carrying on the particular harmony throughout.'[7] The frames designed in the early 1870s have an air of elegance and simplicity. Some paintings, the *Variations in Pink and Grey: Chelsea*, for example, have chequer patterns painted on flat gold frames (Plate 76). More often, as for the *Nocturne in Blue and Gold: Old Battersea Bridge*, the frame has a herringbone pattern, with the butterfly painted on at an appropriate spot (Plate 77). Some of these seem to have been painted by the Greaves brothers; all are born of a concept of framing radically different from the lush excrescences of much Victorian design.

This contrast was carried through the whole arrangement of an exhibition. That Whistler's concern for the setting of his work was not merely fanciful is made manifest by the thoroughness with which he approached every aspect of presentation. Even the small display of twelve etchings at the Fine Art Society in December 1880, which must have been hurriedly organized, was designed to present a simple, unified expression. The etchings were arranged on a maroon-coloured cloth, with rough chalk numbers beneath. For the larger show of fifty-three pastels held in the galleries in the spring of the following year, the arrangement received correspondingly more attention: 'a tall dado of a golden olive in cloth, about 9 feet, and a moulding above of citron gold, surmounted in a frieze of Venetian red and a cornice of ruby gold'.[8]

This creation, with the pastels in simple frames coloured in the various shades of gold used in the decoration of the room, can only have been rich, but, nevertheless, simple and elegant in its impact. To underline this by comparison one can look at the suggestions made by P. G. Hamerton for the arrangement of the perfect gallery. He would at least discard the customary crowding, but to replace it with the sort of display only a strong constitution could withstand. The name of each artist should be 'inscribed over the door, and on the walls within, in great legible golden letters . . . under every picture there should be a detailed account of the intention of the picture, and its history . . . engraved in legible characters on a tablet of marble . . . black marble would be best, with the letters engraved and gilded.'[9] All this to be finished off with a marble bust of the artist, and a ground of dark maroon velvet.

A society which could create this sort of weighty magnificence not surprisingly often found it difficult to accept the delicate and elegant simplicity of Whistler's exhibition arrangements. Probably the most notorious of these was that of early 1883, held, again, at the Fine Art Society. This gorgeous display was carried through entirely in shades of yellow and white, colours echoed in the costume of the attendant at the door, the flowers, the pots, the chairs, the assistants' neckties and even Whistler's socks. Camille Pissarro, in February 1883, wrote to his son Lucien how much he regretted missing the exhibition, 'as much for the fine dry points as for the setting, which for Whistler has so much importance'. He also observed, 'the fact is that we ourselves made the first experiments with colours: the room in which I showed was lilac, bordered with canary yellow. But we poor little rejected painters lack the means to carry out our concepts of decoration.'[10]

At the beginning of 1884 Whistler was invited by Octave Maus to exhibit at the first show of the *avant-garde* Les xx, in Brussels. He was immediately acclaimed by the Press, who admired his work though they found his nomenclature disturbing. Already they remarked the influence of Whistler's etching on other work in the show. In 1886 Whistler was again invited, and in 1887 even proposed for membership. The exhibition was by now of some importance. Artists such as Willy

Finch and Theo van Rysselberghe travelled frequently to France and England to discover the most promising new talent. When invited to show in 1887, W. R. Sickert thanked the Society for what he regarded 'as a mark of the highest distinction'.[11] Invited again in 1888 to the exhibition, on which much care in presentation was always bestowed, Whistler sent many agitated instructions to Maus about the precise hanging of his eight works, including a sketch outlining the arrangement.

It was within the ranks of the Society of British Artists that Whistler was fully able to explore his ideas concerning arrangement, lighting and exhibition. He was first elected a member of this dusty Society in 1884: 'Artistic Society was startled a week ago by the news that this most wayward, most un-English of painters had found a home among the men of Suffolk Street—of all people in the world!'[12] *The Times* was not alone in its incredulity. The Academicians and critics had for long considered themselves in conflict with Whistler. And the Society of British Artists was, as an exhibiting body, recognized as a conservative, even a mediocre, establishment.

By 1884, with exhibitions at the Fine Art Society and Dowdeswell's, Whistler was beginning to attain some recognition; the members of the Society of British Artists were encouraged to secure for themselves the benefit of this rising reputation. According to Albert Ludovici, who was to become a friend and associate of Whistler's, it was he who urged the Society towards the election. Whistler was promised pride of place at the Society's gallery in Suffolk Street, and, accordingly, he showed with them in the winter of 1884. Only two works were forthcoming, however; the *Arrangement in Black No. 2: Mrs Louis Huth* (Plate 79), and a watercolour, *A Little Red Note: Dordrecht*.

The choice of these paintings was well considered, breaking the Society into a new régime without too harsh a jolt. Yet the controlled dignity, the bold simplicity of the portrait and the brilliant delicacy of the watercolour must have made a sharp contrast with the general run of light, domestic genre and attractive landscape which, from the catalogue, evidently dominated. Ludovici himself, that champion of Whistler's cause, contributed six works, including one entitled *Jousting, a Tournament on the River* (Plate 78). From the illustration in the catalogue, there is no evidence of jousting whatsoever, apart from a couple of flags idly waving behind decorative wrought iron railings and two stylishly drawn figures looking, presumably at the spectacle, through a telescope. The whole is a combination of studied elegance, attained during a sojourn in the academic art circles of Paris, and an English reliance upon sentimental or picturesquely illustrative subject-matter.

Discussing the English art world in 1862, P. G. Hamerton had observed:
With regard to the kind of pictures generally bought, we may take the evidence of the exhibitions.

Little figure pictures sell best—rustic figures as well as any. Bits of incident connected with the domesticities take very well . . . Returns of schoolboys, arrivals of interesting letters, scenes of wooing and billing and cooing; all these are saleable subjects.[13]

The Society of British Artists had relied upon its reputation as a certain supplier of this sort of moderately attractive genre painting for many years. The incongruity of his appearance at the Society, however, evidently appealed to Whistler. It also gave him the opportunity of mastering opponents on this unlikely battleground, and possibly even the intimations of official success pleased him. According to Ludovici, Whistler was from the outset interested in the Society and anxious to introduce reform. Already at the winter exhibition of 1884–5 a small body of his friends and supporters had joined him in exhibiting. Fantin-Latour, one of his earliest Paris

78 Albert Ludovici, *Jousting, a Tournament on the River*, illustration from the catalogue of the Society of British Artists exhibition, 1884, 10.0 × 5.5 cm ($3\frac{7}{8}$ × $2\frac{1}{8}$ in.).

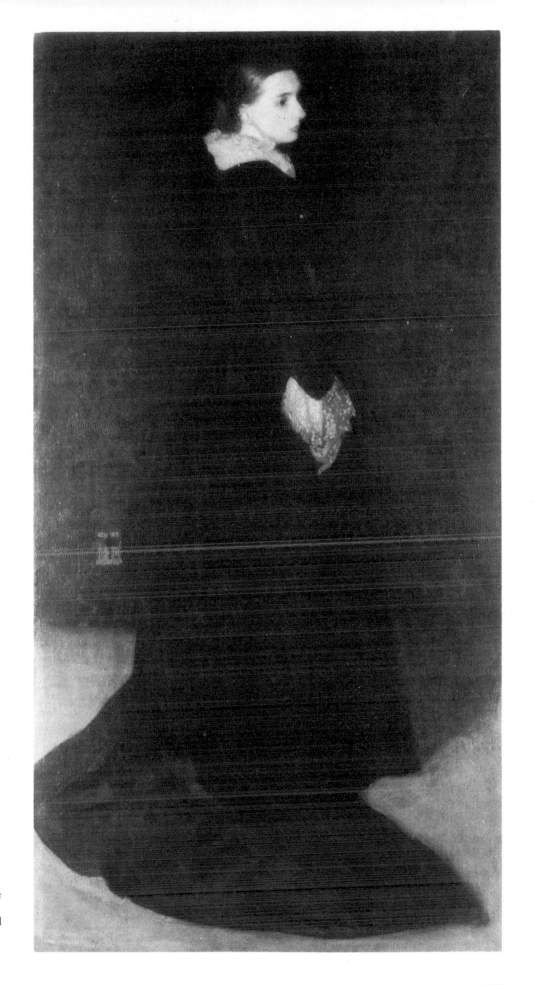

79 *Arrangement in Black No. 2: Mrs Louis Huth*, 1873, oil, 190.5 × 99 cm (75 × 39 in.). Reproduced by permission of Lord Cowdray, Sussex; photo courtesy of the Courtauld Institute of Art, London.

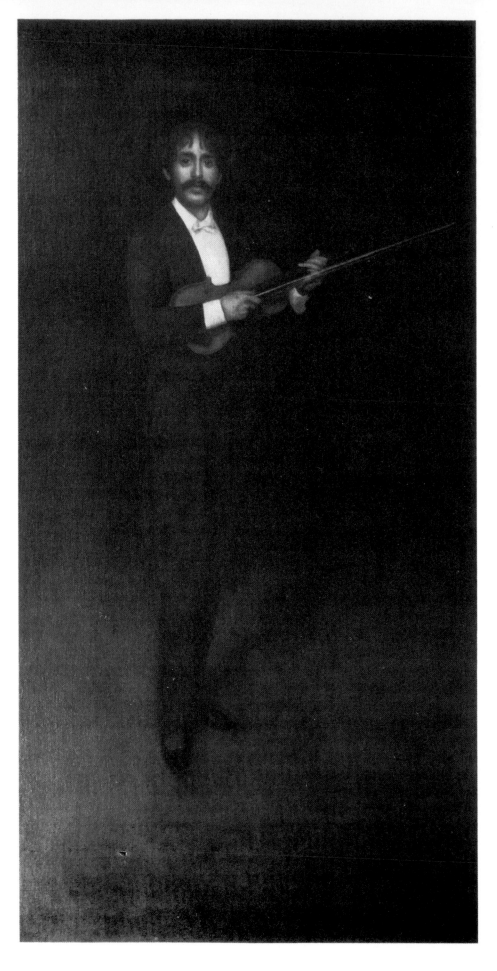

80 *Arrangement in Black: Portrait of Signor Pablo de Sarasate*, 1884, oil, 217.0 × 111.7 cm (85½ × 44 in.). Museum of Art, Carnegie Institute, Pittsburgh, Pennsylvania.

associates, submitted a painting of *Roses*. Moffat P. Lindner, Clifton Lin, Walter Sickert and Sidney Starr, all admirers of Whistler, also showed. For the summer exhibition of 1885 Whistler's own contribution was more substantial, and included the recently completed *Arrangement in Black: Portrait of Signor Pablo de Sarasate*, exhibited for the first time (Plate 80).

By now more critical attention was undoubtedly being paid to the Society. The *Art Journal* observed 'very plain evidence of the infusion of fresh blood'. Yet not all the members were pleased with the character of their new-found fame. Ludovici remarked the ridicule which was directed against the *Sarasate*. Even the shirt front was criticized for its dirtiness. Despite the formal costume — with or without soiled shirt — the effect of this portrait is less static and conventional than that of the portrait of Mrs Huth. The frontal arrangement of the figure, though so simple, is full of subtleties of balance and contrast. The line of light created by the face, shirt and cuffs moves downwards and sparks off at right angles along the tapering line of the bow. The space in which the figure, full of nervous energy, is placed is indefinable, but palpable; the characteristic attention to surface cohesion is nonetheless manifest in the strength of the vertical design, the balance of light and dark.

The impact of Whistler on Suffolk Street resulted in the continued accession of followers and associates. Among these were Mortimer Menpes, Théodore Roussel, Paul Maitland, William Stott of Oldham, Walter Sickert (who preserved his independence by remaining a non-member) and Bernhard Sickert, Frank Brangwyn and that group from Glasgow that included John Lavery and James Guthrie.

These gathering Whistlerian forces confirmed the Society's changing character. In the winter of 1885–6 Whistler showed nine works, four of them in oil. A small, refined pastel of a nude, *Note in Violet and Green*, was despatched on the Press morning with a note that no one was to tamper with the frame, embellished as it was with the words 'Horsley soit qui mal y pense', a humorous challenge to J. C. Horsley, who had criticized the nude as an object for study at the Royal Academy Schools, and also to any concept of propriety with regard to subject-matter in art. Some associates exhibited similar delicate figure studies and poetic landscapes. Although they occasionally fell into the trap of mere fashionable elegance, they nevertheless overwhelmed their more established associates. Ultimately, even though Whistler's contribution to the 1886 summer exhibition was confined to one work, the Society's president, John Burr, tendered his resignation. In June 1886 Whistler was elected to replace him. The only way to account for this astonishing success is to see the older members of the Society as desperate to revive their languishing fortunes by any means. Despite Whistler's controversial character they must have considered popularity, or notoriety, the best prospect of postponing a conclusion to a dying interest.

But no sooner was he seated in the Presidential chair,
Than he changed our exultations into wailings of despair
For he broke up our traditions and went in for foreign schools,
Turning out the work we're noted for and making us look fools.[14]

Whistler took advantage of his new power with an autocracy worthy of Ruskin. He immediately set about revising the whole character of the Society and the exhibitions it held. Hence the winter show of 1886–7 manifested a completely new approach to selection and display. The galleries were entirely redecorated and, despite objections to the removal of the conventionally rich hangings, were turned into what George Bernard Shaw described as a 'vinegar and brown paper bower'.[15] Behind the novelty, however, there was a well considered rationale which only a few appreciated. In a pen and ink drawing, executed in long, quick strokes, Whistler

81 Interior of the British Artists'
Exhibition, 1886, pen and ink, 20.1 ×
15.9 cm (7⅞ × 6¼ in.). Ashmolean
Museum, Oxford.

depicted the appearance of this exhibition (Plate 81). The main focus of attention is
drawn, in the sketch, to the hangings suspended from the ceiling. This velarium was
apparently the subject of much discussion, both within and without the Society; few
recognized it as a practical device to distribute the light evenly.

The galleries themselves were decorated in brown and gold, with hangings of
Indian muslin. The actual number of exhibits arranged on the walls was cut from the
747 of the previous show to 500. The catalogue too was given a facelift. The new
format, introduced in 1886, was smaller, with simple, elegant type replacing the
more stolid and archaic design of the older catalogue with its lion device on the cover
(Plate 82). The advertisements, formerly prolific, were drastically reduced and
confined to a few pages at the back; the illustrations were eliminated altogether. The
list of prices of individual works was removed to the back of the catalogue. All these
moves aroused opposition. The fear was that both revenue and prestige would be
lost. Contemporary critics felt that the whole approach to the exhibition had a

82 Covers of catalogues to the S.B.A. shows of 1885–6 and 1887–8.

'curious and uncommon' effect; a show 'entirely free from any suspicion of a commercial ideal'.[16]

This assertive denial that the artist should be a shopkeeper to the public, pandering to its demands and cramming as much into its windows—the exhibitions—as possible, was a main feature of Whistler's lifelong argument, and was emphasized by his own reticence when it came to the selling of his works. In fact he rarely exhibited at the Society paintings which were for sale. Most of his business he carried out privately.

In the winter of 1886–7 he showed the magnificent *Harmony in Red: Lamplight* (Plate 83), and the unfinished *Harmony in White and Ivory: Portrait of Lady Colin Campbell*. The former was a portrait of Beatrix Godwin, whom Whistler married in 1888. Against the warm, dark ground, the simplified shape of the red cloak burgeons upwards. It reveals the head, sensitively depicted, full of life and energy; an energy reflected in the stance, caught at an instant between movements. This painting is full of assurance, rich, glowing tone and vigorous life, and the design is precisely balanced within the large, upright frame.

Despite the exhibition of such magnificent, and, one would have thought, uncontroversial work, the Society was becoming increasingly dissatisfied with its new president. The hanging committee for the show in the spring of 1887 included Whistler himself, and the number of exhibits was reduced to only 269. Consequently many of those who submitted had contributions rejected; the financial loss and the comparative visual sparseness caused much disenchantment. The cost of the empty

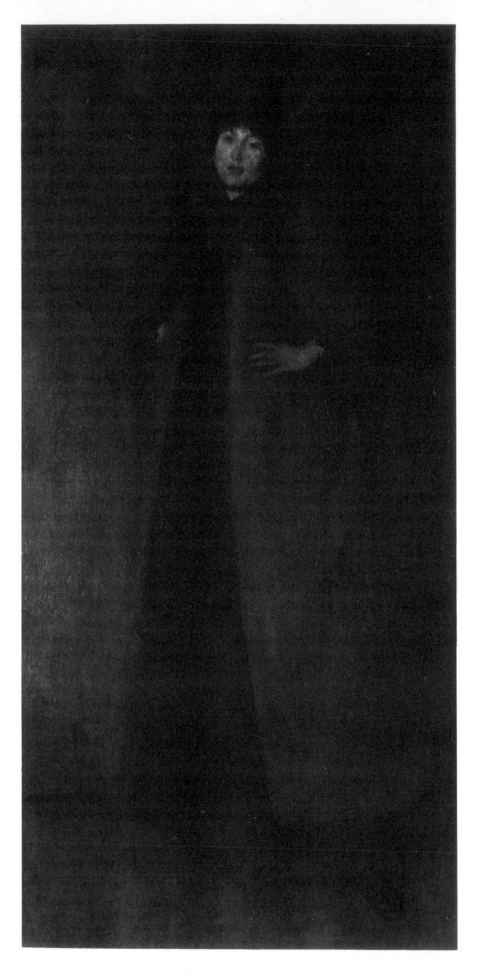

83 *Harmony in Red: Lamplight, Mrs Whistler*,
1886, oil, 189.8 × 88.9 cm (74¾ × 35 in.).
Hunterian Art Gallery, University of Glasgow;
Birnie Philip Bequest.

spaces was calculated: 'The small upright grey note . . . they declared cost the Society £400; this was taking into account the many square feet from floor to ceiling, and around the small frame. . . .'[17]

Whistler did gain a little approbation this year when, on the occasion of the Queen's Jubilee, he prepared an illuminated address, containing also a series of etchings, and hence received a Royal Charter for the Society. The autocratic independence exhibited might here have been excusable, but it eventually led to his downfall. At the end of 1887 Whistler embarked on plans to enlarge the scope of the Society. Some artists proposed for membership he dismissed; among those he did include were Leonard Raven-Hill and Charles Keene, draughtsmen who had previously received little recognition. He also directed his attention across the Channel. In reply to a request from Whistler, Claude Monet wrote, 'It is very good of you to invite me. I shall be delighted to exhibit in London, and especially in your company.'[18] The Belgian Alfred Stevens also wrote expressing his admiration for Whistler and his pleasure at the prospect of exhibiting with him. Stevens's letters are dated September and October; Monet's were presumably written at much the same time. Both artists expressed the desire to come to London for the exhibition.

Whistler's contacts with the *avant garde* in French art had been maintained since his early years in Paris. Although not concurring with the strictly Impressionist view he did occasionally exhibit alongside several of the group,[19] and corresponded with a number of its members, whom he also visited on his frequent trips across the Channel. By the 1880s these contacts were explored with a renewed vigour; and Whistler became a vital link between the art worlds of the two countries. His own work revealed assimilated elements from both England and France; its stimulus acted on many followers in encouraging them to break with insular attitudes. The Society of British Artists had witnessed not only paintings of French scenes appear on its walls, but also a portrait of one of the members of the Impressionist group, a compatriot of Whistler's: *Arrangement in Black No. 8: Portrait of Mrs Cassati* (sic), exhibited in the winter of 1885–6.

The impact of Stevens, and particularly Monet, must have been nonetheless intense. In the latter's work all the lack of finish, vague draughtsmanship and lack of subject so apparent in the paintings of the Whistler coterie was emphasized by brilliant colour and violent technique. And, despite his hope that 'the committee will not be too horrified by my painting',[20] he seems to have chosen for his four exhibits paintings least calculated to appease the sensibilities of an English audience. Two coastal scenes, the *Coast of Belle Isle, Bretagne* and a *Cliff Near Dieppe*, were sent, from several he had recently painted in brilliant, sharp tone, with Japanese-influenced principles of decorative design, even more uncompromising than in Whistler's work. Stevens, who was actually made a member of the Society, contributed five works, quieter in tone, and visually closer to the officially acceptable.

For several decades French art had been regarded with jealous suspicion, and had been little represented in England.[21] The art of the Impressionists was only just becoming acceptable in France; in England, where even academic art from across the Channel was rejected, the work of the Impressionists seemed like an insult:

> The suburban ladies, who had been the support of the Society of British Artists, were shocked at the changes. They found no pleasure in the awning stretched across the middle of the room, the battened walls, the spaced-out 'Impressionist' pictures, and the total absence of the anecdotes and bright colours which they loved. A few hundred visitors of another sort came, and were charmed, but the commercial test of success was not satisfied.[22]

At the next annual election, 1888, Whistler was voted out of office, his place taken by

Wyke Bayliss, a painter of quiet church interiors. According to Ludovici, every last one of the original members was brought in to assist with the expulsion. Stevens tendered his resignation. The majority of those brought into the Society by Whistler followed suit. Francis James, Ludovici, Menpes, Lavery, Roussel, Maitland and many others withdrew from the 1888 exhibition. Sickert still contributed four works, but he did not submit the following year.

The Society thankfully abandoned its notoriety, and re-embarked upon a more conventional course. The interlude had, however, served to instigate a powerful unity of party feeling among many young artists. They had foregathered to combat the academic conventions of art, and the strongest of them continued to fight. Whistler voiced the general response: 'The "Artists" have come out, and the "British" remain.'[23]

7 The Ten o'Clock Lecture

During the 1880s Whistler became popularly known rather as a writer and a wit than as a serious painter. The numerous notes to the papers, written with the most painstaking care for style and impact, perhaps did his reputation more harm than good, for they tended to create the image of a clown rather than that of a man of thought and resolution. Nevertheless, the serious articles of 1878, 'The Red Rag' and 'Art and Art Critics', had revealed a writer who could clearly assess the attitude of the artistic establishment and his own position in relation to it, and could isolate and attack those aspects of it which he found particularly contentious. Despite the scorn he poured on any attempt by the artist or critic to play to the public gallery, on any suggestion that the public should be 'dragged from their beer to the British Museum',[1] Whistler evidently was concerned to expound, to those who would listen, some of his theories. The admiring following he had begun to attract in Venice, and which grew rapidly on his return to London, must have encouraged in him a desire to formulate a compact statement of those theories in relation to his art. There is much evidence in the 1880s of advice and encouragement given to younger, aspiring artists, of discussion of the aims and purposes of their task, and of references to many of the great masters of the past.

His position as a serious thinker, and one who could fluently and poetically express his thoughts not only in his painting but also in writing, was established — at least in the minds of some — by the lecture he delivered to a packed Princes' Hall in Piccadilly, at 10 p.m. on the evening of 20 February 1885.

The plan to give a lecture seems to have had its immediate origin in an invitation by Lord Powerscourt to visit his estate in Ireland, there to distribute prizes for art students of the locality and to deliver a few words of advice for their benefit. Information to support this comes from that indefatigable diarist Alan Cole, who noted in October 1884 that he had spent several evenings with Whistler assisting the latter to write out his views on various artistic matters — including the perennial Ruskin.[2] In November he remarked that Whistler had been invited to Ireland, and planned to lecture in Dublin. In this month Whistler sent twenty-five works, including such major pieces as *Carlyle* and the *Mother*, to an uncatalogued exhibition of the Dublin Sketching Club; he does not, in the event, seem to have ventured to Ireland himself at this time. The lecture, however, was prepared, and he determined to deliver it in London.

Whistler had long been interested in spreading something of his ideas and attitudes concerning his art. Those ideas must have been stimulated and clarified in discussions he had with Oscar Wilde. A friendship between these two had developed after Wilde's notice of the 1877 exhibition at the Grosvenor Gallery, which he had published in the *Dublin University Magazine*. When Wilde made a lecture tour to America in 1882 he was undoubtedly furnished with many of Whistler's theories. In this year he referred to the painter as one of his heroes.[3] In June the following year he again delivered a lecture, this time to the students at the Royal Academy. These activities seem to have caused some sourness in the relationship, Whistler feeling that he had been plagiarized, and also, perhaps, fearing for the innate dignity of his

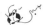

concepts in the brash hands of Wilde, so aptly called by the Pennells 'a perambulating advertisement for the "aesthetic movement"'.[4]

It was probably unjust to accuse Wilde of plagiarism, for there is no doubt that he had had some interest in figures such as Swinburne and Pater before ever encountering Whistler; that their opinions were sympathetic explains the close friendship which grew up between them, despite Whistler's horror of gaudy or extraordinary appearance. Yet the painter obviously contributed much to the matter of the lectures.[5] Despite Wilde's generous tributes to Whistler, one can understand the older man's irritation and disappointment when acclaim went to the young writer for ideas which he had been attempting to propagate for years.

There are numerous drafts and jottings which must relate to the preparation of Whistler's own lecture. It is evident with what care he considered his theories, with what elegance he distilled them. In fact some of the notes reveal a much more pithy, straightforward expression of his thoughts than eventually appeared in the lecture itself: he attacks the notion that

> the merit of a painting depends upon the quality of the incident it purposes to portray . . . the people have the habit of looking . . . not at a picture, but through it, at some human fact which shall or shall not . . . benefit their mental or moral status . . . a bad picture serves as well to point a moral as a good one . . . indeed the good one cannot. *It has no chance in such a contest.*[6]

Whistler's lecture was finally delivered on 20 February, the occasion being organized by Mrs D'Oyly Carte. To its presentation he devoted as much attention as he always did to his exhibitions, designing the tickets and the poster, inviting a selected audience, and rehearsing his delivery to ensure that he should be sufficiently heard throughout the hall.

Those invited as guests to the lecture—held at ten o'clock to obviate the necessity of hastening from dinner—were evidently most carefully chosen. A seating plan was drawn up, organized with precision according to social status and friendship—the former being the first consideration. Many representatives from the Press were invited, as well as dealers, members of fashionable society, patrons, Royal Academicians, friends and associates. Many of the letters of congratulation express not only thanks but also some degree of surprise that the lecture had been serious in intent. As Alan Cole observed, 'some who came to smile and be amused . . . left in a state of meditation and dumbness.'[7]

The 'Ten o'clock' does indeed contain some food for thought, even if it is presented as a rather elaborate piece of confectionery. Some of the themes are familiar. The critic and the philistine are taken to task. Whistler also attacks that newer phenomenon, the 'aesthete', who has self-consciously 'harassed with Art' the common people. Running through the whole, and tying the various arguments together, is the insistence that art should have no didactic, moral or literary purpose.

The critic had, of course, frequently been the subject of Whistler's scorn, especially since the Ruskin trial and his realization that his victory there had been hollow, having made very little impression on Ruskin's reputation. In the lecture Whistler once again rejects the 'middleman in this matter of Art', 'the unattached writer' who had 'brought about the most complete misunderstanding as to the aim of the picture'. It is the critic he blames for creating the expectation that a picture should tell a story, should convey 'a novel—a history—or an anecdote'.[8] Ruskin is not mentioned by name, but it can be none other than he who is singled out as the 'Preacher'.

Whistler had by this date become identified in the public mind with the aesthetic cult. His association with Wilde, the reception his work received in French

Symbolist circles, his own precisely penned little notes to the papers, all tended to confirm this assumption. But in the 'Ten o'clock' he expresses a scorn for the aesthete as uncompromising as his scorn for the critic. He is conscious that a superficial demand for 'art for art's sake' could become as empty, as misleading, as demoralizing for the artist as the more conventional expectation of art for the story's sake:

> The people have been harassed with Art . . . Their homes have been invaded, their walls covered with paper, their very dress taken to task . . .
>
> And now . . . the Dilettante stalks abroad. The amateur is loosed. The voice of the aesthete is heard in the land . . .
>
> Forced to seriousness that emptiness may be hidden, they dare not smile—
>
> While the artist . . . is glad and laughs aloud . . . and is merry at the pompous pretension—the solemn silliness that surrounds him.

The broader theme of the whole lecture, to which he constantly returns, concerns the relationship between art and society, a relationship which, of course, he had been examining for some years. He rejects the Ruskinian notion that great art can only issue from an ideal society, a society with the apparent perfection of that of the ancient Greeks:

> Rembrandt, when he saw picturesque grandeur and noble dignity in the Jews' quarter of Amsterdam . . . lamented not that its inhabitants were not Greeks.
>
> . . . As did, at the Court of Philip, Velasquez, whose Infantas, clad in inaesthetic hoops, are, as works of Art, of the same quality as the Elgin marbles.

He ridicules the suggestion that, in the modern world, art would appear with the rejection of industrialization. He is antagonistic to the 'little hamlets . . . near Hammersmith' for those pursuing the Arts and Crafts ideal. His attitude to industrial development, however, remains romantic; art and industry cannot easily be reconciled.

Whistler characterizes art as a 'whimsical goddess' who will tolerate no dullness, and chooses herself her home—a home in the East among the blue porcelain; in the West with the master of Madrid, or with the marble of Greek statues. No critic, by educating the masses, or reformer, by altering society, could automatically expect great art to result.

The other side of this coin is the denial that art could itself be a vehicle for bringing about social change:

> Humanity takes the place of Art, and God's creations are excused by their usefulness. Beauty is confounded with virtue, and, before a work of Art, it is asked: 'What good shall it do?' . . . So we have come to hear of the painting that elevates, and of the duty of the painter—of the picture that is full of thought, and of the panel that merely decorates.

All this he rejects outright. Art should not have 'become foolishly confounded with education'. The lessons which Nature presents, to the artist alone, are of quite a different character:

> He looks at her flower, not with the enlarging lens, that he may gather facts for the botanist, but with the light of the one who sees in her choice selection of brilliant tones and delicate tints, suggestions of future harmonies.
>
> . . . In all that is dainty and lovable he finds hints for his own combinations, and *thus* is Nature ever his resource and always at his service, and to him is naught refused.

Art should retain its dignity and integrity. It should not be the plaything of the people; should not be the rod of the Preacher; should not be the comforter of the middle classes.

We have then but to wait—until, with the mark of the Gods upon him—there come among us again the chosen—who shall continue what has gone before. Satisfied that, even were he never to appear, the story of the beautiful is already complete—hewn in the marbles of the Parthenon—and broidered, with the birds, upon the fan of Hokusai—at the foot of Fusiyama.

The 'Ten o'clock' was repeated numerous times: for the British Artists in March, for the Cambridge University Art Society in the same month, in April at Oxford and the Royal Academy Students' Club. It was also undoubtedly delivered on several occasions to other groups, individuals or small social gatherings. Nevertheless, it did not perhaps have the general impact that Whistler might have desired. The audiences were select, and, despite wide Press advertising of the lecture itself, he did not wish it to be reported afterwards in the papers. It was not actually published in England until 1888. And even then it could not have exercised much general appeal: 'that is as it were an indigestion of strawberries, a feast for the high gods. . . .'9 Not the sort of fare to appeal to the philistine.

There were some suggestions that Whistler might deliver the lecture abroad, in France, Belgium, Italy and even the United States. In about 1885 he asked Otto Bacher, an old Venice associate, to enquire of George Lucas whether a suitable hall might be found in Paris, but this plan never came to fruition. The *New York Times* announced that Whistler had promised to return to the United States and deliver the lecture.10 This, too, came to nothing, though the 'Ten o'clock' was published in New York.

Although no widely publicized delivery of the lecture was actually made in France, Whistler did, as in England, convey it to small gatherings. Mallarmé, for example, in 1888, proposed for this purpose a *soirée* to which he should invite, among others, Monet and Renoir.11 It was, of course, Mallarmé who was to translate the lecture into French.

The attention paid by the great poet to the writings of the painter must undoubtedly have enhanced their attraction for many Symbolist devotees. Whistler and Mallarmé seem to have been introduced to each other in about 1887, by the critic Duret. At the beginning of 1888 Monet wrote to Mallarmé, 'I am here with Whistler, on the way to Paris, and he will be very happy to become better acquainted with you.'12 The outcome of this meeting was the translation of the 'Ten o'clock Lecture', and a warmly developing friendship between the two artists.

In fact, Whistler and Mallarmé must have known of one another for some years. In the 1870s Swinburne had corresponded with the French poet.13 Mallarmé dedicated a copy of *L'Après-midi d'un Faune* to him, and was probably instrumental in getting a poem by Swinburne published in the French magazine *La République des Lettres*; the poem, significantly, being entitled 'Nocturne'. Mallarmé was greatly admired by Swinburne, his translations of Poe particularly valued. It seems likely, too, that Duret and Monet must have spoken about Whistler long before the meeting with Mallarmé; the latter's sympathy for Whistler's painting and ideas must have had a very firm foundation for him to have undertaken the translation. In a letter Mallarmé wrote to Duret, in which he praises Duret's article on 'Whistler et son œuvre', published in *Les Lettres et les Arts*, he also comments on the 'très rare impression' the painter had made on him.14

There had been other articles on Whistler also, in the French Press. Both he and Mallarmé had been featured in the first number of Edouard Dujardin's *Revue Indépendante*. In February 1887 Duret had discussed 'les eaux fortes de Whistler' in the same journal. And it was Dujardin who published the French version of the 'Ten o'clock', which appeared at the head of the May edition of the *Revue Indépendante*.

It is interesting to compare Mallarmé's translation of this lecture with the original. After the completion of his work, Mallarmé wrote to Whistler,

> I have endeavoured to make an exact translation and to retain the oratorial gesture and tone, as if you yourself were preparing to give the lecture again in French, and if, perhaps, I have altered an expression or two, it is with this in mind, so that everything should be in character.[15]

Whistler was undoubtedly delighted with the translation. The sympathy Mallarmé had shown for the subtleties of his meaning was remarkable. Yet there are places where the voice of the poet takes over, where his constant search for words expressive in a completely new and symbolic way begins to cloud the relative simplicity of Whistler's speech. One or two of Whistler's friends wrote saying that they had found a certain obscurity in the French translation.[16] And Whistler also recognized occasional problems. He wrote from London to the poet,

> I find in the original text one or two passages where the subtle expression of ideas and perhaps the refinement of speech, have created some ambiguity which the translation has made me notice for the first time, and which are unfortunately the cause of slight misunderstandings and for these, my dear friend, I take complete responsibility.[17]

Whistler left immediately for Paris, and he and Mallarmé worked on the translation, altering it slightly for the booklet brought out at the end of May. Mallarmé's interpretation of the lecture must nevertheless have impressed itself upon his associates and perhaps partly explains the readiness found in the circle of Symbolist authors to welcome and admire Whistler as a painter and a writer.

Considering the ideas voiced in the 'Ten o'clock' and the extent to which they represented simply the verbal expression of theories long felt and often discussed, it seems extraordinary that the most virulent criticism of it should have come from sources apparently sympathetic. The first attack was published in the *Pall Mall Gazette*, and written by Oscar Wilde. He must have had much of his article prepared well before the lecture, for it appeared the day after. Perhaps this criticism is not so surprising, for Wilde could scarcely have felt otherwise than resentful at Whistler's jibes at those reformers of dress, and his dry remark that 'costume is not dress.' He also rejected Whistler's supposed 'dictum that only a painter is a judge of painting'.[18]

It was another such artist, poet, critic and close friend, who launched the most scornful attack, in 1888. Whistler's lecture was finally published in England in that year; in the *Fortnightly Review*, in June, Swinburne expressed his scathing rejection of it. At this date writer and painter were no longer such close friends as they had been. Swinburne was living with Theodore Watts-Dunton who, although he undoubtedly tended the poet's physical well-being, also to some extent controlled his mental attitudes. According to notes given to the Pennells, Swinburne only agreed to review the lecture after persistent requests from Whistler that he should do so. Irritated at this insistence, he published a cross and sarcastic note. Whatever the reason, the content of this article reveals an almost deliberate misapprehension of Whistler's theme; all the more astonishing in that, to the painter, it was so totally unexpected.

Swinburne opens by alluding cryptically to Whistler's 'imperial and Olympian contempt'. He fails to understand how the latter can admire together art from Japan, Greece and Spain:

> Assuredly Phidias thought of other things than 'arrangements' in marble—as certainly as Aeschylus thought of other things than 'arrangements' in metre. Nor, I am sorely afraid, can the adored Velasquez be promoted to a seat 'at the foot of Fusi-yama'. Japanese art is not merely the incomparable achievement of certain

harmonies in colour; it is the negation, the immolation, the annihilation of everything else.[19]

He is evidently accusing Whistler of a superficial and muddled understanding. The whole article is a slap in the face. It was not even hurriedly penned in a moment of irritation; from the number of insertions and alterations in the manuscript it is obvious that he devoted to it almost as much painstaking care as Whistler himself might have done.[20] It seems astonishing that he who had once been such a close and sympathetic friend could be so blind to Whistler's message. Yet perhaps a clue can be found in Swinburne's reference to 'the fairyland of fans . . . the paradise of pipkins . . . the limbo of blue china, screens, pots, plates, jars, joss-houses, and all the fortuitous frippery of Fusi-yama'. Despite Whistler's contempt for the superficialities of the aesthetic cult, despite his frank rejection of them in the 'Ten o'clock', the lecture itself was composed with a certain thin delicacy not at all in keeping with the much more passionate, resounding poetry Swinburne was now producing. The latter, who had grown apart from Whistler, could perhaps be forgiven for fearing that his old friend had turned public entertainer, caring little for his art, refining it away to nothing.

Whistler was bitterly disappointed by the attack from this most unexpected quarter. He prepared a reply, revealing the extent of his shock and astonishment:

Do we not speak the same language? Are we strangers, then, or in our Father's House are there so many mansions that you lose your way, my brother, and cannot recognize your kin? . . . Shall I be made to stultify myself by what I never said. . . .[21]

His reply, couched in terms almost as sardonic as Swinburne had used, was published in the *Fortnightly Review*, but he made little other reference to the issue. He did not, as was his habit, widely spread the news of the encounter; the friendship between the two had been irretrievably broken. He felt betrayed.

From this time Whistler's friendship with French painters and poets increased greatly in importance, particularly his close association with Mallarmé. The latter, with his sympathetic appreciation of Whistler's ideas, took the place in the painter's affection once held by Swinburne. And in just the same way as Swinburne and the circle which had surrounded him had created an environment in which Whistler could clarify and develop his ideas, so in the late 1880s and 1890s he found the sympathetic encouragement which enabled him, at last, to reap the benefits of his long apprenticeship, to work with the joy of creating of which he speaks in the 'Ten o'clock'; 'with bold openness, and high head, and ready hand—fearing nought and dreading no exposure'.

8 The Portraits of the Later Years

There are indications of innumerable portraits begun, some finished and some cast aside, in the 1880s and 1890s. As the result of their extraordinarily thorough scouring of every source of information, the Pennells received many letters from people asking the whereabouts of portraits, or describing sittings for works which they knew were never completed.

One of the first important patrons to ask Whistler for a portrait on his return from Venice was Mrs, later Lady, Meux. He worked, in fact, on three portraits of her, only two of which were completed; the third, with the figure wrapped in furs, was apparently being worked on as late as 1886, but was never finished. Evidently the social commitments of Lady Meux prevented her from sitting as regularly as Whistler might have wished, but by the end of 1881 he was able to write to his sister-in-law, Mrs William Whistler, that one of the portraits was nearly complete. This, the grand *Arrangement in Black No. 5*, was exhibited at the Salon in 1882, the first time that Whistler had been represented there since 1867 (Plate 84).

Undeniably impressive, there is perhaps something slightly laboured, slightly formless about this figure. It must not be forgotten that for a long time Whistler had apparently made no attempt at large figure painting, being preoccupied with oils, etchings and pastels of much smaller and daintier proportions. The portrait received in Paris a reaction from many critics which was almost an echo of their earlier response to the *White Girl* paintings. The staid Duret himself, for example, saw mystery and fantasy in it. It is not surprising then, that in the 1890s, when Whistler finally settled in Paris rather than London, he was hailed as a Symbolist painter, and found among the Symbolist writers friends predisposed to be sympathetic and understanding.

The second portrait of Lady Meux, the gorgeous and magnificent *Harmony in Flesh Colour and Pink*, was also shown in Paris but not until the Champ de Mars Salon of 1892 (Colour Plate 17, p. 133). Yet again, she was interpreted as a fey creature: 'l'étrange figure de femme', with 'l'air d'une apparition'.[1]

This now hangs in the Frick Collection, New York, together with the earlier portrait of Mrs Leyland. It is a rich, vigorous and sensuous painting, and it is difficult to find much ephemeral or mysterious about it. The ruffles of the dress are indicated with bold, broad crisscross strokes, the challenging face looks out beneath a hat painted with short, racy touches. The picture has been very thoroughly cleaned and restored and there is now no trace of a butterfly placed some inches lower than the motif that is now visible, but this can be seen in an early photograph of the painting in the Pennell Collection at Washington. It is interesting to note that even at this date Whistler was not always completely sure in his formal design. Despite this, the monumental simplicity of the pose, the vastly subtle range of brown, pink, grey and red tones, stand out as evidence of an ease and assurance which were lacking almost a decade earlier when the portrait of Mrs Leyland was executed. This, though rich and delicate, even rather wistful, is undeniably tentative, a little heavy-handed, a little over-elaborated in comparison.

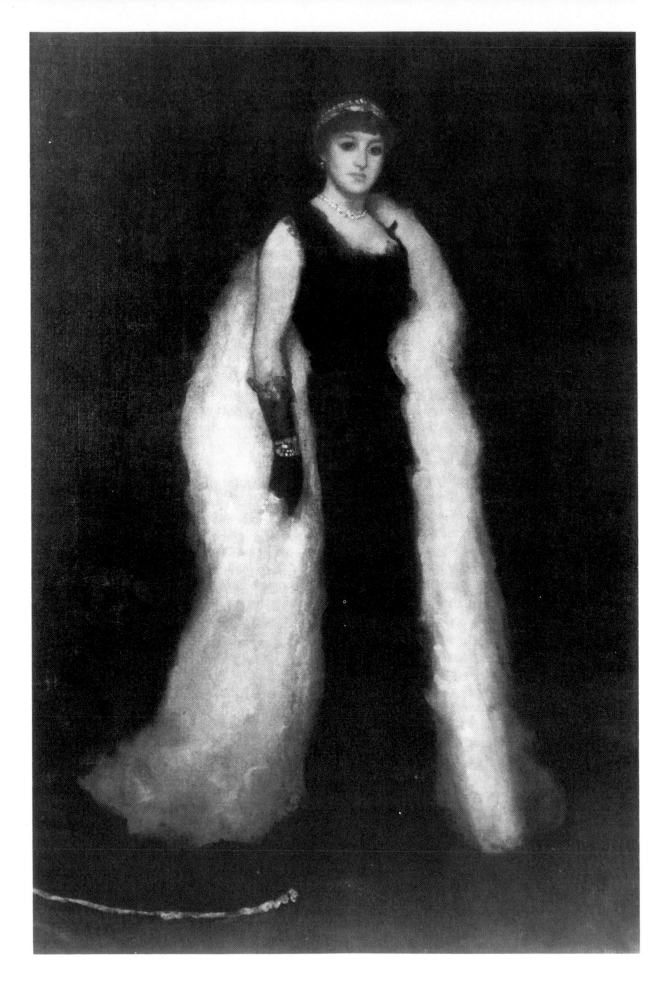

These portraits of the early 1880s have, without question, a breadth and vigour which those of earlier years have not. Whistler, from the very fact that he was now being surrounded by followers and admirers, was evidently more self-confident than he had ever been. He had a substantial number of exhibitions in the 1880s, and despite the occasional setback these were, on the whole, well received. Yet perhaps the most significant factor is that he was once again moving away from insularity, was making many friends, particularly in France, to whom he wrote and whom he often visited. Of the Impressionist group he corresponded with Monet and Degas, though with neither very frequently. At Easter 1881 he met Renoir at Chatou.[2] And it must have been in November 1880 that Manet sent Whistler a letter introducing Duret, 'Just as you are a master painter, my friend Théodore Duret is a master connoisseur.'[3]

Whistler had not been very close to any of these painters, with the possible exceptions of Degas and Manet before his death in 1883, but there was mutual respect and admiration. In the late 1860s and 1870s Whistler had felt threatened by what he considered their brashness: 'I shouted with the assurance of ignorance, "Vive la Nature"! Nature, my boy—that cry was a piece of bad luck for me.'[4] But the experience and control gained during these years now enabled him to look confidently outwards once again, and learn what he could from these sources. The succulent, vigorous brushwork of these two portraits of Lady Meux surely indicates more than just a glance across the Channel. In particular they show evidence of the influence of Manet. Manet's work had, of course, attracted the attention of the Société des Trois as early as 1861.[5] An early biographer of Manet makes reference to these admirers: the 'American, Whistler, painter of the Woman in White, Alphonse Legros . . . and Fantin-Latour—these were the most devoted companions of this misunderstood artist.'[6] Manet had been a most important figure for the young Whistler, encouraging the vitality and breadth, the sensuousness of touch, which later blossomed so brilliantly. He had also shared, and probably reinforced, Whistler's interest in Velazquez. When, in the 1870s, Manet began to work with the brighter palette and shorter brushstroke of the Impressionists, Whistler probably felt that their ways had parted. However, a link still existed in Swinburne, who admired Manet, having been introduced to him by Whistler in 1863.[7] The Pennells record that in his later years Whistler dismissed Manet as a mere 'student with a certain sense of things in paint'.[8] But this would seem to have been little more than the result of a passing irritation. Through his friendship with Mallarmé, who had an enormous admiration for Manet, Whistler's own understanding seems to have developed and sharpened. And certainly, it was Manet whom Whistler expressly desired should accompany Duret when the latter was visiting the Salon in 1882 to see the *Arrangement in Black No. 5*.[9]

The portraits of Lady Meux were followed by several other commissions. It was in the early 1880s that Whistler painted Sarasate and Lady Archibald Campbell; he even planned to execute an *Arrangement in Yellow* with Mrs Langtry as the subject. The sitters were all that Whistler could have desired in terms of brilliance, refinement and fashion. Yet the number of English patrons gradually began to decline, clearly reflecting, as well as encouraging, the painter's growing sympathy for France and his own native America.

The portrait of Duret, for whom Whistler appears to have felt much affection, was being worked on in the early 1880s (Colour Plate 15, p. 129). It was probably begun in 1882, although Duret himself mentions 1883. There is a letter from Whistler reminding Duret to bring the same costume for his next sitting, 'que nous puissions toujours avoir le même effet'.[10] According to Duret the painting resulted from a

84 *Arrangement in Black No. 5: Lady Meux*, 1881, oil, 194.2 × 130.2 cm (76½ × 51¼ in.). Honolulu Academy of Arts; photo courtesy of The Arts Council of Great Britain.

discussion after the two had visited an exhibition together. Whistler criticized a portrait of a man in an old-fashioned, picturesque costume, the robes of some society, topped by a contemporary hairstyle. From this came the suggestion of a portrait of Duret in modern evening dress. Whistler's ridicule of the old-fashioned costume he found in the portrait reflects Baudelaire's assertion, made almost four decades earlier, that 'Great colourists know how to create colour with a black coat, a white cravat and a grey background.'[11] The Duret painting is not, of course, Whistler's first portrait of a man in contemporary dress. Both Carlyle and Leyland immediately come to mind as sitters whose dress reveals the dark and limited colour scheme of respectable male attire. But it is the first portrait in which Whistler was quite obviously and consciously concentrating upon and developing this colour scheme. In his own dress he himself was, of course, always elegant and impeccable — if occasionally eccentric. The simple black and white harmony of his costume was often highlighted by a note of yellow, perhaps, or mauve. In the same way he insisted that Duret should carry for the portrait a rose-coloured cloak, the tone of which is echoed through the whole.

In his clear, sensitive style Duret outlines Whistler's method of approach.[12] He began the portrait without preliminaries, evidently having the whole organized in his mind before he confronted the canvas. The balance of the figure was outlined, this followed by a study and the steady build-up of tonal detail. The colour of this composition is resonant and subtle. Multiple hues of pink, grey and white emanate from the cloak, the keynote being struck by the rich, sensuous carmine of the fan. The cloak is painted with slender, fluid strokes, and is full of vitality and delicacy. The overall impact of the painting, however, is not altogether happy. Duret's character is conjured for ever as staid and a little weighty. The left side of the picture is quite heavily worked, as also is the head; and yet again there appears to have been some uncertainty over the placing of the butterfly. Whistler himself seems to have been aware of this incomplete success. Over ten years later, in 1895, at a time when he felt at last full of confidence and power, he was still hoping to inject a little life into this portrait of his friend.[13]

Both the Duret painting and the portrait of Lady Archibald Campbell were shown at the Salon in 1885. Whistler was now exhibiting frequently both in France and England. It was, of course, during these years that he was causing havoc within the Society of British Artists. In a letter of 1886 he was still writing of his 'beloved London', and declaring himself the 'most determined cockney'.[14] And yet by the early 1890s he was busily directing his work to markets anywhere but in England, and was settling in Paris after an absence, except for visits, of over thirty years.

During the late 1880s, in England, Whistler, having been mounting the ladder of success, began once more to find both the critics and patrons turning against him. His close followers were more numerous than ever. In 1889 a large body of people gathered together at the Criterion Hotel and held a dinner in Whistler's honour; but what they were specifically honouring was the award of membership conferred upon him not by any English body but by the Bavarian Royal Academy in Munich. The more common feeling among the general public, doubtless exacerbated by the growing strength of Whistler's influence, is reflected in a letter written to the *Pall Mall Gazette* in the same year: '. . . "impressionism" probably conveys to most people the idea of a very large crop of funny frames containing very small pictures which you can't make out.'[15]

In 1886 the *Nocturne in Blue and Gold: Old Battersea Bridge* was greeted with hisses when it was up for sale at Christie's, and was 'knocked down' for only sixty pounds. In the same year Harper Pennington witnessed a quarrel between Lady

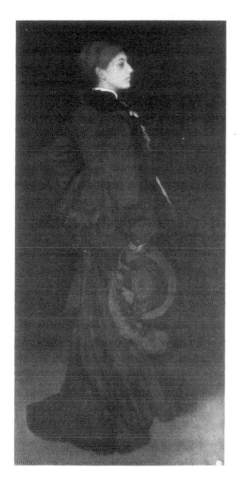

85 *Arrangement in Black and Brown: Miss
Rosa Corder, c.* 1876, oil, 190.8 × 89.8 cm
(75⅛ × 35⅜ in.). Copyright The Frick
Collection, New York.

Meux and Whistler which resulted in at least a temporary discontinuation of the
portrait sittings. It does not now appear to have been a very major disagreement; but
in her hasty words which suggested that Whistler's portraits of her were not properly
finished, Lady Meux evidently touched an extremely sensitive chord.[16]

In 1889 Sickert organized a retrospective exhibition of Whistler's work at the
College for Working Men and Women, 28 Queen Square. This was a major show: it
comprised some fifty works, including the portraits of his mother, Carlyle, Irving
and Rosa Corder (Plate 85). But it was very little advertised and attracted almost no
attention. Doubtless it had been hoped that its opening, coinciding with the
Criterion dinner, and Whistler's recent honours, would have been publicity enough.

In contrast to all this consistent disparagement, Paris must have appeared as
something of a haven. Instead of the unexpected and most bitterly resented attacks
from old friends such as Swinburne and Wilde, after the 'Ten o'clock Lecture',
Whistler found sympathetic criticisms from Duret and Gustave Geffroy. Instead of
being expelled from the Royal Society of British Artists, he was invited to show at the
international exhibition at Georges Petit's in 1887; had a substantial group of work
shown at Durand Ruel's in May 1888; and was made a Chévalier de la Légion
d'Honneur by the State in November 1889. In England, indeed, there was, in 1892 at
the Goupil Gallery, one very successful exhibition, 'Nocturnes, Marines and
Chevalet Pieces'. From letters which passed between the Gallery's manager, D. C.
Thomson, and Whistler, it is evident that a great deal of time and effort was put into
the organization of the show. Many people were asked if they would lend their
paintings. There was even the hope that Parliament would authorize the purchase of
a picture for the National Gallery, thus following the example set by the French
Government, which had purchased the *Mother* portrait only two months earlier.
D. C. Thomson relates the popularity of the show, the number of Royal
Academicians who visited, and confides to the painter's wife, 'Mr. Whistler is
becoming the Fashion, at least it is becoming the correct thing to pretend to admire
him.'[17] However, even this success brought a sting. Shortly afterwards Whistler was
outraged to discover that some of his early patrons were selling his work at a vast
profit; one or two of his old friends had even sold paintings given to them as presents.

From November 1891 Whistler lived in Paris. Except for the occasional trip
across the Channel, he seems to have left the majority of the organizing even for the
Goupil Gallery show to D. C. Thomson, though he certainly visited and was
delighted with the exhibition just before it opened on 19 March. And, though
Thomson wrote to Whistler of various possibilities of important English sitters, the
majority of portraits were now of French or American patrons.

The first major commission which Whistler had received for some years came to
him from the extraordinary Comte Robert de Montesquiou-Fezensac. There is some
suggestion that Henry James initially introduced them in 1884.[18] In June 1891 the two
were breakfasting together in Paris, and the portrait was begun when Montesquiou
was in London for a month later in the year.

As an individual Montesquiou deserves some attention. It is well known that he
was the model for J. K. Huysmans's anti-hero Des Esseintes in *A Rebours*, a copy of
which had been presented to Whistler by the author. When visiting him in 1891, the
de Goncourts described Montesquiou surrounded by the trappings of a respectable
Symbolist interior augmented by the occasional ancestral portrait. There were in
Whistler's library several sumptuous editions of the Count's poetry, presented to the
painter, warmly inscribed and largely uncut. One book dedicated on 29 April 1892
contains poems, each introduced by short quotations from Gautier, Baudelaire, José
María de Heredia and others. The silver- and gold-coloured silk with which it is

covered is decorated with a pattern of bats: the whole tenor of Montesquiou's life and art was epitomized by this sort of extravagant richness and mysterious decadence.

Whistler and the Count developed a close understanding and friendship. In November 1891 Whistler wrote to Mallarmé that Montesquiou was briefly with him in London: 'I am working on the portrait every day until dusk.'[19] In fact there were initially two portraits planned, but only one progressed, when worked on in Paris in the early part of 1892. It seems to have been almost completed to Whistler's satisfaction within a very short time, but was not ultimately concluded until 1894, when it was exhibited at the Champ de Mars Salon.

The painting now hangs in New York (Plate 86). The figure is tall, elegant and imposing, full of pride and slightly awe-inspiring. The frame in its simplicity enhances this effect. The range of tone moving through black, brown and grey is strong, rich and subtle, heightened by a few firmly brushed strokes of lighter hue. The paint is quite heavily worked around head and shoulders: Whistler had written to his wife that he had painted the head, but planned to leave the figure and the background until a little later, and to complete the whole with one final coat. It is possible, in fact, to reconstruct in some detail the progress of the work from accounts in Whistler's letters, Montesquiou's memoirs, and, particularly, from the de Goncourts's journal. They describe in detail the beginnings of the portrait, for which Montesquiou gave twenty-seven sittings when first in London: 'For most of the time the painter approaches the canvas with the brush, but does not touch it—he throws the brush away! and takes another—and sometimes, in three hours, makes about fifty strokes on the canvas.'[20] This description is significant and is backed up by references made by both Duret and Lady Meux to the amount of time Whistler spent apparently not progressing at all, placing just the occasional note of paint on the canvas or scraping off the whole to start anew. From the fact that he would often paint until it was almost quite dark—and frequently ruined a canvas in the process— it is evident that Whistler was still not altogether happy when translating the balanced composition he had developed in his mind into a series of sensitively related colours on a solid canvas confronting him in full daylight. His sitters stood not far away from the painting, Whistler well back, in turn contemplating and painting. His dedication to the task in hand was intense; many unhappy sitters were obliged to pose for hours, unable to rest or eat. Many are the letters Whistler penned in apology for his treatment. But this exclusive preoccupation with his composition was essential; a break for any length of time was often fatal. Thus concentrating utterly on the image he wished to convey, he seems to have felt that he could gradually draw from his mind something of the clarity of composition and atmosphere he desired, and set it down on canvas. His constant concern for unity, for the unlaboured 'skin' of his painting, factors in the actual mechanics of the creation, were problems he had to confront continuously. It was not until the later 1890s that he suddenly was able to release what must have been almost unbearable tension when working, and found a new confidence and ease.

The tension was undoubtedly difficult also for the sitters. Those with whom Whistler felt some sort of special sympathy almost invariably proved the subjects of the most successful work. Something of their essential character was grasped during the intense, almost séance-like sessions of posing. Montesquiou, in a magnificently macabre piece of description, relayed to the de Goncourts his experience of these hours: 'It seemed to Montesquiou that Whistler was draining his life blood with the fixity of his attention, sucking something of his individuality and in the end he felt so exhausted he experienced what felt like a shrinking of his whole being.'[21]

Colour 15 *Arrangement in Flesh Colour and Black: Portrait of Théodore Duret*, c. 1882–4, oil, 194.0 × 90.8 cm (76⅜ × 35¾ in.). Metropolitan Museum of Art, New York.

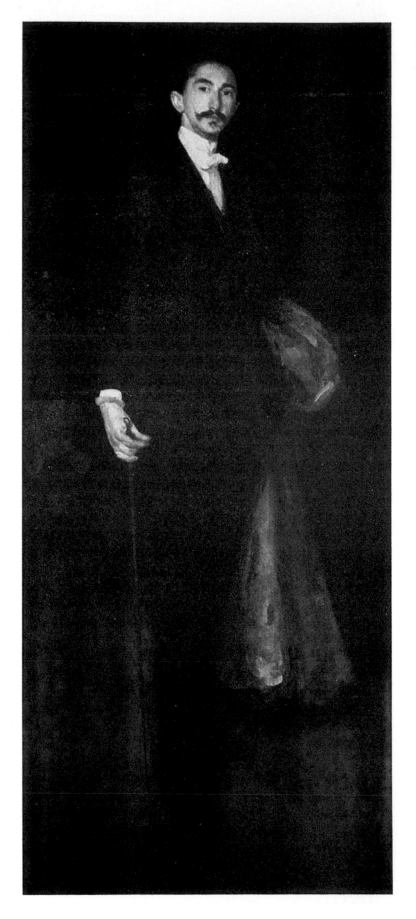

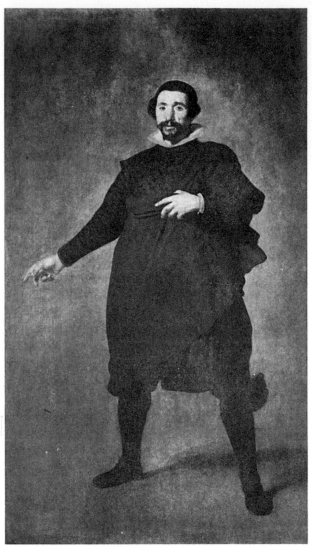

87 Velazquez, *Pablo de Valladolid*, 1630s, oil. 209.0 × 123.0 cm (82¼ × 48⅜ in.). Prado, Madrid. Cf. Plate 104.

86 *Arrangement in Black and Gold: Robert, Comte de Montesquiou-Fezensac*, 1891–4, oil, 205.7 × 88.8 cm (81 × 35 in.). Copyright The Frick Collection, New York.

Fortunately, no doubt, for Montesquiou, he found a suitably decadent answer to his predicament: 'He had discovered a certain *vin au coca* which restored him after these terrible séances!'

The Montesquiou portrait does, in fact, have an almost mesmeric quality; the powerful character of the proud French Count is full of challenge and assurance. It impressed Pissarro when it was shown at the 1894 Salon; he wrote describing the painting to his son, Lucien, and mentioning in comparison the work of Velazquez[22] (see Plate 87).

Velazquez was, of course, a painter whom Whistler had always greatly revered. His early attempts to visit Spain to see the paintings have been mentioned. There are some indications that the Spanish painter was, in the 1880s and 1890s, attracting Whistler's renewed attention; this perhaps was to some extent responsible for his strong interest in portraiture during these years. Among his friends in the early 1880s there seems to have been much discussion of Velazquez. Alan Cole, for example, noted in his diary in August 1881 that, while busy working on the Meux portraits, Whistler spoke to him of the great Spanish painter.[23] A later friend, J. Kerr Lawson, describes Whistler's dramatic gesture of homage before a Velazquez, when he saw it in the Uffizi many years later:

> The flat brimmed 'chapeau de haut forme' came off with a grand sweep and was deposited on a stool with the long stick and then the master, standing about six feet from the picture and drawing himself up . . . with his left hand upon his breast and the right thrust out magisterially exclaimed 'quel Allure'![24]

Whistler's renewed involvement with portraiture was encouraged by the substantial number of his compatriots who patronized him in these years. His work had been well received in America, and from the 1880s onwards he was in close touch with E. G. Kennedy of Wunderlich. Several of his sitters became devotees and began to make collections of his work, besides writing and speaking of their home-grown 'master'. A. J. Eddy, for example, a Chicago lawyer, commissioned Whistler to paint his portrait in 1893. This, on Eddy's insistence, was finished the following year (Plate 89). Like others among Whistler's American patrons Eddy later wrote a book of *Recollections and Impressions*, and in 1904 gave a talk on Whistler at the Copley Society, Boston. Eddy's recollections are obviously the result of careful and sensitive observation of the artist at work. He gives detailed descriptions of Whistler's care over lighting. In his studio the skylights were well shaded and adjusted daily. The famous long-handled brushes, which caused such amusement in the popular Press, were used only for the initial lay-in; the subsequent coats of thin colour were laid on with ordinary tools. The most outstanding factor of Whistler's approach, for Eddy, was the minute devotion he paid to the study of precise tones. He recalls, for example, not only the insistence later placed, in Whistler's teaching studio, the Académie Carmen, on the meticulous preparation of tone on the palette, but also an occasion when there was a desperate search for a brown tie of just the right shade for the sitter.[25] Evidently a portrait was, first and foremost, a composition of line and tone which had to be organized with precision from the outset. And the portrait of Eddy is just that: a subtly balanced play of rhythmic line and interwoven colour.

Another patron who later wrote of his experience, but one who was not so fortunate in getting his portrait finished, was J. J. Cowan. He had approached Whistler through one of the latter's great admirers, John Lavery. His wife and daughter had been painted by Lavery in no more than ten sittings of a couple of hours each, and he doubtless expected the 'master' to be even more speedy. He was disappointed. He in fact gave Whistler over sixty sittings between 1893 and 1900, in

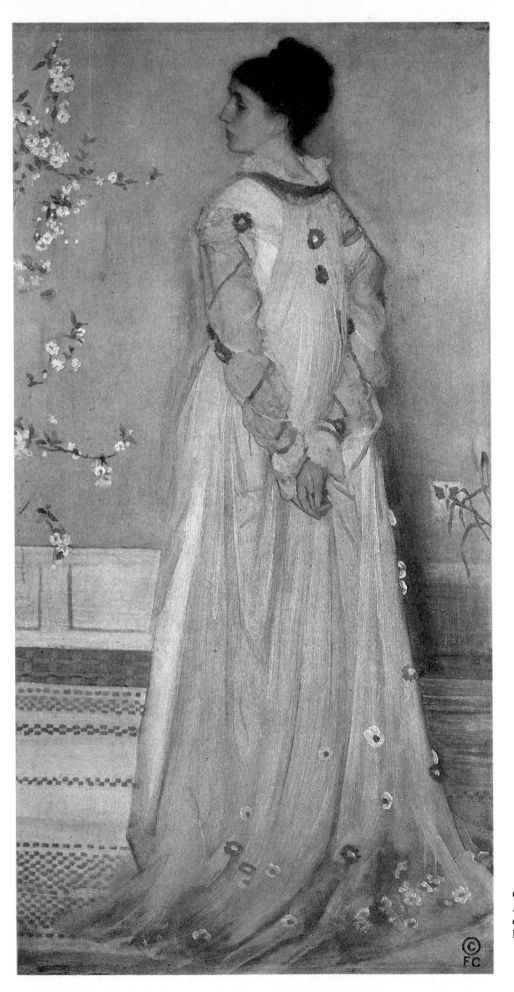

Colour 16 *Symphony in Flesh Colour and Pink: Mrs Leyland*, 1873, oil, 189.5 × 96.0 cm (74⅝ × 37¾ in.). Copyright The Frick Collection, New York.

Colour 17 *Harmony in Flesh Colour and Pink:
Lady Meux*, 1881, oil, 190.5 × 90.5 cm (75 ×
35⅝ in.). Copyright The Frick Collection, New
York.

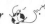

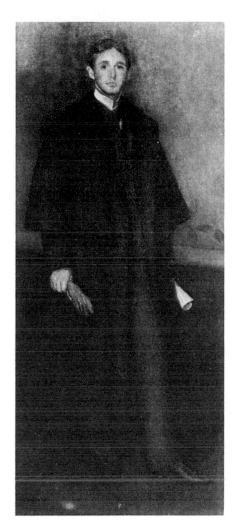

89 *A. J. Eddy*, 1893–4, oil, 210.2 ×
93.3 cm (82¾ × 36¾ in.). Courtesy of the
Art Institute of Chicago; Arthur Jerome
Eddy Memorial Collection, 1931.

both Paris and London, but the portrait remained incomplete.[26] Instead, Cowan bought several other paintings, including the delightful small *Lillie in our Alley* (Plate 88). This is one of the most simple and sensitive of the many beautiful studies Whistler made of young girls in the late 1880s and 1890s. It is utterly fresh and unlaboured; the direct candour and ease of youth expressed not only in the features but also through the sensuous warmth of the brushwork.

The Pennells rightly assert that the portrait 'destined to make more talk than any other picture he ever painted' was the *Brown and Gold* portrait of Lady Eden; the portrait at the root of 'The Baronet and the Butterfly' saga. The general public's reaction to this incident is summed up by an American newspaper writer in 1911. He tells the story of an 'eminent English lady' who demanded a picture she had bought. Whistler's response is composed: 'the impudence of these people who think that because they pay a few paltry hundred pounds they own my pictures. Why, it merely secures them the privilege of having them in their houses now and then!' The controversy was not, however, as straightforward as this. Sir William Eden initially seems to have approached Whistler for a portrait of his wife through the good offices of D. C. Thomson, after the success of the 1892 exhibition. But it was not until 1894, through George Moore, that a firm commission was given, after Whistler had apparently mentioned a sum in the region of a hundred to a hundred and fifty pounds for a watercolour or pastel sketch. He became interested in his sitter, however, and worked on a small oil which was nearly finished by 14 February, the day Sir William Eden rather clumsily presented him with a 'Valentine' of a hundred guineas. Whistler's vulnerable pride was undoubtedly hurt. It had been a painting he was very pleased with, and this was, after all, a time when his work was attaining much higher figures: Samuel Untermeyer bought the *Falling Rocket* for eight hundred guineas, while Alexander Reid had been instructed to ask two thousand guineas for the '*Princesse*'. The *Brown and Gold* was admittedly much smaller, but Whistler was understandably incensed at not being asked to state his own price. The outcome of all this is well known. Whistler returned neither money nor portrait. He repainted the figure of Lady Eden entirely, using a different model. A court case in Paris ensued; a decision in Sir William's favour in March 1895 was reversed in December 1897.

The death of Whistler's wife disrupted his whole life at this time. Perhaps partly as the result of this, the Eden issue seems to have grown out of all proportion in his mind: the number of letters relating to the issue and the pamphlet 'The Baronet and the Butterfly' are witness to an overriding absorption in this rather strange affair. It even brought about a break in his friendship with Walter Sickert, to whom he had been close for more than ten years. Whistler's own conclusion was printed in the pamphlet: 'Established: The Absolute right of the artist to control the destiny of his handiwork—and at all times, and in all circumstances, to refuse its delivery into unseemly and ridiculous keeping.'

It would not be true to say that this theory represented a long-considered conviction. Whistler had always been preoccupied with the way a painting of his was displayed, and he did express pleasure when his work found its way into particularly sensitive hands. But his work was often handled by dealers, and he obviously could not control its movement. One can only assume that Sir William Eden aroused particular antipathy, and that circumstances combined to make Whistler more than usually sensitive.

Many further portraits, of all sizes, were worked on during these years. Several major collections of Whistler's work were built up, one of the largest being gathered together by Charles L. Freer (Colour Plate 23, p. 144). He had apparently met

88 *Brown and Gold: Lillie in our Alley*,
1898, oil, 50.8 × 30.5 cm (20 × 12 in.).
Fogg Art Museum, Harvard University,
Cambridge, Mass.; Grenville L. Winthrop
Bequest.

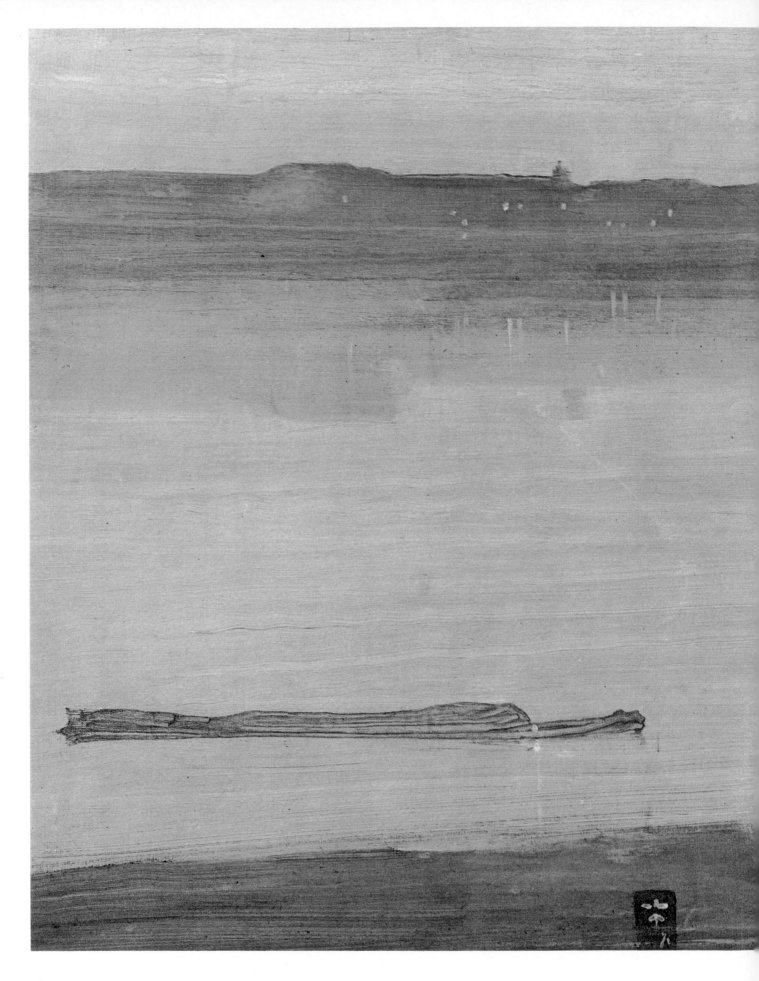

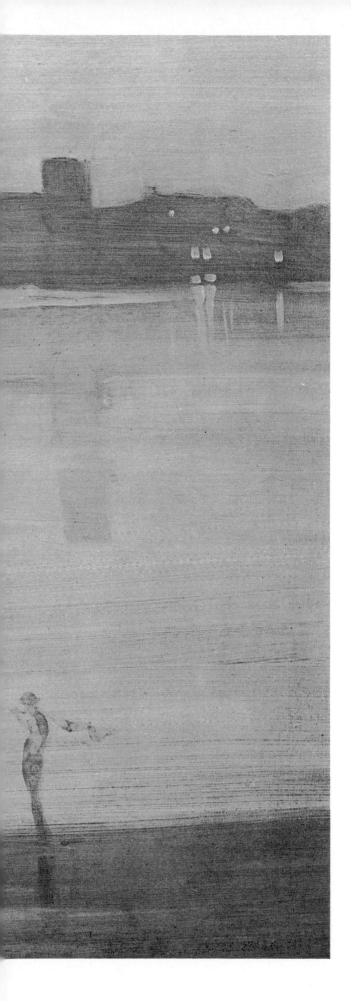

Colour 18 *Nocturne in Blue and Green: Chelsea*, 1871, oil on wood panel, 48.2 × 59.8 cm (19 × 23½ in.). Tate Gallery, London.

Whistler at the conclusion of a business trip in London in 1888, and the two became fast friends. Freer was one of those collectors to whom Whistler was particularly pleased to send work. The small unfinished portrait of him, with its broadly brushed, glowing colour is a warm and powerful study, the face full of many different hues of red, grey, brown and even touches of green. Whistler worked on it in 1902, and the broad, easy, unlaboured appearance makes it seem unlikely that he returned to it at a later date.

These portraits reveal an ever growing ease in wielding the brush, in capturing something of the sitter's essential personality, and in controlling minute subtleties of tone in rhythmic progress across a large surface. Even the portraits of Carlyle and Cicely Alexander seem, in comparison, to have a tightness and coldness which is quite gone by the late 1880s. It is, perhaps, significant that it was from these earlier works that paintings were chosen to be bought for national collections. Despite their simplicity, there is occasionally something about them that reflects a Victorian sense of enclosed refinement and shallowness, even sentimentality. Portraits such as that of Lady Meux, or the later half-length studies, have a pithiness, a breadth and freshness which reveal Whistler reaping the benefits of years of study and experiment.

9 Crisis and Fulfilment

In the tiny panels of the late years, the majority of which are landscapes and seascapes, Whistler attained an ease and freedom, an expression of brilliant warmth unequalled in his earlier work.

One of the reasons for this blossoming must have been the congenial and admiring society Whistler found awaiting him in France. His friendships with Manet, Duret, Monet and Degas have already been mentioned. His closest and most sympathetic companion, however, was the poet Mallarmé. Mallarmé was, of course, a leading figure of the Symbolist circle. The question inevitably arises as to what extent Whistler's painting of his last years evolved from the doctrines of this group, and, indeed, to what extent he was, in turn, influential on the Symbolists. The problem is a vexed one, and one to which he himself gave no real answer.

From the slightest glance at the names of the friends most frequently associated with Whistler in the 1880s and 1890s, it is apparent that these belong to writers of the Symbolist school and not to painters. No painter could have been more opposed to anecdote than Whistler. It would seem, then, something of a paradox to suggest that Whistler found inspiration within the circle of Symbolist writers. To understand the nature of this inspiration it is necessary to examine his relationship with the group, and the extent to which he comprehended their aims.

At a literary level it seems as if no conscious endeavour towards understanding was ever seriously made. In Whistler's library there was a substantial number of books by writers such as Huysmans, Montesquiou and Mallarmé. There was even a copy of Henrik Ibsen's *Hedda Gabler*. But many of these books, sent to him as tokens of admiration, often with the most flattering of dedications, remained uncut. He frankly admitted to his sister, Lady Haden, that he found (as who would not) Mallarmés poetry 'curiously difficult' to understand, though he declared him to be 'the most charming and *raffiné* of men'.[1] And of Montesquiou he wrote little appreciative of the poetry, much of the Count's refinement and nobility of character. This gives a clear indication of the basis of Whistler's sympathy for these writers. He discovered in France artists sharing something of his own sense of the peculiar aristocracy of the artist as opposed to the common man. It was to this elegance and refinement that he responded. He made little attempt at a detailed analysis of their literary work.

At what one might call a more intuitive level, however, Whistler's appreciation, especially of Mallarmé's writing, was deep and admiring. His frequent attendance at the poet's exclusive evening gatherings; his spontaneously warm letters to Mallarmé; his eagerness to know Lady Haden's opinion of his friend's work; the remarkable lithograph he created for the frontispiece of *Vers et Prose* (Plate 90); his devastation on Mallarmé's death in 1898: all point to a relationship as close and comprehensive as the earlier one between himself and Swinburne had been.

Such was the intimate understanding that existed between the two that there must have been support and stimulus for each to find in the work and demeanour of the other. In 1890 Whistler introduced Mallarmé to an English audience using terms which could very easily have applied to his own work: 'colour, harmony, and musical effect alone bring with them that completeness, that polished finish, that correction,

overleaf
Colour 19 *The Shore, Pourville, c.* 1899, oil on wood panel, 14.0 × 23.2 cm (5½ × 9⅛ in.). Ashmolean Museum, Oxford.

Colour 20 *Summer Sea*, 1880s, oil on wood panel, 12.9 × 21.6 cm (5⅛ × 8½ in.). Courtesy of The Smithsonian Institution, Freer Gallery of Art, Washington D.C.

Colour 21 *An Orange Note, Sweetshop, c.* 1884, oil on wood panel, 12.2 × 21.5 cm (4¾ × 8½ in.). Courtesy of The Smithsonian Institution, Freer Gallery of Art, Washington D.C.

Colour 22 *Angry Sea, c.* 1883, oil on wood panel, 12.4 × 21.7 cm (4⅞ × 8½ in.). Courtesy of The Smithsonian Institution, Freer Gallery of Art, Washington D.C.

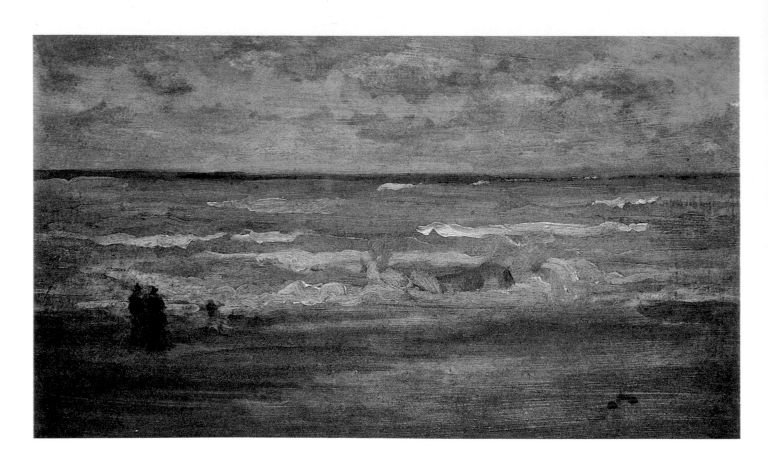

90 *Mallarmé* (frontispiece to 1st edition of *Vers et Prose*), 1893, lithograph, 19.0 × 21.0 cm ($7\frac{1}{2}$ × $8\frac{1}{4}$ in.). Hunterian Art Gallery, University of Glasgow; Birnie Philip Gift.

which accompany infallibly the work of the master.'[2] In the 1880s and 1890s Whistler's work reveals a heightened sense of poetry, a 'poetry of sensation, of evocation; poetry which paints as well as sings'[3] —qualities recognized by the Symbolist writer Arthur Symons as being common to the work of Whistler, Mallarmé and Paul Verlaine.

Duret remarked on the 'indeterminate nuances of expression' which he found in these same three. The very essence of Symbolism can be found in its tentative suggestions of images, delicate nuances of meaning, subtle accumulations of references to sensory experiences which are fleeting and elusive. Mallarmé declared that 'Poetry is the expression, by means of human language brought back to its essential rhythm, of the mysterious sense of existence.' Opposed as he was to literary painting, Whistler found no contradiction in looking to this art of abstract suggestion for stimulus.

On the other side, it cannot be doubted that Whistler's evocation of nature,

especially in his Nocturnes, acted as a stimulus upon the work of many of the writers and poets in the Symbolist circle. Verlaine admired Whistler's 'transparent shadows' and 'ephemeral apparitions'. With its sonorously repeated references to nuance, to dreams, Verlaine's poem 'Art Poétique', published in 1884, conjures visions of a painting such as the *Nocturne in Blue and Green: Chelsea* (Colour Plate 18, p. 136):

> Car nous voulons la Nuance encor,
> Pas la Couleur, rien que la nuance!
> Oh! la nuance seule fiance
> La rêve au rêve et la flûte au cor![4]

Mallarmé's work depends, so often, on visual imagery, on an intensely complex series of recollections, on an accumulation of experiences conveyed with words which have mysterious layers of meaning. His references are to silence, death, passion, resurrection. Baudelaire was, of course, important to him in his early years. But his work seems to become more fleeting, more mysteriously evocative:

> Un ciel pâle, sur le monde qui finit de décrépitude, va peut-être partir avec les nuages: les lambeaux de la pourpre usée des couchants déteignent dans une rivière dormant à l'horizon submergé de rayons et d'eau.[5]

The images are of fading, dying, decaying. They are images which might be gleaned from one of Whistler's Nocturnes of the 1870s. One has to be wary, however, of suggesting that these imitations of decadence and melancholy were initially part of Whistler's deliberate intention.

Any examination of this relationship abounds in pitfalls. It depends upon a shared inheritance, upon the mutual recognition of the qualities of Baudelaire and Poe, Swinburne and Pater, all of whom were receiving renewed attention on both sides of the Channel in these decades. It has the elusive quality of family relationship. Whistler's work seems to have been welcomed as the realization in paint of the ideal dream of the Symbolist poet. His Nocturnes were probably a direct stimulus. For Whistler himself, the importance of the contact must lie more in reciprocal respect and sympathy which engendered a popularity he had not previously experienced. He benefited from this congenial atmosphere, absorbing qualities of subtlety and precision, delicacy and richness from its ambience.

Whistler's careful restraint, scrupulous concern for the details of his craft, enigmatic poetry and subtle nuances of jewel-like colour were all characteristics which, innate in earlier work, attained a polished brilliance in these years. Even the tiny proportions of the panels he used are in harmony with those of much evocative Symbolist poetry: Villiers de L'Isle-Adam, for example, is quoted as contending that 'no poem should be extended beyond a single line.'[6]

Many of the paintings Whistler produced in the last twenty years of his life are a delight. *The Shore, Pourville* must have been worked on in the late 1890s, possibly 1899[7] (Colour Plate 19, p. 140). The paint on the small wood panel has the delicacy, the freedom and ease of handwriting. The blurred, brown touches of two figures, and perhaps a third, a child playing in the sea, are placed against long, smooth stretches of green, grey and rust sand. The sea is painted with a frothy variety of shades: green, citrus, brown, cream and grey. It is separated by a dark horizon line from the warm-toned sky. Through all, the red of the wood glows. There is an expression of rich, singing life, an enigmatic poetry about it that harmonizes well with a Mallarmé poem. But there is also something more. Despite the size of the panel, Whistler evokes the fresh, vibrant air, the wide expanses of rolling water to be found in such a place. There is no hesitancy, rather a vigour and immediacy that one would not expect to issue from the enclosed atmosphere of the Symbolist circle. Yet the stimulus for it is indeed to be found not far from that circle.

91 Edouard Manet, *Olympia*, 1863, oil, 130.0 × 190.0 cm (51 × 74¾ in.). Louvre, Jeu de Paume, Paris; photo Musées Nationaux.

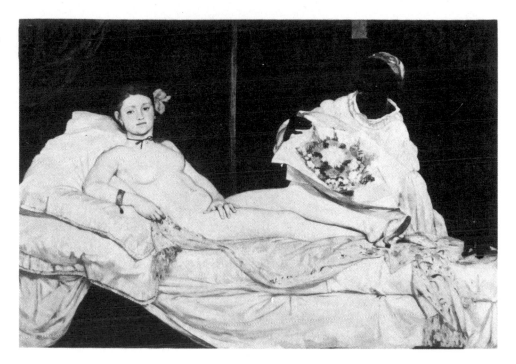

In Paris perhaps the majority of Whistler's painter friends belonged to the group of fashionable portraitists that included Jean Boldini, Antonio de la Gandara and Paul-César Helleu. Besides these, however, Whistler could not have avoided developing closer ties of friendship with artists admired by his poet friends, artists with whom he himself had long been familiar: the Impressionists. Apart from Puvis de Chavannes, it was not, on the whole, declared Symbolist painters who had attracted the recognition and understanding of the poets, but artists such as Manet, Monet and Degas. As early as 1876 Mallarmé had written in the *Art Monthly Review* an article on 'The Impressionists and Edouard Manet'.[8] This is, perhaps, not surprising, for it is possible to recognize in Manet—his *Olympia* for example (Plate 91)—something of that 'intellectually perverse' attitude which Mallarmé discusses. But he also refers with delight to the freshness and vigour of Manet's work. In the same year Manet illustrated the exotic and exciting *L'Après-midi d'un Faune*. The connection was on a personal as well as an artistic level and even after Manet's death in 1883 was continued within the family circle. Berthe Morisot, at one time a pupil of Manet and his sister-in-law, was a close friend, and when she died in 1895 Mallarmé was at her bedside.

Monet, too, was acquainted with Mallarmé. He facilitated the growth of friendship between Mallarmé and Whistler, and the three met together on many subsequent occasions in the 1880s and 1890s. Whistler was also in correspondence with both Monet and Degas, and exhibited with them in Paris. In May 1887, for example, at the invitation of the Impressionist group, he showed fifty works at Georges Petit's international exhibition, and the following year he was included in a series of exhibitions held by Durand Ruel. Mallarmé himself certainly seems to have recognized many characteristics common to the work of Whistler and the Impressionists. He had concluded his 1876 article in the *Art Monthly Review* with a simulated manifesto of the Impressionist movement, including among its adherents not only Manet, Monet, Renoir, but also Degas and Whistler.[9] By 1893 at one of his fashionable evening gatherings he was still discussing that same group of painters:

Colour 23 *Charles L. Freer*, c. 1902, oil on wood panel, 51.8 × 31.7 cm (28⅜ × 23½ in.). Courtesy of The Smithsonian Institute, Freer Gallery of Art, Washington D.C.

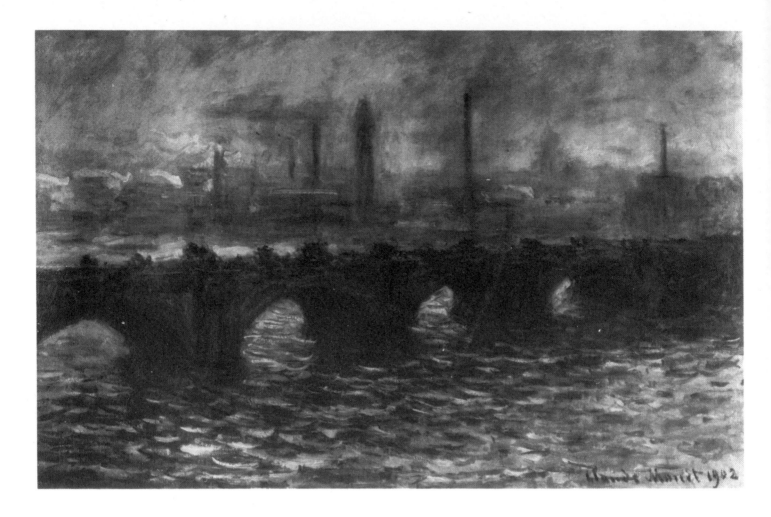

92 Claude Monet, *Waterloo Bridge*, 1902, oil, 66.0 × 100.0 cm (26 × 39⅜ in.). Kunsthalle, Hamburg.

Manet, Whistler and the Impressionists.[10] And one can hear echoes of his recognition of the sympathy which existed between Impressionism and his own Symbolism in an article by Arthur Symons written in the same year:

> Both are really working on the same hypothesis, applied in different directions. What both seek is not general truth merely, but 'la vérité vraie', the very essence of truth—the truth of appearances to the senses, of the visible world to the eyes that see it, and the truth of spiritual things to the spiritual vision.[11]

It is clear that Whistler still had moments of impatience with the Impressionists' lack of austerity. But he and they were in many ways converging and providing new inspiration for each other. The atmosphere created by Monet in his paintings of London at the turn of the century has often been compared, in its poetry and delicacy, to Whistler's own rich compositions on the theme (Plate 92). In 1892 Degas held an exhibition of small landscape sketches, described by Pissarro: 'rough sketches in pastel that are like impressions in colours . . . these notes so harmoniously related, aren't they what we are seeking?'[12] The pastels are brilliant, almost acid in colour, but they have an enigmatic poetry, a vigorous life which can be compared with some of Whistler's landscape sketches in pastel or watercolour (Plate 93); quite different in character from the bold draughtsmanship and challenging compositions that are usually felt to be typical of Degas.

The stimulus of these various French associates must have been an important factor in the release in Whistler's art which was very evident in the mid 1880s and culminated in the following decade. Even as early as the Venice etchings shown at

the Fine Art Society in December 1880 the perspicacious Duret had remarked an increased ease and simplification. He drew parallels with Impressionism: the lightness of touch, the grasp of momentary sensation, the hint of fantasy. And perhaps it was the experience of wandering around Venice, working in odd corners, on etchings and pastels, that initially developed in Whistler his latent sympathy with the natural world and a desire to work in close and immediate contact with it (Plate 94).

He had always loved water, but in earlier years he had explored this love mainly in his Thames scenes, these largely worked up in the studio. In 1881, however, he was writing to his sister-in-law Mrs William Whistler of his plans to go to the sea, to paint something to be included in a Fine Art Society exhibition of sea pieces by J. C. Hook, John Brett, and others.[13] The same year, during a trip to Guernsey and Jersey, he had been 'perched perilously' on cliffs, painting for hours.[14]

More sea pieces, those exhibited in May 1884 and 1886 at Dowdeswell's, had mainly been executed at St Ives, Cornwall, visited by Whistler in the winter of 1883-4, in company with two of those who deemed themselves his followers, Mortimer Menpes and Walter Sickert.

Whistler from his letters was evidently pleased with the work he was producing on this trip. From the many panels composed over the next twenty years it is difficult to determine which exactly were painted in St Ives. But among them is probably the *Angry Sea*, which, from the butterfly, must be of about this date (Colour Plate 22, p. 141). The sea is, indeed, a winter one, the strong, creamy strokes of the waves playing over heavy slate tones in the sea. A ship is tossed on the horizon, its pattern balanced by the brief indication of a butterfly at the lower right. The panel has a ground of charcoal, showing darkly through the paint and establishing the atmosphere. It is interesting to compare this with another small work, the *Summer Sea*, which is, in composition, very close (Colour Plate 20, p. 140). Here the light tone of the panel glows through the soft turquoise of the water. The whole

93 Edgar Degas, *The Path through the Meadow*, c. 1892, pastel, 30.0 × 40.0 cm (76¼ × 15¾ in.). Private collection; photo Sotheby's.

94 *The Doorway* (K. 188 1), 1880, etching, 29.2 × 20.3 cm (11½ × 8 in.). Hunterian Art Gallery, University of Glasgow; Birnie Philip Bequest.

atmosphere is utterly different, created by just a few slight touches of subtle hues of mauve, pink and green. It is richly painted panels such as these to which Whistler is referring in a letter written to Ernest Brown of the Fine Art Society. He had decided to stay in Cornwall a little longer: 'the sea to me, is, and always was, most fascinating. Perhaps you will think that there is a novelty about the little things I bring back . . . I am doing things quite new down here. . . .'[15]

This sense of freshness and fascination is manifest in many of the subsequent sea paintings. In a watercolour, a *Note in Grey and Green: Holland*, for example, the full translucent weight of water, the brisk clouds of the sky are intimated in a few

95 *Note in Grey and Green: Holland,*
c. 1887, watercolour, 12.7 × 21.6 cm (5 ×
8½ in.). Hunterian Art Gallery, University
of Glasgow; Birnie Philip Gift.

delicate, fluent strokes (Plate 95). Whistler was frequently in the Low Countries, Holland or Belgium, during the mid to late 1880s, and there are numerous watercolours of a similar vigorous, glowing delicacy from this period. Several such were shown by the American firm of dealers Wunderlich in 1889, and proved very popular on the American market.

The *Sad Sea – Dieppe* possibly entered the collection of Freer through Wunderlich (Plates 96, 97). The title itself is significant: like others—the *Angry Sea*, the *Great Sea*—it expresses in simple terms not only something of the prevailing atmosphere, but also something of Whistler's own attitude towards the scene. The importance he always laid upon his titles would imply that these were in no way casually applied, but were the definite result of a very deep personal feeling of unity with the natural world. It was not simply visual appearance for which he searched, but the expression, through paint, of that essential inner character which can be discerned behind the appearance. This was not entirely new in Whistler's work, for it can be found in earlier paintings: *The Ocean* worked on in the mid 1860s has a certain weighty solemnity. But now his sensitivity is heightened through his awareness of Symbolist poetry and he has a new ability to express his feelings. The *Blue Wave*, for example, painted in 1862, was shown at the 1892 Goupil Gallery exhibition. Whistler, seeing it anew, applauded its strength and vigour. It has nothing, however, of the breadth and ease of a tiny panel, *Green and Silver: the Great Sea, Pourville* painted in the 1890s, on the spot, full of life, gaiety and intimacy (Plate 99).

According to the Pennells, Whistler was, in the nineties, more careful than ever with the quality and mixing of his colours, the size, texture and preparation of canvas or panel. This is manifest not only in the sea pieces, but also in the panels of shop

above
96 *Sad Sea—Dieppe*, 1880s, oil on wood
panel, 12.5 × 21.7 cm ($4\frac{7}{8}$ × $8\frac{1}{2}$ in.).
Courtesy of The Smithsonian Institution,
Freer Gallery of Art, Washington D.C.

left
97 *Sad Sea—Dieppe* (detail). Courtesy of
The Smithsonian Institution, Freer
Gallery of Art, Washington D.C.

right
99 *Green and Silver: the Great Sea,
Pourville*, 1890s, oil on wood panel, 10.8 ×
21.0 cm ($4\frac{3}{4}$ × $8\frac{1}{4}$ in.). Hunterian Art
Gallery, University of Glasgow; Birnie
Philip Gift.

fronts, busy streets and quiet corners. *An Orange Note : Sweetshop* comes from about 1884 (Colour Plate 21, p. 141). Brilliant touches of a gem-like orange, in the window, and red, in the child's costume, are placed in a setting of muted tones of grey and brown. A high varnish enhances the sparkle. By the following decade the colour glows even more richly.

In the summer of 1895 Whistler and his wife visited Lyme Regis. In about October Beatrix returned, ill, to London, apparently having insisted that Whistler remain and concentrate on his work. In letters to his wife written during this time it is evident that he was undergoing something of an artistic crisis. He appears full of excitement, demanding from himself continued courage and determination not to compromise. Clearly he was feeling that he could reap at last some of the benefits of his life's work. He still speaks of the concentration demanded of him, the necessity of searching for 'scientific' results. Yet his confidence grows steadily. The desperate scraping out, repainting, discarding that had occupied so much of his time and energy were no longer necessary. The labour of creating a painting which should finally look effortless—often the cause of a certain restraint—could be discarded. Whistler's sense of ease, relaxation and happiness emerges from these letters, and reflects itself in the paintings, etchings and lithographs, some of which were exhibited at the Fine Art Society in December of that year (Plate 98).

Two of the portraits executed in Lyme Regis are, supposedly, of father and daughter: the *Blacksmith* and *Little Rose of Lyme Regis* (Plates 101, 102). Both have an intimate, almost challenging stare; both are full of life and warmth. The thin, fluid

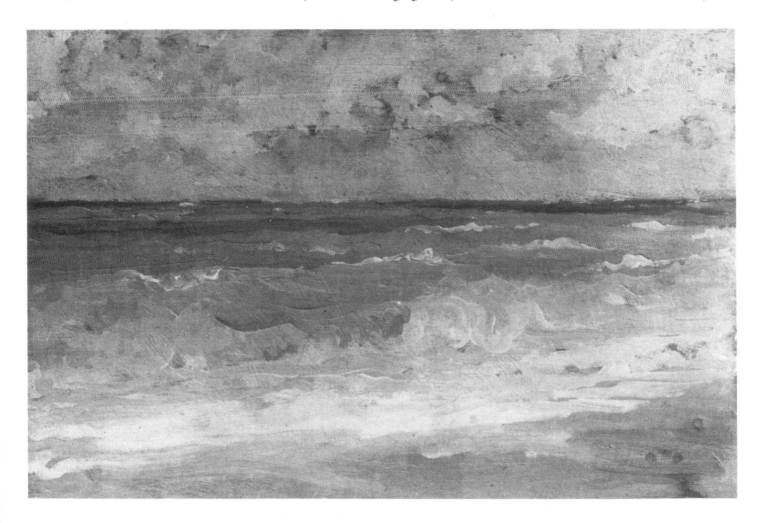

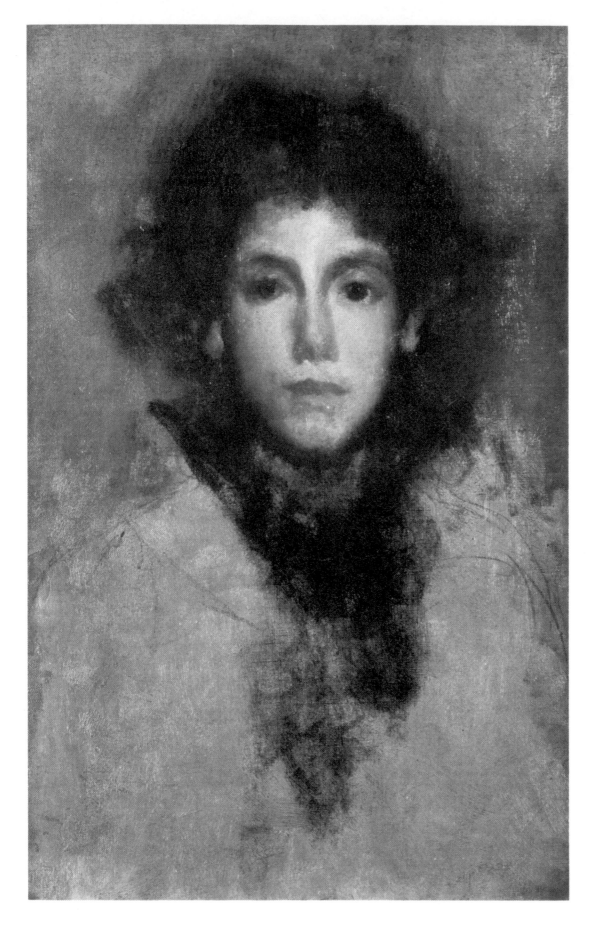

above
101 *The Blacksmith of Lyme Regis*, 1895, oil, 50.8 × 31.1 cm (20 × 12¼ in.). Courtesy of The Museum of Fine Arts, Boston, Mass.

above right
102 *Little Rose of Lyme Regis*, 1895, oil, 50.8 × 31.1 cm (20 × 12¼ in.). Courtesy of The Museum of Fine Arts, Boston, Mass.

100 *Little Juniper Bud* (Lizzie Willis), *c*. 1896–1900, oil, 51.5 × 31.3 cm (20½ × 12¼ in.). Hunterian Art Gallery, University of Glasgow; Birnie Philip Bequest.

paint in *Little Rose* moves over a fairly coarse canvas, the somewhat disturbing, sensuous expression enhanced by the glowing red-brown of dress and red-gold of face. This is another of the numerous portraits of young girls painted at this time, many of them with the same disturbing, pensive air (see also Plate 100). They appear sensuous, slightly evasive, immediately present. They reflect not only Whistler's new joy in life, but also, surely, a hint of the passion, the erotic sensibility, the subtlety, the enigma of Symbolist poetry, expressed with a refinement comparable to that of Mallarmé.

Whistler's association with the Symbolists had much to do with the subsequent characterization of him as a slightly decadent, effete creator of insubstantial work. It was largely the late work which bore the brunt of this sort of criticism. When examined, however, it stands apart from any such feeling of decadence, of overwrought exquisiteness and superficiality. It reflects instead power of intellect and depth of purpose, a sensitivity to natural form and a lucid control of materials which was the supreme outcome of a life of research and analysis.

10 *Friends and Followers*

In his early years in London Whistler had attracted a few close friends and admirers, and two very devoted pupils and assistants. The latter, the Greaves brothers, adored Whistler, and their unselfconscious imitation of his dress and manner drew many amused remarks. From the sixties they were aggressive in their defence of 'the master', making it apparent that his work was 'not to be gazed upon by everybody' — evidently a sideshoot from Whistler's own aristocratic sense of self-protection. Even in the 1890s Whistler had not cast off Walter Greaves, the more gifted of the two brothers; and the latter had not abandoned his Whistlerian manner and dress[1] (Plate 103).

It was, however, from the 1880s that a substantial number of young followers and admirers devoted themselves to Whistler. During his months in Venice he had begun to attract several such. They were not, on the whole, socially inferior, as were the Greaveses. Most were also better educated, having had at least some sort of artistic training. Hence a few of them began to study Whistler's methods and arguments; examining the matter rather than simply the manner of his art.

One of these followers was Mortimer Menpes, who wrote a number of articles on the 1880s, on the time when he and his fellow students 'were boiling over with enthusiasm. We thought of nothing else but Whistler. We talked of nothing else but Whistler.'[2]

Menpes came into contact with Whistler just after the latter had returned from Venice and was occupied with the printing of some of those plates that had been commissioned by the Fine Art Society. For several years after that Menpes devoted himself to Whistler. His dedication was without doubt serious; yet he wrote in later years articles in which he makes the relationship between Whistler and followers appear somewhat farcical: 'We used to steal in and furtively make sketches of his palette and then meet to discuss the combinations of colour that he used. One of us found that he had been using black as a harmoniser, and that was so important a discovery that we called a general meeting at once to consider it.'[3]

No doubt some of the 'followers' did take their adulation to exaggerated lengths. Yet, surrounding Whistler daily as he worked, many of them must have absorbed much of value, even though he did not often actively instruct them. Throughout his career, and particularly in his early work, Menpes manifests his debt. His *Little Shop in Chelsea*, for example, painted 1883–4, exhibits a remarkable similarity to many of Whistler's tiny panels of shop scenes, such as the *Sweetshop, Chelsea* (Plates 105, 106). In both, lively and delicately drawn figures are seen against a background of a shop window full of colours which are threaded in and out between the small panes, appearing and reappearing as in a patchwork.

During the years when he was close to Whistler, Menpes frequently accompanied him on his trips, both at home and abroad. In the winter of 1883–4 he was with him in St Ives, Cornwall. Here too he painted the shop and street scenes that had become so dear to Whistler.

It is Menpes, ever defensive of his position as one of Whistler's major followers, who, in referring to this trip to Cornwall, mentions in an amusingly casual manner 'a painter [who] happened to be travelling with us, a man who had once been an actor,

103 Walter Greaves, *Self Portrait*, late
1890s, oil, 40.0 × 32.1 cm (15¾ ×
12⅝ in.). Tate Gallery, London.

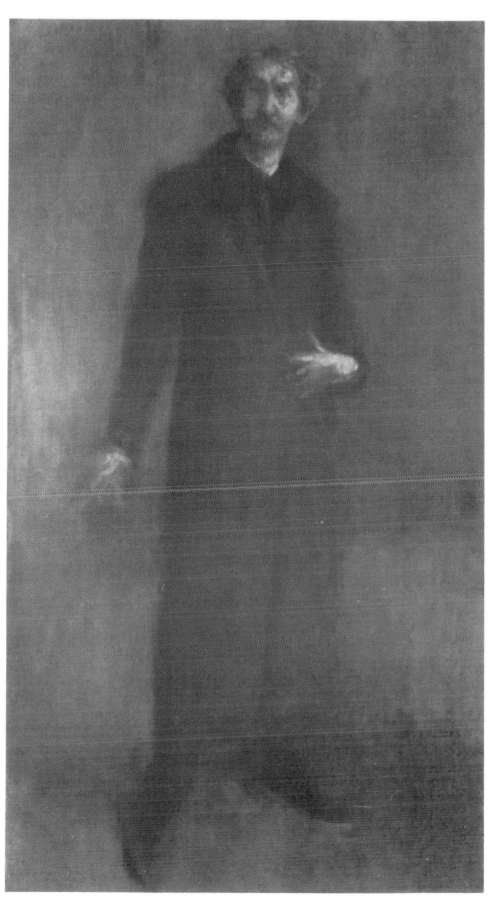

104 *Gold and Brown: Self Portrait*,
c. 1898, oil, 95.8 × 51.5 cm (37¾ ×
20¼ in.). Hunterian Art Gallery, University
of Glasgow; Birnie Philip Bequest.
Cf. Plate 87.

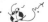

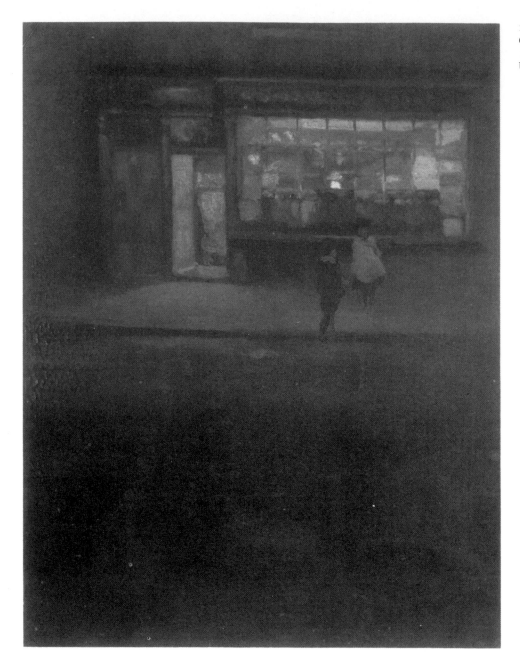

105 Mortimer Menpes, *A Little Shop in Chelsea*, 1883–4, oil, 20.0 × 15.9 cm (7⅞ × 6¾ in.). Hunterian Art Gallery, University of Glasgow.

touring the provinces, who knew St Ives well'.[4] This, of course, could be none other than Sickert, who shared with Whistler this important and fruitful time in Cornwall. Sickert had first encountered the elder artist in May 1879 and at that time already entertained a substantial admiration for him. It was not, however, until 1882 that he left the Slade, where he had spent about eighteen months, to become Whistler's assistant.

In Cornwall, according to Menpes, Sickert frequently painted several panels a day. He exhibited, however, only two Cornwall paintings, *Barnoon Fields: St Ives, Cornwall* and *Clodgy, Cornwall* (Plate 109), both at the Society of British Artists in the summer of 1885. The latter is very Whistlerian in size and execution, and can be closely compared with Whistler's own *Cliffs and Breakers, with Open Sea*, for which it provides a probable identification (Plates 108, 110). It seems likely that the two

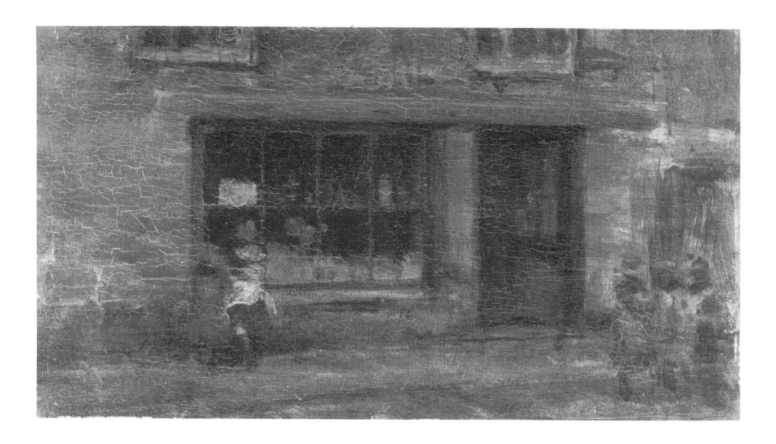

106 *The Sweetshop, Chelsea*, 1880, oil on wood panel, 12.1 × 21.0 cm (4¾ × 8¼ in.). Isabella Stewart Gardner Museum, Boston, Mass.

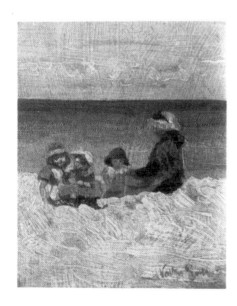

107 Walter Sickert, *On the Sands, St Ives*, 1883, oil on wood panel, 14.6 × 11.8 cm (5¾ × 4⅝ in.). Private collection.

paintings are of much the same scene, taken from different angles. Certainly the compositions are very close. The Whistler, however, is calm and gentle in its impact, a multitude of differing tones merging quietly, spreading horizontally. The Sickert, in contrast, is a bit wild and woolly, with touches of a rich, strong, very un-Whistlerian green. The rolling waves are caught with thin, curling strokes, from which the pattern of the rocks beneath emerges. There is not that absolute certainty which one finds in a Whistler; the brush is sometimes aimless, the horizon vague. Nevertheless it has a life and movement, and a richly individual pattern of touch, which gives the tiny panel a weight and atmosphere.

Another panel painted by Sickert at St Ives is *On the Sands*, a minute gem of rich colour and pattern (Plate 107). At this date Whistler's panels are rarely of a vertical format, and such an intimate emphasis is rarely placed on the figures. Nevertheless, though the paint is quite thick, its handling could only have been inspired by the 'master'. With a relatively broad brush Sickert has chased the paint over the surface, giving it a rich and lively texture. The direct freshness of vision, too, must come from Whistler; its charm and gaiety are entirely in keeping with the latter's work at this date.

The attention paid to the individuality of the figures is a notable characteristic of Sickert's, and one which he cultivated. He found stimulus for it in France, most particularly in the work of Whistler's old friend Degas. It is again Menpes who describes the first specific impact of Degas upon the group of Whistler's followers: 'Walter Sickert ... first saw Digars' [sic!] work. He brought enthusiastic descriptions of the ballet girls Digars was painting in Paris. We tried to combine the methods of Whistler and Digars, and the result was low-toned ballet girls.'[5]

For too long the major influences on Sickert's work, Whistler and Degas, have

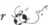

108 *Cliffs and Breakers, with Open Sea*, 1883, oil on wood, 12.4 × 21.6 cm (4⅞ × 8½ in.). Hunterian Art Gallery, University of Glasgow; Birnie Philip Bequest.
109 Walter Sickert, *Clodgy, Cornwall* (or *Clodgy Point, Cornwall*), 1883, oil, 12.3 × 21.5 cm (4⅞ × 8½ in.). Hunterian Art Gallery, University of Glasgow.

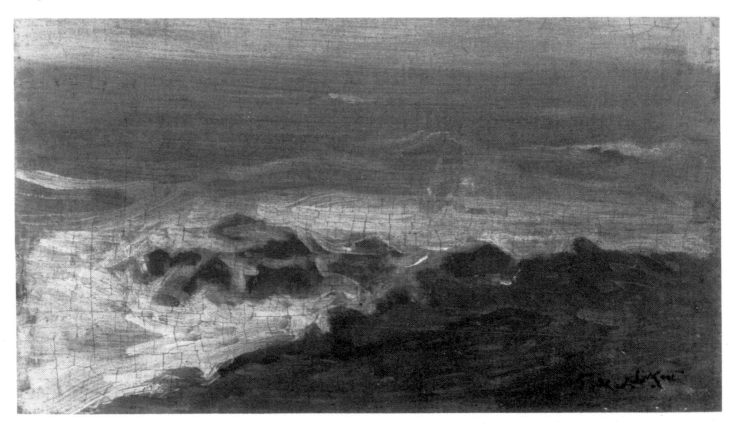

110 *Cliffs and Breakers, with Open Sea*
(detail). Hunterian Art Gallery, University
of Glasgow; Birnie Philip Bequest.

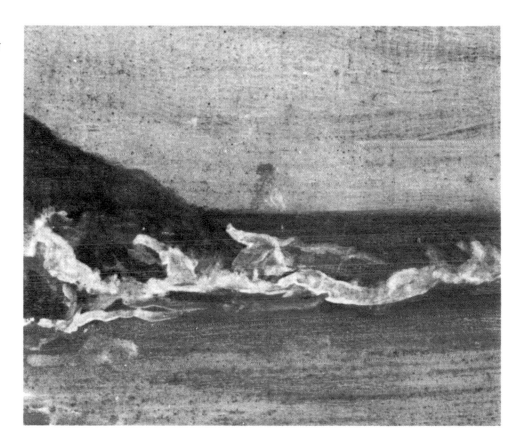

been regarded as separate, indeed almost exclusive of one another. Yet there is much
that these two artists, friends for many years, had in common—most particularly an
all-pervading respect for their materials. It is significant that from the beginning
Sickert was aware that it was a background of French training which had enabled
him to come to Whistler's art with sympathy and comprehension.[6] Not only was
Whistler's art of a French heritage, but it was a heritage he recognized, and one from
which he always encouraged others to draw inspiration. When in 1883 Whistler sent
Sickert to Paris to accompany the *Mother* portrait, which was to be shown at the
Salon, he equipped the younger painter with letters of introduction to both Degas
and Manet. Sickert did visit Manet's studio, and was able to see some of the
paintings there, but Manet was too ill to receive him. Degas, however, welcomed
him. The contact was renewed in the summer of 1885, one of many spent in Dieppe,
where Jacques-Emile Blanche had established himself at the centre of a
cosmopolitan group which frequently foregathered at his house.[7]

There are other followers, too, in these years of flourishing success for Whistler.
Any selective discussion of them is bound to be somewhat arbitrary. But perhaps one
of the most productive aspects of Whistler's influence is to be found in this
encouragement of the young to look beyond national boundaries, particularly
towards the vigorously developing art of France.

The work of French Impressionist artists, despite the occasional appearance in
England of a Degas or a Pissarro, surprisingly took a good deal longer to reach
English audiences than did the work of their successors, grouped together in 1910
and 1912 at the Grafton Galleries by Roger Fry as 'Post-Impressionists'. It was only
after Durand Ruel had organized an exhibition of Impressionism at the Grafton

Galleries in 1905 that some of the first British collections to include any substantial amount of such work were built up, by Hugh Lane and the two Davies sisters, Gwendoline and Margaret.

Nevertheless, as early as 1886 there was evidence of a clear recognition on the part of a group of young artists that it was to France that they should look for their training and inspiration. The New English Art Club was formed as the direct result of dissatisfaction with current opportunities for exhibition, and teaching systems, in England. One of the many young artists who studied in France, at the very popular free Académie Julian, A. S. Hartrick, describes vividly the characteristics of English teaching that drove away so much talent:

> Great care and surface finish were the main qualities demanded for success . . . only the surface drawing was important and this was made smooth with a stump or stippled with a pointed chalk pencil to a paralysing degree of finish. The cast or statue was examined with field glasses to explore the smallest accidents . . . A drawing two feet to a yard high would take anything from three months to a year to complete—and the one which took a year was likely to be considered the masterpiece.[8]

Many of those who did not go to France—as well as several who did—found a substitute in the Slade, under Legros, until Fred Brown took over in 1892. The New English Art Club provided a common meeting ground. Its first exhibition was held at the Marlborough Galleries in 1886. From there the group moved to the Dudley Gallery in 1887, and from this year a substantial number of Whistler's close admirers could be found amongst the exhibitors. Very quickly, however, the NEAC itself broke into several factions, some of which moved away and established their own exhibitions.

In 1889 Sickert wrote to J. E. Blanche that he felt it better to stay in the background that year, as the dominating faction, headed by the Newlyn School, was increasingly antagonistic towards 'the Impressionist nucleus'.[9] The 1889 exhibition was not large. Sickert showed only *Collins' Music Hall, Islington Green*; one of a number of paintings of music halls which he showed at the NEAC, the result of his nightly visits to these places of entertainment. Sickert must, of course, have seen the *café-concert* paintings of Degas, which undoubtedly acted as a stimulus. But it seems that his obsession with music hall themes stemmed initially from his own love of London, a love which appears to have occupied the attention of the whole group of Whistler admirers in the late 1880s. It was the period when Whistler and his associates were wandering around the London streets, selecting odd shops and street corners to portray on small wooden panels, or on a plate. This must inevitably have enhanced any feeling towards the everyday scenes or the visual surprises encountered. It is to this period that Menpes is referring when he recalls the group of followers travelling around London, sketching from the top of buses. And it is with a similar love of London that Sickert speaks in the preface to the catalogue of the 'London Impressionist' exhibition, which was presented at the Goupil Gallery in December 1889.

This show was set up by that 'Impressionist nucleus' of the NEAC to which Sickert referred. Sickert himself wrote the introduction. In this he conveys, with some confusion, both the fascination exerted by the metropolis, 'the most wonderful and complex city in the world', and something of his own understanding of the word 'Impressionist'. The term seems to be one he has grasped rather casually, and doubtless his use of it served further to confuse many writers when discussing contemporary artistic movements and to encourage their vague adoption of the word to classify anything they found disturbing. Sickert uses it to underline his love of life,

movement, idiosyncratic activity. This emerges strongly in his six contributions to the exhibition, over half of which were music hall subjects. He also declares:

> . . . it may . . . be possible to clear away several sources of error by endeavouring to state what Impressionism . . . is not. Essentially and firstly it is not realism. It has no wish to record anything merely because it exists . . . It accepts as the aim of the picture what Edgar Allan Poe asserts to be the sole legitimate province of the poem, beauty.

He illustrates his ideal with a reference to the low and subtle harmonies of tone he finds in the paintings of Whistler and Velazquez. Clearly he sought and found in French Impressionism qualities which must initially have been introduced to him by Whistler. It is interesting to remark the similarities between this interpretation of Impressionism and Mallarmé's simulated manifesto of the group.[10]

The whole tenor of the preface to the catalogue is in fact fundamentally Whistlerian in both individual tastes and general opinions. This is true too of the body of the work by the ten artists who were exhibiting. Théodore Roussel submitted seven works, all paintings of Chelsea or the Thames riverside, except for one portrait. Roussel's pupil Paul Maitland also was represented by six of his characteristic, low-toned paintings of the Chelsea environs. Fred Brown and P. W. Steer both contributed scenes painted at the sea, at Walberswick and Montreuil. Francis James too had been to the sea. His was the largest contribution, numbering twelve, including paintings of Cornwall, Corsica and Italy. In fact, despite Sickert's emphasis on London and its sights and sounds, the majority of the paintings revealed much more strongly a love of the coast and countryside and a fascination, when in London, for romantic, unpopulated effects.

The first of these mentioned, Théodore Roussel, seems to have become a close associate of Whistler in about 1885, when, apparently, a watercolour exhibited by him at Dowdeswell's late in that year caught the attention of the 'master'.[11] By 1887 he was firmly entrenched within the small and exclusive group of Whistler followers. He was to be found at the Fulham Road studio, together with Menpes, Sickert and William Stott of Oldham. He exhibited at the NEAC in spring 1887 a portrait of Menpes; at the RSBA in the autumn of the same year a portrait of Menpes's wife; and at the Grosvenor in 1888 one of Mrs Walter Sickert.

The landscapes and numerous scenes of sea and beach that he executed in the late 1880s and the 1890s are probably closest to the work of Whistler. At the Goupil Gallery in the summer of 1899 Roussel showed a whole series of marine studies, vigorously brushed with thin, flowing paint. The *Approaching Storm, Dover*, for example, is broad and soft, the tiny ship dashed on the horizon with something of Whistler's delicate brevity (Plate 111). The low horizon, the somewhat directionless brush create, however, a much looser, less decorative, less sparkling impression than a Whistler marine.

The impact of Whistler is also very strongly felt in Roussel's graphic work. He began to etch in about 1887–8 under the latter's tuition. He declared that 'Anything I have done in etching I owe absolutely to the influence of Whistler.' The areas of the Thames around Chelsea and Kensington provided much of his material. Two tiny etchings now in the Victoria and Albert Museum, for example, *Pleasure Boats, Chelsea* and *Chelsea Palaces, Chelsea Embankment*, are both delicate and playful; very Whistlerian in their impact (Plate 112). They reveal a fascination for the casual details of life, for the concise definition of architecture, for the pattern of light and shade over surfaces. But, like all Roussel's work, they are characterized by a somewhat harder touch, a more pedestrian movement than is to be found in a Whistler.

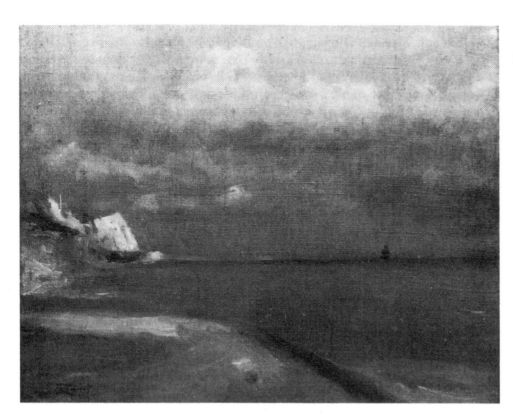

111 Théodore Roussel, *Approaching Storm, Dover*, 1890s, oil, 49.0 × 61.0 cm (19¼ × 24 in.). Lincolnshire Museums, Usher Gallery, Lincoln.

112 Théodore Roussel, *Chelsea Palaces, Chelsea Embankment*, c. 1890s, etching, 7.9 × 12.1 cm (3⅛ × 4¾ in.). By courtesy of The Victoria and Albert Museum, London.

Roussel became increasingly absorbed in his graphic work. He etched on the spot, did his own printing, echoed Whistler's concern over the framing and presentation of his work, and devoted much attention to experiments with coloured etchings. It is probably his involvement in these experiments that is the most interesting aspect of his work. He made detailed studies of the minute gradations of different tones; among the belongings that were in his studio there is a series of small squares of paper, coloured in various shades of a single hue, for use when researching into the problems of purity of optical tone.[12] These experiments seem to have been occupying Roussel even before he met Whistler, whose constant reference to the necessity for a scientific approach to a painting must have been an encouragement. In his monograph Frank Rutter tries to explain the aims: 'the means of discovering in any pigment of the palette the prismatic rays it reflects. We have no pigment of a pure colour for the palette, they are all at least binary combinations.' Roussel's arguments are complicated; his activities were sometimes comic:

> . . . one evening Théodore Roussel came to the Chelsea Arts Club in great excitement; he had got a commission from a rich patron. After he had been working at it for a month, telling us in the interval how it was progressing, at last he said it was finished. A few days afterwards I went to his studio, hoping to see it. When I asked where it was, he pointed to about fifty little pots, saying 'Le voilà'![13]

Yet his approach to his experiments would seem to have been both logical and passionate, a serious attempt to understand the true nature of colour. It is, if nothing else, certainly most fascinating to look at such experiments in the light of similar, and, perhaps, more conclusive ideas to be found across the Channel.

The ripples of Whistler's influence touched others, such as Roussel's pupil Paul Maitland. He was an extremely shy and retiring individual, suffering from poor health and physical handicaps. He had been a student at the Royal College, but probably gleaned more from working with Roussel in the environs of Chelsea. He certainly absorbed from the latter much of Whistler's poetic, tonal sensitivity and atmospheric subtlety. His favourite haunts were Kensington Gardens and Chelsea riverside. An early painting of *Kensington Gardens* was executed perhaps in about 1898 (Plate 115). It is built up from a sequence of low, subtle tones, finely applied and softly gradated. Grey, green, ochre and brown are punctuated by the dark uprights of the trees in the middle ground. The lower half of the painting is muted, empty of detail. It is worth recalling that Jean-Baptiste Corot was a French artist admired in London; one whose work had been exhibited at various galleries since the 1860s. There is something of Corot's soft brushiness in the application of paint in this little scene of Kensington Gardens.

Another version of the theme, probably somewhat later, is *Kensington Gardens, Vicinity of the Pond* (Plate 113). It has a similar range of tones: greens, greys and buff-yellows. The trees on the horizon have none of the plush boldness of Roussel's handling, nor the elegant vigour of Whistler's. They reflect, instead, the character of the artist: quiet, muted and delicate. The work is composed, restful, horizontal. It is noticeable that almost invariably in these delicate paintings there is an element of self-effacement, of melancholy. This is conveyed not only by the expanses of grass, or water, which fill the foreground of his pictures. There is often also a row of trees, a fence, or some other solid obstacle cutting off the spectator. It is interesting to compare these with a roughly contemporary work by Whistler, the *Street in Old Chelsea* (Plate 114). The latter is somewhat smaller than the Maitlands, its colours are similarly subtle, low-toned. But the whole character of the Whistler is warm and glowing. The figures—dashed in to punctuate the architecture of the shop fronts or the bare expanse of foreground road—are full of a rich vitality. The atmosphere is

113 Paul Maitland, *Kensington Gardens, Vicinity of the Pond, c.* 1907, oil, 25.4 × 45.4 cm (10 × 17⅞ in.). Tate Gallery, London.

114 *Street in Old Chelsea*, 1880s, oil on wood panel, 14.0 × 22.9 cm (5½ × 9 in.). Courtesy of The Museum of Fine Arts, Boston, Mass.

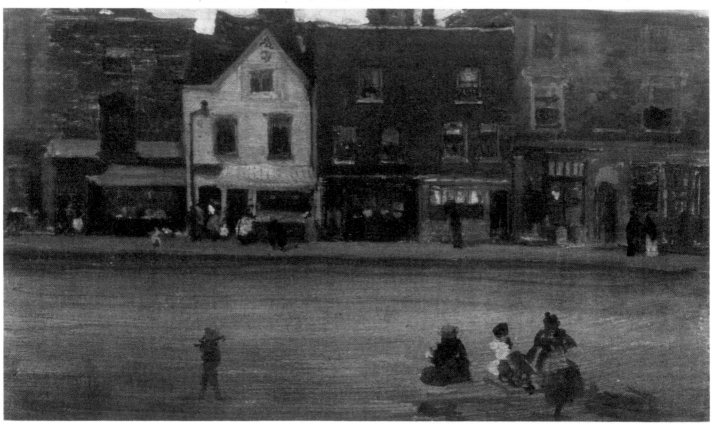

115 Paul Maitland, *Kensington Gardens*, c. 1898, oil, 26.0 × 46.0 cm (10¼ × 18⅛ in.). Ashmolean Museum, Oxford.

one of involvement and delight. In contrast, the Maitlands are wistful and distant. The tones are cooler, are applied more slowly and with less casual sparkle.

It was probably his reticence that prevented Maitland from meeting and becoming friendly with Whistler. He exhibited rarely. He did not show with the RSBA, though he did submit to the NEAC from 1888, and was included in this 'London Impressionist' group in 1889.

Another of this gathering whose connection with Whistler himself was not particularly close on a personal level was P. W. Steer. He had travelled to Paris in 1882, where he found himself among that group of English and American students that included John Lavery, William Stott of Oldham and Edward Stott. They seem to have remained fairly isolated from Impressionism. Steer's early development reveals no consistent interest in any particular style and when he left France in the summer of 1884, it was because of his failure to pass a compulsory examination in French at the Ecole des Beaux-Arts: an indication of the insularity of his way of life in Paris. On his return to London he began to frequent Whistlerian circles. He was not a dedicated follower, however; the work he showed during these years revealed his exploration of many different ideas. His contributions to the 'London Impressionists' were particularly interesting. Two of these, *Knucklebones* and *The Beach, Walberswick*, presented his favoured seaside subjects. The surface of the former is thickly matted, with touches of brilliant colour; almost a tapestry-like effect. A painting of the latter subject is now in the Tate Gallery, London, under the title *Three Girls on a Pier, Walberswick* (Plate 116). It is dated 1891, but is very heavily worked and numerous studies of this broad curve of shingle can be found in sketchbooks datable not later than 1889;[14] it seems likely that this or a related study was the painting exhibited. There are touches in the sea and sand of complementary

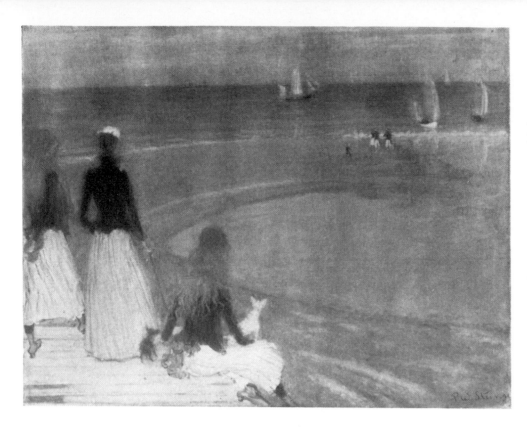

116 P. W. Steer, *Three Girls on a Pier,
Walberswick* (or *The Beach at
Walberswick*), *c.* 1888–91, oil, 61.0 ×
76.2 cm (24 × 30 in.). Tate Gallery,
London.

117 P. W. Steer, *Girls Running:
Walberswick Pier, c.* 1889–94, oil, 63.5 ×
91.4 cm (25 × 36 in.). Tate Gallery,
London.

colours, applied with soft, dotting brush over a broadly painted base. The charm of details such as the shoes, the little dog, the figures on the distant shingle, play against the broad curve of the water sweeping in from the right. The figures are still, simplified into patterns touched with brilliant tendrils of hair or dress. The fascination for bright red hair is strongly Pre-Raphaelite in flavour. There is much in this of the growing sympathy for the pensive, slightly decadent qualities that now came under the banner of Pre-Raphaelitism; qualities being increasingly discussed on both sides of the Channel.

This strange aura emanates also from the *Girls Running: Walberswick Pier* (Plate 117). Signed and dated 1894, it is, again, very heavily worked, the encrusted paint probably representing successive experiments. Besides the bold colour, one is struck by the twin figures, posed for ever as they run. They recall no painter as strongly as Georges Seurat; the tiny figure of a girl running on the right of *La Grande Jatte* is almost identical, though reversed.

La Grande Jatte was sent to the *avant-garde* exhibiting body Les xx in 1887 (Plate 118). Sickert, too, had been invited to show this year. There can be no doubt that the attention of his friends, including Steer, must have been directed to the exhibition.[15] There is no evidence to suggest that Steer himself went to Brussels to see the show; but there is no reason why he should not have made a brief, unrecorded trip. And whether he did or not there is evidence that Neo-Impressionism did create something of a stir in the Whistlerian circles in London at this time. According to

118 Georges Seurat, *Sunday Afternoon on the Island of La Grande Jatte*, 1884–6, oil, 205.7 × 305.8 cm (81 × 120⅜ in.). Courtesy of The Art Institute of Chicago; Helen Birch Bartlett Memorial Collection.

119 P. W. Steer, *Lady in Grey: Mrs Montgomery*, 1887, oil, 182.8 × 91.4 cm (72 × 36 in.). City Art Gallery, Bristol.

the humorously naïve Menpes, the 'followers' 'became prismatic . . . We began to paint in spots and dots; we painted also in stripes and bands.'

Rather more serious evidence of this interest emerges from a meeting between Lucien Pissarro and Steer in May 1891, at a Symposium organized by the Art Workers' Guild. Lucien wrote to his father of Steer, that 'he divides his tones as we do, and is very intelligent.'[16] In both 1889 and 1891 Steer and Seurat exhibited at Les xx. And D. S. MacColl reluctantly admits that at least one painting, *Procession of Yachts*, now also in the Tate, executed in 1893, had caught a 'passing infection' from the Neo-Impressionists.

It seems likely that the extent of Seurat's influence on that group of artists surrounding Whistler in the late 1880s and early 1890s has been underestimated. Steer, at least, was apparently fascinated by Seurat's methods, though he had taken little notice of the native developments when he was in France. He did not attempt to approach Seurat in his scientific analysis of tone, but he did capture something of the latter's evasive, still poetry: qualities that Whistler himself must have isolated.

The direct impact of the work of Whistler himself is more apparent in paintings executed during the winter, in the studio, than in these summer sketches at the seaside. It was the qualities of enigmatic poetry that again caught Steer's imagination. The dignified, low-toned *Lady in Grey* recalls some of Whistler's portraits, though there is a pensive, almost melancholy quality peculiar to Steer (Plate 119). Bruce Laughton reasonably suggests that this was the work shown at the Grosvenor in 1887 as *Portrait of a Lady*.[17]

At the London Impressionists Steer showed a portrait of '*Pretty Rosie Pettigrew*', just one of several portraits of the same model which date from this time.[18] She reappeared at the NEAC in April 1890 in *Jonquil*, where she is posing in front of a window with a strong shadow cast on the frame (Plate 120). The whole pattern is tightly knit, clearly articulated, and recalls, in its structure and its emotional intensity, Whistler's early portraits of Jo. It also manifests some of those evasive qualities of passion and sensuousness to be found in Whistler's later paintings of young girls.

It appears to be from about the time of the 'London Impressionist' show until the mid nineties that Steer was working most closely to Whistler. His work reveals an increasing sensitivity to colour and tone, an increasing sensuousness of touch. It is also quite clear that he was beginning to make frequent references to French Impressionism and Neo-Impressionism, references perhaps encouraged and directed by the example of Whistler himself.

It is worth taking a glance at one more painter, fascinating and elusive, who followed his early training in France with a devoted admiration for the work of Whistler. Arthur Studd was one of a group of artists who had initially studied at the Slade, and established themselves through exhibitions at the NEAC. He had had a spell in Paris, at the Académie Julian in 1889, and had from there travelled to Le Pouldu, Brittany, in 1890. While in Le Pouldu Studd seems to have met both Gauguin and Meyer de Haan.[19]

Studd probably joined the circle of Whistler's close friends in about 1894. There are one or two letters dating from that year, and in one Studd refers to 'the great artistic debt that I am proud to acknowledge'.[20] Something of this debt is manifest in the small panel painting *Washing Day* (Plate 121). There is much in this of the strong, articulate patterning of Gauguin. The touches of paint are firm and sometimes dry. The colour is very brilliant. Yet Whistler's influence is also revealed in the delicacy of the brushwork in the sky, the glow of the red wood panel through the thin paint of the lower areas.

120 P. W. Steer, *Jonquil* (or *Jonquils*), *c*. 1889–90, oil, 91.4 × 91.4 cm (36 × 36 in.). Private collection.

Of all the letters written by Studd to Whistler, the most fascinating is one written from Papeete, Tahiti, in 1897. In this Studd actually exhorts Whistler, whom he addresses as 'cher maître', to join him:

> there are amazing things to paint—women who walk like goddesses—splendidly proportioned youths sitting in the moonlight, crowned with garlands, where palms wave in the background like huge black plumes against the sky . . . We have had beautiful cloudy weather ever since my arrival a month ago and the day would be for you full of sea pieces and the night of nocturnes. . . .[21]

The fascinating combination of stimuli from Gauguin and Whistler lends Studd's art both subtlety and precision. He seems to have emulated Whistler in his exploration of several different media; he exhibited paintings, pastels, drawings and etchings. His submissions to the NEAC reflect immediately his visits first to Brittany then to the South Seas and Venice. Some of his Venetian paintings are the most Whistlerian, executed on small panels in delicate and subtle colour. These are usually dated to the mid 1890s, though the fact that no Venetian painting seems to have been shown before about 1907 would cast doubt on this. It is likely that he travelled quite extensively between about 1903, after Whistler's death, and 1908. The best of these panels have a delicacy, a control, a joy in working, which echo Whistler's own (Plate 122).

It is clear that by the 1890s Whistler's influence was widespread. Perhaps its most important effect was to challenge insularity; to encourage enquiry. This attitude is

121 Arthur Studd, *Washing Day*, c. 1894, oil on wood panel, 21.6 × 15.9 cm (8½ × 6¼ in.). City Art Gallery, York.

reflected in the Society of which he became President in April 1898: the International Society of Sculptors, Painters and Gravers.

Whistler was assisted in his initial attempts to organize the International Society by E. A. Walton. One of a group of painters from Glasgow who much admired Whistler,[22] Walton had left Scotland to become a neighbour in Cheyne Walk in 1893. The two approached, in vain, both the Grosvenor and the Grafton Galleries. They must have had more success in interesting other painters, however, for the first council meeting was held at the Prince's Skating Rink, Knightsbridge, on 23 December 1897. It was here that the exhibition was to be held; at first sight a bizarre location, but it was large and fashionably central. Much of the organization was conducted by the Vice-President of the Society, John Lavery, another artist from Glasgow who owed much to Whistler. The latter was spending most of his time in Paris, but the progress was reported to him in detail, and his ultimate control was never in doubt.

122 Arthur Studd, *Venetian Twilight*, *c*. 1903–8, oil on wood panel, 12.7 × 21.6 cm (5 × 8½ in.). City Art Gallery, York.

Whistler was very keen to display much foreign work at the first exhibition, which opened in May 1898. He looked particularly to France. Durand Ruel promised paintings by Degas, Manet and Monet. Other French exhibitors included Toulouse-Lautrec, Fantin, Puvis de Chavannes and J. E. Blanche. Engravings and designs were submitted by many; among them Edouard Vuillard, Pierre Bonnard, Alfred Sisley, Pierre Auguste Renoir and Odilon Redon.

One of the most important paintings shown was Manet's *Execution of the Emperor Maximilian*. Whistler took particular delight in this, and it was through his efforts that it was secured for the show. Opposite it hung the *Vagabond Musicians* by the same artist.

The international exhibitions were organized under Whistler's presidency until his death in 1903, and they included an increasingly representative selection of work from many countries. Artists from Scotland and England were, of course, well to the fore. Whistler's influence was prevalent. He felt sufficiently secure to demand a ruling that no member of the Exhibition Council should also be a member of another artistic institution.[23] J. J. Shannon, an artist for whom the 'master' came 'above other men', went so far as to abandon the Academy. Whistler declared this 'the most brilliant incident of the season.'[24]

Others also appeared in force. In 1899 Pissarro, Sisley, Renoir and Monet all showed. Some of the most enigmatic, most exciting of the Symbolist group—Gustav Klimt, Félicien Rops, Giovanni Segantini, Fernand Khnopff—sent work. The Society further carried out its original aims by holding exhibitions far afield, including the United States and Germany. In 1905 it put on a major memorial show of Whistler's work which was acclaimed by Press and public.

The whole organization of the Society had given Whistler the opportunity to

demonstrate at last the destruction of British insularity and to enable the public to see contemporary national artistic developments in their context. It gave him the chance to exercise a power of controlling the whole character of the exhibitions, without the constant wranglings and ultimate rejection he had experienced with the Society of British Artists. He was now working from a position of influence, a position which could not easily be undermined by opposition or criticism. He had found in France, and in England too, intelligent followers and sensitive critics. The New English Art Club had been set up to cater for that group of artists which was looking to France, encouraged by Whistler's own admiration for French art. The school he opened in Paris in the autumn of 1898, the Académie Carmen, though short-lived, attracted students on an international basis. The International Society was the conclusive statement of Whistler's broad, enquiring, cosmopolitan approach.

11 *Writers and Critics: the Impact of Whistler*

Whistler attracted the attention of his contemporaries not only by the products of his brush or engraving needle. His writings, too, were an important part of his activities. He considered them of sufficient merit to be gathered together and republished in *The Gentle Art of Making Enemies* in 1890. And though his notes and articles now appear somewhat thin and over-dressed at times, the fact that they had the social success denied, on the whole, to his paintings, cannot be ignored. They had an impact both on the general public and on Whistler's close associates. Not only did they do much to convey Whistler's consciously developed theories concerning art and the position of the artist in society; they also set a pattern of interest in both painterly and verbal expression of ideas among his followers and admirers. But it was not only those close to Whistler who were impressed by his writings. His insistence that a work of art should have an integrity without reference to the value of its subject; his consistent exploration of the expressive qualities of his media; his use of musical terminology to convey his concepts—all these appear as the fundamental beliefs of writers who may not have had a close connection. In fact even when the reputation of Whistler's paintings suffered after his death, when they paled beneath the glare of Post-Impressionism, the influence of his concept of painting was still pervasive.

As an indication of the pattern of opinion concerning Whistler's painting, it is worth examining the evaluation of one of his close followers, one who made a sizable contribution to the field of criticism: Walter Sickert. He embarked upon his writing career initially in support of Whistler, and, as we have seen, by 1889 in the preface to the London Impressionist catalogue, he was expressing views that were almost entirely conditioned by him. His interest in French painters was encouraged by Whistler and his choice of those he particularly admired, Degas and Manet, must have been directed from the same source. His interpretation of Impressionism, his affection for the daily sights of London, were clearly influenced by Whistler. Indeed, his attitudes and opinions in these early years were largely formed by his friendship with the older artist.

After Whistler's death the popularity of his work suffered a decline. The appearance of those doggedly researched tomes, the Pennells' two volumes of the *Life of James McNeill Whistler*, in 1908, did little to revive it.[1] By 1910, Sickert specifically published a rejection of his former master, 'Abjuro': 'The truth is that in our honest enthusiasm to see Whistler get his due, we succeeded in starting a snowball which became as much bigger than the truth as it began by being short of it.'[2] It was the delicacy and the 'tastefulness' of Whistler's painting that caused Sickert, and others, to reject it at this time. The impact of the French had created a desire for something tougher, altogether more assertive: 'The more our art is serious, the more will it tend to avoid the drawing room and stick to the kitchen. The plastic arts are gross arts, dealing joyously with gross material facts . . . they fade at a breath from the drawing room.'[3]

By the mid 1920s, however, when the furore caused by Post-Impressionism had once again died down and the painter was allowed back into the drawing room,

Sickert found himself able to look at Whistler's work with something of his old fervour: 'The beauty of Whistler's painting was that he achieved its form purely by relations, considered as opaque, between a restricted number of tones. This . . . is so rare that only the great painters can do it.'[4] This assessment echoes—or records— the general development of Whistler's popularity. Yet despite the differences and the criticisms, the central fact remains that whereas in the last decades of the nineteenth century theme and meticulous approach to naturalistic detail were the two important criteria of artistic judgement, in the first decades of this century the ability to exploit the media with subtlety and vigour, and the recognition of much more abstract qualities in a work of art, became more important.

Any choice of individual writers and critics to illustrate this change is bound to be somewhat arbitrary. Perhaps among the most significant in conditioning and stimulating the development of critical attitudes in the early years of this century were D. S. MacColl, George Moore, R. A. M. Stevenson and Roger Fry:

> The painters grouped round the New English had been straining at the leash for some years, but had little or no chance with the press when, suddenly, an attack on orthodox art came from unexpected quarters: first from the *Spectator*—a most respected organ—due to MacColl, who had not long been appointed its art critic, and then from George Moore in the columns of the *Speaker*.[5]

D. S. MacColl was art critic on the *Spectator* from 1890 to 1896, then moving to the *Saturday Review* until 1906, at which date he became Keeper at the Tate Gallery. These positions of vantage he used to the full, exploiting them with his firm and vigorous personality. His influence was substantial precisely because he was never extreme, because he presented his arguments with moderation; and because, at the same time as being what Alfred Thornton described as a 'revolutionary art critic', he before long appeared well on the way to fitting himself satisfactorily into an official mould.

Trained initially as an artist, he was familiar with such individuals as Sickert and Steer, and for the latter in particular he had a great and abiding admiration. MacColl did not always agree with Whistler. He was not happy with the extremes to which many of Whistler's followers had turned in their rejection of subject-matter; despite the fact that he was one of the first critics to come out strongly against Ruskinian notions of literary painting, MacColl retained a fascination for a literary theme. But the two men seem to have got on well together in spite of their differences, MacColl making several visits to the artist in Paris in the 1890s. Both from this direct contact and from frequenting the circles of the NEAC—at which he exhibited in the spring and autumn of 1892[6]—the writer must have absorbed much from Whistler.

In the *Spectator* and the *Saturday Review* MacColl presented his ideas through numerous reviews of exhibitions, discussing the NEAC; the portrait painters at the Grafton Gallery; Manet; the International Society shows; and many such topics. The tenor of these was summed up in his survey of *Nineteenth Century Art* which he published in 1902. Whistler was discussed at length, together with some of his associates:

> paint came by its rights again, claimed a share in determining subject, refused to be strained and worried to cover all that to the mind is interesting in visible things . . . In the painting of Courbet, Whistler, Manet—there revived a delicate kindness for the material . . . for the easy, unforced flowering of its own nature.[7]

This sympathy with the materials used became the theme of MacColl's arguments and directed all his critical judgements. He introduced musical terminology to explain: 'each form of the . . . arts . . . has its own limited best notes, is not a register that gives indifferently well all visible appearances . . . The painting of nature is not

always compatible with the nature of paint.'[8] He had great respect for the dignity of technique, of considered form and pause, and this is what he understood in Whistler's work.

Even in later years, when MacColl's opinion of Whistler had changed somewhat, when he interpreted the artist's work more in terms of a romantic longing for escape,[9] it was nevertheless a Whistlerian concept of art which still dominated the critic's consciousness. He still spoke of the 'music of space and form'. He firmly differentiated between the two languages of paint and speech. He attacked those who demanded subject-matter 'noble' in character, and deemed this a 'very childish and very simple . . . view of things', revealing 'a disregard of the range of notes from which an emotional effect of a high order may be struck out'.[10]

George Moore, like MacColl, made his mark as a supporter of the NEAC. He had produced a substantial amount of critical writing in the 1880s, but probably did not make a great impact until the 1890s. Moore had been to Paris in 1872, where he attended the Ecole des Beaux-Arts and the Académie Julian, and got to know Pissarro, Manet and Degas. Here, too, he became familiar with the work of writers beloved of Whistler: Baudelaire, Gautier, Verlaine and Poe. In his *Confessions of a Young Man*, published in English in 1888, he made some general statements on the meaning of art: 'Nature is not the end and aim of art. —She is, at most, the means to an end'[11] —a Whistlerian statement that contradicts those who demand literary essays in their pictures.

Once again Moore's ideas are nicely encapsulated in a book, *Modern Painting* which he published in 1893. In discussing Whistler he admitted that the painter had helped to purge art of the vice of subject. He admired the *Firewheel* Nocturne. Yet, despite his sympathy with the Nocturnes and most of the earlier work, he perpetrated that notion which conditioned so much of the contemporary attitudes towards Whistler and described his work as the outcome of nervous tension and physical weakness.

One aspect of Moore's criticism that slowly emerges is that very often he isolates precisely those elements of a painting that are novel and individual. He recognizes that Whistler's art is preconceived; that it depends upon delicately gradated tonal developments; that his handling of materials is masterly; that in the portrait of Carlyle references to nationality, rank, manner of life have been purged. Yet he concludes, after all this, that the artist's work is the hasty outcome of a 'highly strung, bloodless nature'.[12] His discussion of Monet is similar. He admires a 'radiant snow picture'. He specifically selects for discussion one of the contributions Monet made to the development of art in this century: his exploitation of the medium to create a flat, vigorously executed and organized pattern. But he objects to the picture's being 'so much on the surface', and wonders 'why one did not enter into it as one does into a picture by Wilson or Corot?'[13] Similarly he suspects Renoir of 'vulgarity' and Pissarro of perpetrating 'tedious sentimentalities'.

Moore's writings tend to comprise a conglomeration of ideas; sometimes a penetrating insight, sometimes an extraordinary obtuseness. His contemporaries must have been aware of this and perhaps it made his criticism less influential than it might have been. But he was undoubtedly well known. His enthusiasm, moreover, expressed with the same lack of restraint as one finds in his condemnation, must have been infectious. He must, at least, have confirmed the interests of those groups whose attention had already been directed across the Channel by Whistler.

In his book *Impressions and Opinions*, published in 1913, Moore conveys a clear, if naïve, picture of the changes which were taking place in people's attitudes at the beginning of the century:

Father admired the work of the Academician, but . . . Julia's opinions have to be considered for she goes to Camden Town three times a week for lessons in painting, and her advice to her father is that . . . Highland cattle in heavy gold frames are out of place . . . in white painted rooms hung with chintz and muslin;

she suggests . . . etchings in pretty Whistlerian frames for the drawing room.[14] Clearly, the influence of Whistler's art and ideas had percolated through the whole of society.

'This . . . change of front has come about gradually . . . in this country the change has been brought about very largely by the effort of two men, one a painter, the other a critic.'[15] The painter here referred to by Frank Rutter is Whistler; the critic is R. A. M. Stevenson.

Stevenson was yet another who initially visited France, in 1874, to study—under Carolus-Duran—to become an artist. It is interesting and significant that it was men trained to be painters, trained to understand the nature of the artist's media, who at this time became the critics who shaped the taste of both other artists and the general public; it was not social reformers, or men of literature.

Unlike MacColl or Moore, Stevenson did not become a writer who produced a vast amount of work. He did not have a substantial official position. He wrote for the *Magazine of Art* from 1885 and also contributed to the *Saturday Review*. In 1888 he took up the Chair of Fine Art at the University of Liverpool. This was the only time he held any such official position: it was evidently too official for him and he resigned it in 1892. He turned again to journalism and worked for the *Pall Mall Gazette* from 1893 to 1899. He reviewed exhibitions of the International Society, the Royal Academy, the occasional Paris Salon and various London galleries. He was not, apparently, much concerned about the outcome of his criticism. Yet for painters, for that exclusive group of NEAC artists, he expressed more coherently and richly than anyone else in the 1890s the essence of the new attitudes towards art. MacColl recognized his importance. He considered that Stevenson's *Velasquez*, first published in 1895, was the most important contribution to the theory of painting since Ruskin's early *Modern Painters*, full of insight and rich description.

Whatever his theme or his attitude, Stevenson's writing is always warm, lucid and amusing. These qualities are, indeed, most evident in the *Velasquez*. By its very nature this specialized study could not have had a great deal of popular appeal. But there are parts in it that must have done much to define and consolidate the opinions of his peers.

During the 1890s Stevenson frequented the same circles as Whistler. These were years, of course, when Whistler was often talking of Velazquez. The Pennells actually refer to a discussion on Velazquez taking place between Stevenson and Whistler.[16] The two were obviously in sympathy, sharing their enthusiasm. Indeed, in his introduction to the book, Stevenson writes that the 'sympathetic comprehension of a Whistler or a Carolus-Duran is needed for Madrid.' Whistler is frequently mentioned as a standard, and his teachings implicitly introduced. The 'Ten o'clock Lecture' obviously lies behind Stevenson's declaration that 'the growth in art is sporadic . . . Genius is concocted by the momentary accidental commerce of a man and woman.'[17] For Whistler it was just such an accident that had conjured the genius of Velazquez: fate had 'dipped the Spaniard's brush in light and air'. It was not the result of perseverance or devoted moral conviction. It is when looking at technique that Stevenson reveals all his sensitivity. The most significant chapter in the *Velasquez* deals with the 'Dignity of Technique', a title which in itself implies that paint could take on individual character, could present itself in a variety of ways, and could interpret more completely, perhaps, than a subject, the attitudes and state

of mind of its master. The painter's approach to his technique is compared to that of the musician; the precision of relationships has first to be established. Once the artist has the ability to control his medium, he has the freedom to manipulate it.[18] Stevenson's richly evocative descriptions of Velazquez's handling could also embrace Whistler's work. He describes the

> running, slippery touch which . . . at the focus gives colour, pattern, sparkle and underlying form with the utmost precision and completeness . . . the paint is smeared in thin, filmy scales which vary in size, looseness and breadth, with the necessities of the subject and the composition. It is a style founded on the pursuit of more than usually just and subtle modelling, a modelling which changes character with the size of the canvas[19]

About contemporary English art he is largely scathing, reflecting Whistler's belief that the English artist could handle neither colour nor space. He is full of scorn for the 'English stipple of colours', and laughs at those who 'make a tunnel with their hands to shut out everything but the one patch of colour they are matching'. For this inability to discover values and relations of colour, he ultimately places the blame on Ruskin. He is scathing, too, about the aesthete, the sentimentalist, and the artist who 'would show all Browning's work in a face'.

Stevenson's writing is irresistible. All the charm and vigour of his personality emerges with force. Yet he turned to critical journalism through the need to earn a living. His conversation was what his contemporaries most valued, and the influence he exerted must have been substantial.

It is interesting to compare Stevenson's attitudes with those of a critic of the twentieth century, Roger Fry. Fry is principally known as a champion of modern art, and for some years from about 1910 his name was almost as familiar as Ruskin's had been in the second half of the nineteenth century. He too entered his career by training as a painter, both in London, under the Whistlerian artist Francis Bate, and in Paris, at the Académie Julian, from 1892. His London friends William Rothenstein and Alfred Thornton similarly looked to France for their inspiration; all encouraged, no doubt, by their attendance at the evening classes given by Sickert at The Vale. Fry was not noticeably successful as a painter, but achieved recognition as a critic fairly quickly. He joined the *Athenæum* in 1901 and the *Burlington Magazine*, founded in March 1903, from the start included him as a consultant editor. It was a 1905 visit to New York, to seek financial backing for the magazine, which resulted in his being appointed Curator of the Department of Painting at the Metropolitan Museum, New York. He resigned in 1907, but remained an adviser until 1910.

It was in this latter year that he organized the first of two major exhibitions of Impressionist and Post-Impressionist work in England; the second was held in 1912. Both aroused a furore in the Press, particularly the second, which included a substantial selection of work from some of the most *avant-garde*, including Pablo Picasso, Henri Matisse and Wassily Kandinsky. Fry defended these vigorously, revealing especially his great admiration for Paul Cézanne, who satisfied his demands for positive, assertive construction. Because of his concern with a more trenchant abstraction, a solidity of mass and shape, Fry's attitude to Whistler was rather negative, hesitant. Yet he could find qualities that he admired. In 1909 he acquired for the Metropolitan Museum Whistler's portrait of Théodore Duret, *Flesh Colour and Black*. He writes to the Museum Director, from Paris:

> It is . . . one of the solidest and soundest works he did . . . The background is a grey warm neutral of a wonderful quality. It has a faint echo of the dull-rose of the domino . . . The domino is dull-rose with exquisite notes in the half tones and the face introduces a single note of positive red.[20]

Whistler forces even Fry to look closely at qualities of subtle handling and tonal composition. Besides writing, Fry in the 1920s began broadcasting, taking among his themes the 'Symphony of Line and Colour' and the 'Relations of Volume and Space'. Yet again one finds musical terminology introduced. And it was by a sympathetic appreciation of musical parallels that Fry could defend one of the most revolutionary artists to be included in the Allied Artists' Exhibition, held at the Albert Hall in 1913. Of Kandinsky's 'Improvisations' he writes: 'the forms and colours have no possible justification, except the rightness of their relations . . . these improvisations . . . are pure visual music.'[21] Fry introduced artists who would undoubtedly have horrified Whistler. Nevertheless, the whole basis of his judgements depended upon an analysis of form, pattern, colour developments, which must have owed something to Whistler.

MacColl, Moore, Stevenson and Fry were all effective and vigorous voices. They did not all like Whistler's painting. Yet their attitudes, their tastes, their criteria for judgement undoubtedly illustrate the extent of the changes which had taken place towards the end of the nineteenth century. By 1911 one writer, Frank Rutter, could declare, 'Nowadays it is hardly an exaggeration to say that no person of education takes the art criticisms of Ruskin very seriously, but in 1877 he was generally considered the arbiter of British art.'[22]

It cannot be doubted that the work and ideas of Whistler were among the most significant influences to effect this change. As we have seen, after the turn of the century, attention was grabbed by Post-Impressionism. Encouraged by one or two apostolic critics, artists of the *avant garde* applauded its rigour and boldness. The reticent dignity of Whistler's art appeared totally reactionary, while the extravagantly undignified episodes in his life were remembered with delight. Yet it was Whistler who had created the precedent of independent thought in England. It was he who had brought into question the authority of the Ruskinian concept of the role of art in society; he who had broken the barriers of English insularity, and directed attention to the rich possibilities of art and ideas to be found across the Channel. Behind the sometimes irritating refinement of style and manner he was an artist uncompromising both in the demands he made upon the materials used for individual works, and in his examination of the purposes of the artist. He encouraged the exploration of ideas fundamental to much of the art of the twentieth century: the abstract qualities of handling, form and colour, and the redefinition of the relationship between the artist and society. With the elegant phrases of the 'Ten o'clock Lecture' he makes his position clear:

> . . . the artist is born to pick, and choose, and group with science . . . that the results may be beautiful—as the musician gathers his notes, and forms his chords, until he brings forth from chaos glorious harmony.
>
> That Nature is always right, is an assertion, artistically, as untrue, as it is one whose truth is universally taken for granted. . . .
>
> False again, the fabled link between the grandeur of Art and the glories and virtues of the State. . . .
>
> Let us reassure ourselves, at our own option is our virtue. Art we in no way affect.
>
> A whimsical goddess, and a capricious, her strong sense of joy tolerates no dullness, and, live we never so spotlessly, still may she turn her back on us.

Notes to the Text

1. Early Years: Training, Contacts and Influences (pp. 6–26)

1. E. R. and J. Pennell, *The Life of James McNeill Whistler*, London 1908, vol. 1, p. 47.

2. Charles Clément, *Gleyre*, Paris 1878, p. 174.

3. *Mademoiselle de Maupin* was published in Paris in 1835. Gautier declared in the preface, 'The great moral pretension which reigns at present is completely laughable . . . This book is dangerous, this book recommends vice.' *Scènes de la Vie Bohème* was first published, serially, in Paris in 1847–9.

4. Whistler, recognizing himself in the idle 'Joe Sibley', brought an action against du Maurier. The character was removed from the book, also published in 1894.

5. Even Albert Boime in his thorough and interesting discussion of Gleyre's *atelier* does no more than indicate that Whistler's 'relationship to Gleyre may have been more decisive . . . than his relationship to the pupils of Lecoq de Boisbaudran.' He adds that Whistler's care over the preparation of the palette and his love for a grey tonality must also come from Gleyre. See Albert Boime, *The Academy and French Painting in the Nineteenth Century*, London 1971, pp. 61, 63.

6. For a full discussion of the reforms of 1863 and the implications of the demands for originality, see Albert Boime, *Academy and French Painting*, p. 181.

7. Pennell, *Life*, 1, p. 72.

8. See Adolphe Jullien, *Fantin-Latour*, Paris 1909, p. 152.

9. Quoted from Gustave Courbet, 1866—an autobiographical note, now in the Bibliothèque Nationale, Paris. Georges Boudaille, *Courbet*, Greenwich, Connecticut 1969, p. 13.

10. Jonathan Mayne (ed. and trans.), *Charles Baudelaire. Art in Paris 1845–62. Salons and other Exhibitions*, London 1965, p. 47.

11. *La Mère Gérard* was, according to Whistler, the first original picture he painted in Paris. (Pennell, *Life*, 1, p. 73.) It seems likely that the painting was worked on before the meeting with Fantin and the encounter with Courbet, for the influences most strongly apparent are those of Rembrandt and Géricault. Courbet's bold and vigorous stimulus is much more evident in the *Head of an Old Man Smoking*.

12. Marcel Guérin (ed.), *Degas' Letters*, trans. M. Kay, Oxford 1947, p. 235.

13. In 1858 Thoré Bürger had chastised the ill-considered and confused use of the terms 'Dutch' and 'Flemish', especially when applied to the seventeenth century.

14. It is interesting to note that in Henri Murger's *Scènes de la Vie Bohème* a group of four young art students gather themselves together in a similar way.

15. Legros first obtained charge of the engraving class at South Kensington. In 1876 he succeeded Poynter at the Slade and made a successful career there until in 1894 he was, in turn, superseded by Fred Brown.

16. Pierre Courthion and Pierre Cailler (eds.), translated by Michael Ross, *Portrait of Manet by Himself and his Contemporaries*, London 1960, p. 16. Letter dated 26 August 1868.

17. Fernand Desnoyers, a critic friend of Courbet's, described the impression made on the group of friends by the *Guitarrero*: painted in a certain strange new way of which the astonished young painters thought they alone had the secret, a kind of painting midway between that called realistic and that called romantic . . . It was decided then and there by this group of young artists to go in a body to Manet's.

. . . They did not limit themselves to this first visit.

G. Heard Hamilton, *Manet and his Critics*, New Haven 1969, p. 27. There are other references to the devotion of Whistler, Fantin and Legros. See Courthion and Cailler, *Portrait of Manet*, pp. 42, 65. This close contact between Manet and Whistler at such an early stage is significant and must, without doubt, have done much to encourage in Whistler the development of his innate sensitivity to the richness and sensuousness of his media.

18. Among the more recent analyses of the problem one might look at: E. Scheyer, 'Far Eastern Art and French Impressionism', *The Art Quarterly*, vol. 6, spring 1964, pp. 117–42; J. Sandberg, 'The Discovery of Japanese Prints in the Nineteenth Century before 1867', *Gazette des Beaux-Arts*, May–June 1968, pp. 295–302; J. Sandberg, 'Japonisme and Whistler', *Burlington Magazine*, November 1964, pp. 500–507; J. de Caso, 'Hokusai Rue Jacob', *Burlington Magazine*, September 1969, p. 562.

19. J. Crépet (ed.), *Œuvres de Charles Baudelaire. Correspondance*, Paris 1948, vol. 4, pp. 33–4. Further information suggesting that Japanese prints were certainly known in Paris by 1861 is given by J. de Caso in the *Burlington Magazine* of September 1969, p. 562.

20. In the *Spectator*, 1 February 1896, there is an interesting article, 'The American Share in Opening up Japan'.

21. Library of Congress, Washington, Pennell Correspondence, vol. 285, no. 3152.

22. Léonce Bénédite, *French Artists of our Day. Gustave Courbet*, London 1912, p. 79. There does not seem to be much trace of these early paintings.

23. See Pennell, *Life*, 1, p. 118.

24. Adolphe Jullien, *Fantin-Latour*, p. 63.

25. W. M. Rossetti, *Dante Gabriel Rossetti. Letters and a Memoir*, London 1895, vol. 11, p. 180. Letter dated 12 November 1864.

26. 'Letters of Whistler's Mother', *Atlantic Monthly*, September 1925, p. 319. Letter dated 10 February 1864.

27. Paul Mantz, *Gazette des Beaux-Arts*, 1 July 1865. Fantin's painting was, in fact, destroyed by the artist, but the head of Whistler was preserved.

2. The White Girl (pp. 27–52)

1. Daphne du Maurier (ed.), *The Young George du Maurier, Selection of his Letters 1860–67*, London 1951, p. 105. Letter dated February 1862.

2. Pennell, *Life*, 1, p. 97.

3. Léonce Bénédite, 'Whistler', *Gazette des Beaux-Arts* XXXIII, June 1905, p. 507.

4. Fernand Desnoyers, *La Peinture en 1863: Le Salon des Refusés, par une Réunion d'Ecrivains*, Paris 1863.

5. The date of the quotation must be about 1861, for Proust

mentions that Manet had just painted the *Guitarrero*. Courthion and Cailler, *Portrait of Manet*, p. 42.

6. This is just the fourth stanza of Swinburne's poem 'Before the Mirror', which was reshaped from three or four stanzas of 'A Dreamer', 1862.

7. When enclosing the poem for Whistler, Swinburne declared, 'I know that it was entirely . . . suggested to me by the picture, where I found . . . the metaphor of the rose and the notion of sad and glad mystery in the face languidly contemplative of its own phantom . . .' C. Y. Lang (ed.), *The Swinburne Letters*, New Haven and London 1959, vol. I, p. 120. Letter dated 2 May 1865.

8. Hamerton's article is dated 1 June 1867. Whistler's reply was by letter, not published in the *Art Journal* until 1887.

9. See W. M. Rossetti, *Rossetti Papers 1862–1870*, London 1903, p. 229.

10. Bénédite, *Gazette des Beaux-Arts* XXXIV, 1905, p. 154.

11. There is also the suggestion that Degas might have made his copy from the painting, which was in Paris, in the house of Whistler's brother, early in 1867. The carefully contrived pose, the languid attitudes and the flattened space of *Mlle Fiocre* certainly indicate that the two painters were exploring similar means of expression at this time. Theodore Reff, *The Notebooks of Edgar Degas*, Oxford 1976, notebook 20, p. 17.

12. Bénédite, *Courbet*, p. 76.

13. Glasgow University, Birnie Philip Collection II, C/64 176. Letter dated 14 February 1877.

14. Bénédite, *Gazette des Beaux-Arts* XXXIV, p. 232.

15. Bénédite, *Gazette des Beaux-Arts* XXXIV, p. 233.

16. W. M. Rossetti noted in his diary on Tuesday, 26 March 1867, 'Gabriel has received the Botticelli (female half figure) which he bought at Christie's (Colnaghi's sale) the other day for £20.' Rossetti, *Papers*, p. 228.

17. These classical terracotta figurines dating from about 300 B.C. were appearing in the British Museum and in private collections at this time. In the Glasgow University Collection of Whistleriana there is an album of photographs of figurines which were in the Ionides collection. On one blank page Whistler has even made a copy of the statuette opposite. It is interesting that there is in the Pennell Collection in Washington a photograph of Whistler and a group of friends in his London studio, Tite Street, 1881. In the background is a small statuette of a figure, apparently painted, and about one foot high. She stands with the grace of a Tanagra figure, though dressed in modern costume. According to Frederick Lawless, who sent the photograph to the Pennells, the figure was modelled by Whistler himself. There is no evidence of any further venture into this field, but this was a time when Whistler was experimenting with all sorts of media and the statue does have the elusive grace of some of his portraits of the period. Library of Congress, Washington, Pennell Correspondence, vol. 291, no. 2740. The photograph is reproduced by Pennell, *Life*, II, p. 10.

18. Glasgow University, B.P.II, M/98. Letter dated 19 July 1870.

19. A. C. Swinburne, 'Some Pictures of 1868', *Essays and Studies*, London 1875. The reference to Gautier is interesting. It emphasizes the awareness in Whistler's circle in England of ideas fermenting in Paris.

20. Of the six schemes only one, the *Symphony in White No. 4*, seems to have been exhibited in Whistler's lifetime. In a catalogue of oil pictures prepared by Bernhard Sickert the remaining five in the group are noted as sketches. Bernhard Sickert, *Whistler*, London [1908], p. 154.

21. Glasgow University, Revillon, w/118. The letter is datable to about July 1868.

22. Swinburne writes, 'In one, a sketch for the great picture, the soft brilliant floorwork and wall work of a garden balcony serve . . . to set forth the flowers and figures of flower-like women.' Robin Spencer, in his M.A. thesis, 'James McNeill Whistler and his Circle. A study of his work from the mid 1860's–mid 1870's', London 1968, relates this to the *Balcony*. He supports this by referring to the squared-up sketch for the picture at Glasgow University. Whistler certainly did plan a full-size version of the *Balcony*. Swinburne, however, here states that 'in two of the studies the keynote is an effect of sea.' He goes on to describe the 'sketch for the great picture', which, he indicates, is not set against the sea, for a garden balcony serves 'in its stead' as a background for the figures; I would suggest that this is the setting for the *Symphony in White No. 4*. It is undoubtedly characteristic of this period of anxiety that Whistler should make several attempts at this sort of full-scale realization of his ideas.

23. Val Prinsep, 'A Collector's Correspondence', *Art Journal*, 1892, p. 252.

24. Pennell, *Life*, II, p. 130.

25. Rossetti, *Papers*, p. 229. Dated Sunday, 31 March 1867.

26. Clifford Addams, writing to the Pennells in 1912, makes this suggestion. Library of Congress, Washington, Pennell Correspondence, vol. 278. The Pennells also describe Whistler's house as 'full of Japanese dolls' in the early 1860s. Pennell, *Life*, I, p. 109.

27. Bénédite, *Gazette des Beaux-Arts* XXXIV, p. 155.

3. The Nocturnes (pp. 53–76)

1. The photographs in the Pennell Collection, Library of Congress, Washington, are interesting in their range and variety. Many of them are reproduced in their biography of the painter. There are a few which would appear to have been of quite early Nocturnes, but many are now so faded as to be quite unrecognizable.

2. Pennell, *Life*, I, p. 100.

3. Photographs by Hedderly are now kept in the Chelsea Public Library, London.

4. See 'Current Art Notes', *Connoisseur*, January 1931. For this reference I am indebted to Ronald Pickvance.

5. Library of Congress, Washington, Pennell Correspondence, vol. 281, no. 657.

6. There are several reasons why Whistler might have felt it desirable to leave London at this time. The arrival, in the spring of 1865, of his brother, just returned from fighting in the American Civil War, is bound to have made him feel restless. But there are also indications that the beautiful Jo was becoming something of a problem. See, for example, Daphne du Maurier, *George du Maurier, Letters*, p. 227. The Pennells give a lengthy account of the trip, as Whistler had described it to them. *Life*, I, pp. 134–6.

7. Lang, *Swinburne Letters*, I, p. 52. Letter dated 1 February 1866.

8. The will was drawn up on the last day of January 1866 and witnessed by his solicitor, J. Anderson Rose. Library of Congress, Washington, J. Anderson Rose Correspondence, letter 39.

9. Rossetti, *Papers*, p. 196. Dated 2 November 1866.

10. Library of Congress, Washington, J. Anderson Rose Correspondence, letter 49. Letter dated 14 May 1866. Even earlier than this, in 1865, George du Maurier was writing to Thomas Armstrong, admiring not only Whistler's *Two Little White Girls*, but also 'many a scape of sand and sea and sky which he hath lately wrought on some distant coast'—presumably work produced at Trouville, with Courbet. Daphne du Maurier, *George du Maurier, Letters*, p. 266.

11. Rossetti, *Papers*, p. 222. Dated 5 February 1867.

12. For Walter Greaves's account of Whistler at work, see Pennell, *Life*, I, p. 146.

13. Miss A. L. Merritt, writing in 1907 to the Pennells, is only one of several people who described 'seeing the Nocturnes set out along the garden wall to bake in the sun'. Pennell, *Life*, I, p. 165.

14. Val Prinsep, 'A Collector's Correspondence', *Art Journal*, 1892, p. 252.

15. J. A. Mahey, 'The letters of James McNeill Whistler to George A. Lucas', *Art Bulletin*, September 1967, p. 247.

16. Eugène Delacroix, *Revue de Paris*, May 1829. Reprinted New York, December 1946.

17. Théophile Gautier, *L'Art Moderne*, Paris 1856, p. 143.

18. 'Now the days are coming when, throbbing on its stalk, each flower sheds its perfume like a censer; the sounds and perfumes spiral in the evening air, in a melancholy waltz, a slow, sensual gyre.' Francis Scarfe (ed. and trans.), *Baudelaire*, Middlesex 1968, p. 143.

19. *Complete Poems and Stories of Edgar Allan Poe with Selections from his Critical Writings*, intro. A. H. Quinn, New York 1946, p. 1027.

20. *Lyrical Poems of Edgar Allan Poe*, intro. A. Symons, London 1906, p. viii.

21. Edgar Allan Poe, *Poetical Works*, London 1858, p. 227.

22. Walter Pater, *The Renaissance—Studies in Art and Poetry*, London 1910, p. 238.

23. *The Letters of A. C. Swinburne: with some Personal Recollections* by Thomas Hake and Arthur Compton-Rickett, privately printed London 1918, p. 20. Letter dated 28 November 1869.

24. Théodore Duret, *Histoire de James McN. Whistler et de son Œuvre*, Paris 1904, p. 176.

25. Edward Lockspeiser, 'Chabrier, Debussy and the Impressionists', *Apollo*, January 1966, p. 10.

26. Library of Congress, Washington, Pennell Correspondence, letter 4226.

27. It is interesting that on one occasion when Whistler gave a painting a very specific musical title, *Symphony in B sharp*, he seems to have regretted it. Library of Congress, Washington, Pennell Correspondence, vol. 282. Letter dated 16 August 1908.

28. Glasgow University, B.P. II 38/1.

29. The *Blue and Gold* was added by Whistler for the 1892 Goupil exhibition. In a letter to William Graham, written in 1877, Whistler refers to it as *Nocturne in Blue and Silver No. 5*. Andrew McLaren Young, Catalogue of the Arts Council Exhibition, 'James McNeill Whistler', London and New York 1960, p. 56.

30. Tissot had been a student in Paris at the same time as Whistler. In the 1860s he shared the craze for orientalia. He left for London after the 1871 Paris Commune. From notes in Alan Cole's diary, he was obviously much in Whistler's company during the 1870s. Evidently the British Press was aware of the closeness between the two artists. There is a delightful review of the Royal Academy of 1874 in the *Daily Telegraph*, 21 May 1874. The critic refers to Whistler in his etchings as the 'Claude of Old Chelsea' and the 'Cuyp of Rotherhithe' and adds, 'so may we qualify Mr. Tissot as the Watteau of Wapping.'

31. J. Meier-Graefe, *Modern Art*, London 1908, vol. II, p. 208.

32. George Moore, *Modern Painting*, London 1893, p. 6.

33. *Cremorne Gardens No. 1* (Plate 55), now at the Fogg Museum, Cambridge, Massachusetts, appears to be the result of an exciting but unresolved experiment, with a liquid wash of blue-grey paint apparently dripped over the canvas, and just a few highlights of red, orange and yellow. It must be said that from the illustration that appears in the Pennells' *Life*, I, p. 164, it is clear that the painting has darkened considerably with time.

4. The Artist in Society (pp. 77–92)

1. 'Letters of Whistler's Mother', *Atlantic Monthly*, September 1925, p. 319. Letter dated 10 February 1864.

2. Rossetti, *Papers*, p. 196. Dated 2 November 1866.

3. Library of Congress, Washington, Pennell Correspondence, vol. 281, letter 641.

4. Pennell, *Life*, I, p. 137.

5. Bénédite, *Gazette des Beaux-Arts* XXXIV, p. 236. Also see J. Sandberg, 'Japonisme and Whistler', *Burlington Magazine*, November 1964, p. 500.

6. 'The Work of James McNeill Whistler', *Edinburgh Review*, no. 412, April 1905, p. 454.

7. J. K. Huysmans, *Certains*, Paris 1889, p. 68.

8. Pennell, *Life*, I, p. 90.

9. Pennell, *Life*, I, p. 172.

10. The White House was intended to accommodate not only Whistler but also a small school. The top floor had a large studio. There was a second, drawing room studio, five bedrooms, dining room and kitchen. The plans for the White House led to other and grander commissions for Godwin. Archie Stuart Wortley bought three plots of land adjoining the White House, while Frank Miles commissioned a slightly smaller house. Of this latter, Godwin wrote in the *Building News*, 7 March 1879: 'when the first elevation was sent to the Board of Works our respected friend, Mr. Vulliamy said, "Why, this is worse than Whistler's."' Douglas Harbron, *The Conscious Stone*, London 1949, pp. 125–8.

11. This incident is related by Horace Gregory in *The World of James McNeill Whistler*, London 1959, p. 118.

12. Glasgow University, B.P. II 23/26. Letter dated 17 July 1877.

13. Whistler's reaction to the quarrel is made quite apparent in the cruel caricatures he produced of Leyland: *The Gold Scab or Eruption in Frilthy Lucre* is the most renowned (Plate 68). It describes Whistler's long-suffering patron as a demon in a frilled

shirt, exuding gold sovereigns from every pore, seated upon the White House.

14. This letter, written to Duret in about 1885, is now in the Archives of the Metropolitan Museum of Art, New York, letter 16.

15. Catalogue of an exhibition of Whistleriana, 'Relics and Works of Art', Chelsea Public Library, 1948, no. 27. It is not clear for whom, of several patrons, these instructions were intended. At the end of 1881 he was occupied with schemes for his brother. In 1884, on his marriage, Oscar Wilde took a house in Tite Street which he invited Whistler and Godwin to decorate. And among others who commissioned Whistler to devise colour schemes were Heinemann, Sarasate, Sickert and Mrs D'Oyly Carte.

16. Walter Hamilton, *The Aesthetic Movement in England*, London 1882, p. 141.

17. Library of Congress, Washington, Pennell Correspondence, vol. 280, no. 371. Letter dated December 1907. The following quotations are from the same source.

18. Archives of the Metropolitan Museum of Art, New York, letter 5. From the butterfly with which he concludes, Whistler must have written this in about 1881–2.

19. See note 17. A copy of 'Rainbow Music' accompanied the letter to the Pennells, no. 373.

20. Library of Congress, Washington, Pennell Correspondence, vol. 281. Alan S. Cole's diary entry 26 May 1881.

21. Pennell, *Life*, I, p. 301.

5. The Red Rag and the Ruskin Trial (pp. 93–104)

1. *Art Journal*, 1873, p. 367. The exhibition had opened in November 1872.

2. First published in the *World*, 22 May 1878. Republished in *The Gentle Art of Making Enemies*, London 1890, p. 126. The following quotations are from the latter source.

3. This painting is now in the Fogg Art Museum, Cambridge, Massachusetts. There are notes in the Archives to the effect that it was shown at the Dudley Gallery in the winter of 1872. The three paintings shown that year were the *Symphony in Grey and Green: the Ocean*, a *Nocturne in Blue and Silver* and a *Nocturne in Grey and Gold*. Since contemporary Press reviews are both scathingly brief and vague, there is no definite identification, but it seems quite likely that the last Nocturne was, indeed, *Chelsea Snow*.

4. When presenting *La Cigale* in Paris in 1877, Meilhac and Halévy apparently obtained the co-operation of Degas, for there it was Impressionism proper that was lampooned, and not the work of that British symbol of modernism, Whistler. Theodore Reff, 'Degas and the Literature of his Time', II, *Burlington Magazine*, October 1970, p. 687.

5. John Hollingshead, *The Grasshopper. A Drama in Three Acts. Adapted from 'La Cigale' by MM. Meilhac and Halévy*, London 1877. The following quotations are taken from this source.

6. Theodore Reff, *Burlington Magazine*, p. 687.

7. Pennell, *Life*, I, p. 210.

8. The portrait of Irving must have been shown in an earlier state than the one we now see, as Whistler reworked it heavily in the late 1880s.

9. Sidney Colvin, *Memories and Notes*, London 1921, p. 42.

10. Published 2 July 1877. The Ruskin Galleries, Bembridge School, Isle of Wight, have Ruskin's indexing copy of *Fors*, neatly labelled 'Whistler, Mr., impudence of.'

11. Ruskin was, in any case, accustomed to criticizing vigorously the work of artists of whom he disapproved, and his attack on Whistler undoubtedly would have sunk into oblivion had not the painter sued him. As early as 1856 *Punch* published a poem by a 'Perfectly Furious Academician':

> I takes and paints
> Hears no complaints
> and sells before I'm dry,
> Till savage Ruskin
> He sticks his tusk in
> Then nobody will buy.

James S. Dearden (ed.), *The Professor. Arthur Severn's Memoir of John Ruskin*, London 1967, p. 111.

12. Mentioned in a letter written by Swinburne to Ruskin in 1865. Lang, *Swinburne Letters*, I, p. 130.

13. John Ruskin, *Stones of Venice*, London 1951–3.

14. John Ruskin, *Aratra Pentelici*, London 1872.

15. Ruskin first published an essay on 'Pre-Raphaelitism' in 1851. It was, in fact, largely devoted to Turner. He followed this with lectures on the subject, including one delivered in Edinburgh on 18 November 1853.

16. W. M. Rossetti, 'Pre-Raphaelitism; Its Starting Point and its Sequel', *Art Monthly Review*, vol. 1, no. 8, 31 August 1876, p. 104.

17. George Birkbeck Hill (ed.), *Letters of Dante Gabriel Rossetti to William Allingham, 1854–70*, London 1897, p. 272.

18. Dearden, *The Professor*, p. 108.

19. Dearden, *The Professor*, p. 114.

20. Dearden, *The Professor*, p. 112. It was not until three years later that Gilbert cast the composite Whistler–Oscar Wilde character Reginald Bunthorne.

21. Quoted by R. de la Sizeranne in *English Contemporary Art*, translated by H. M. Poynter, London 1898, p. 297.

22. John Ruskin, *The Laws of Fésole*, London 1877.

23. From the third of a series of *Lectures on Art*, delivered to the University of Oxford in 1870.

24. James McNeill Whistler, *The Gentle Art of Making Enemies*, London 1890, p. 126.

25. Pennell, *Life*, I, p. 232.

26. The Pennells mention this in the *Whistler Journal*, Philadelphia 1921, p. 321. But, despite some research, no such papers have come to my notice.

27. 'The Work of James McNeill Whistler', *Edinburgh Review*, no. 412, April 1905, p. 454.

28. This is now in the Collection at Glasgow University.

29. Quoted by J. H. Buckley, *The Victorian Temper. A Study in Literary Culture*, London 1952, p. 159.

30. Glasgow University, B.P. II 2(p) 144. Letter dated 4 March 1892.

31. Whistler used this comment in *Gentle Art*, p. 12.

32. Glasgow University, B.P. II 2(p) 146. Letter dated 5 March 1892.

33. Proust was working on translations of Ruskin from about

1899 to 1906.

34. In later life when, as an invalid, Proust scarcely ventured beyond his door, he nevertheless visited the Whistler Memorial Exhibition. It is clear too that the character of Elstir in *A la Recherche du Temps Perdu* owes something to Whistler.

35. Proust was describing Whistler's reactions to Ruskin in a letter written to a friend in 1904. Marie Nordlinger-Riefstahl, *Marcel Proust and His Time*, Manchester 1955, p. 60.

6. Venice and London (pp. 105–116)

1. Whistler had planned to travel to Venice as early as 1862, with Jo. In the mid 1870s he was still intending to make the trip. In a letter to Whistler written in August 1876, Leyland remarked, 'I don't think I shall be in town again for some time, probably not before you start for Venice.' Glasgow University, B.P. II 23/37.

2. Glasgow University, B.P. II 13/30. Letter dated 15 February 1882.

3. Marcel Proust, *The Bible of Amiens*, Paris 1904, p. 245, footnote.

4. Pennell, *Life*, I, p. 271.

5. The *Globe*, 3 December 1880.

6. *Daily News*, 31 January 1881.

7. J. A. Mahey, 'The Letters of James McNeill Whistler to George A. Lucas', *Art Bulletin*, September 1967, p. 247.

8. *Country Gentleman*, 5 February 1881.

9. P. G. Hamerton, 'Thoughts about Art', *A Painter's Camp in the Highlands*, London 1862, vol. II, p. 169.

10. John Rewald (ed.), *Camille Pissarro. Letters to Lucien*, London 1943, p. 22. Letter dated 28 February 1883.

11. Octave Maus, *Trente Années de Lutte pour l'Art, 1884–1914*, Brussels 1926, p. 55.

12. *The Times*, 3 December 1884.

13. P. G. Hamerton, *A Painter's Camp*, II, p. 145.

14. This is just one verse from a lengthy piece, written in Gilbert and Sullivan rhythm, and published in *Fun* as 'The Sufferings of an Old Suffolk Streeter'. Other verses are quoted by Ludovici in 'The Whistlerian Dynasty at Suffolk Street', *Art Journal*, 1906, p. 195.

15. The *World*, 3 April 1887.

16. *Art Journal*, 1888, p. 222.

17. Ludovici, *Art Journal*, 1906, p. 195.

18. Glasgow University, B.P. II M/106.

19. In 1887, for example, Whistler contributed fifty works, small oils, watercolours and pastels, to the international exhibition staged by Georges Petit in May. Others who were showing included Monet, Morisot, Pissarro, Renoir, Rodin and Sisley.

20. Glasgow University, B.P. II M/107. Letter dated 25 October 1887.

21. See, for example, *Letters and Journals of Lady Eastlake*, London 1895, p. 158. Notes made on 9 May 1861. And, over a decade later, J. J. Jarvis, 'The Nude in Modern Art and Society', *Art Journal*, 1874, p. 65.

22. *The Times*, 18 July 1903.

23. *Pall Mall Gazette*, 11 June 1888.

7. The Ten o'Clock Lecture (pp. 117–122)

1. 'Whistler *v.* Ruskin. Art and Art Critics', republished in *Gentle Art*, p. 32.

2. Library of Congress, Washington, Pennell Correspondence, vol. 281. Alan S. Cole's diary, entry 24 October 1884.

3. See a letter written to Mrs George Lewis, March 1882. Rupert Hart-Davis (ed.), *Letters of Oscar Wilde*. London 1962, p. 39.

4. Pennell, *Life*, II, p. 42.

5. See, for example, Oscar Wilde, *Miscellanies*, London 1908, p. 30.

6. Glasgow University, B.P. II 32/1.

7. Glasgow University, B.P. II 32/15. Letter dated 21 February 1885.

8. These and the following quotations from the 'Ten o'clock Lecture' are taken from *Gentle Art*, pp. 135–59.

9. W. E. Henley, *Views and Reviews: Essays in Appreciation*, London 1902, p. 164.

10. *New York Times*, 24 June 1888. There are numerous other suggestions, both in private correspondence and in the Press, that Whistler was expected in America at this time.

11. Carl P. Barbier, *Correspondance: Mallarmé–Whistler*, Paris 1964, p. 14.

12. Barbier, *Correspondance*, p. 6. Letter dated January 1888.

13. See A. C. Swinburne, *Letters to Mallarmé*, ed. Edmund Gosse, privately printed, London 1913.

14. Barbier, *Correspondance*, p. 8. Letter dated 2 March 1888.

15. Barbier, *Correspondance*, p. 14. Letter dated 25 May 1888.

16. See, for example, Glasgow University, B.P. II s/72. Letter from Arthur Stevens, dated summer 1888. Also Archives of the Freer Gallery of Art, Washington, letter from Lady Campbell, dated 3 July 1888.

17. Barbier, *Correspondance*, p. 16. Letter written from London, May 1888.

18. The publication of Wilde's review was followed by intermittent skirmishes, conducted in the columns of various journals, during the subsequent months. Wilde grew increasingly bitter and even accused Dowdeswell of taking to Whistler's own dictation the first appreciative article to appear in an important English magazine, the *Art Journal*, in April 1887. See *Gentle Art*, p. 236.

19. *Gentle Art*, p. 251.

20. See facsimile ms. printed in 1913, in the British Museum.

21. Glasgow University, B.P. II 38/37. There are several drafts of Whistler's reply now in the Collection at Glasgow.

8. The Portraits of the Later Years (pp. 123–138)

1. Paul Gsell, 'L'Art Français Moderne Apropos du Salon du Champ de Mars', *Revue Bleue* XLIX, no. 24, p. 760, 11 June 1892.

2. Renoir mentioned this meeting in a letter to Duret. *L'Amour de l'Art*, February 1938. For this information I am indebted to John House.

3. Glasgow University, B.P. II M/159. Letter dated 22 November [1880].

4. Letter from Whistler to Fantin. This opens with a word of regret for the death of Baudelaire, which took place on 31 August 1867, thus giving a guide to the date. Bénédite, *Gazette des Beaux-Arts* XXXIV, p. 233.

5. See Chapter 1, note 17.

6. Edmund Bazire, *Manet*, 1884. Quoted by Courthion and Cailler, *Portrait of Manet*, p. 42.

7. Swinburne, *Letters to Mallarmé*.

8. Pennell, *Life*, II, p. 261.

9. Archives of the Metropolitan Museum of Art, New York, letter 12.

10. Archives of the Metropolitan Museum of Art, New York, letter 18.

11. Jonathan Mayne (ed. and trans.), *Charles Baudelaire. Art in Paris 1845–62: Salons and Other Exhibitions*, London 1965, p. 118.

12. Théodore Duret, *Histoire de James McN. Whistler et de son Œuvre*, Paris 1904.

13. Glasgow University, Reserve Collection, B.P. II 12/34.

14. Maus, *Lutte pour l'Art*, p. 48.

15. *Pall Mall Gazette*, 2 February 1889.

16. Pennell, *Life*, I, p. 302. The disagreement took place in 1882. It obviously upset Whistler, but the association must have been re-established: by the 1890s their correspondence was resumed.

17. Glasgow University, B.P. II 2(p) 154. Letter dated 19 March 1892.

18. Denys Sutton, *James McNeill Whistler*, London 1966, p. 45.

19. Barbier, *Correspondance*, p. 123.

20. E. and J. de Goncourt, *Journal, Mémoires de la Vie Littéraire*, ed. R. Ricatte, 22 vols, Monaco 1956, tome XVIII, 1891–2, p. 53.

21. De Goncourt, *Journal*, XVIII, p. 53.

22. Rewald, *Pissarro Letters*, p. 238.

23. Library of Congress, Washington, Pennell Correspondence, vol. 281. Alan Cole's diary entry 26 August 1881.

24. Library of Congress, Washington, Pennell Correspondence, vol. 291, no. 2738. The date of the visit was probably early 1899, when Whistler was in both Rome and Florence.

25. A. J. Eddy, *Recollections and Impressions of James Abbott McNeill Whistler*, London 1903, p. 191.

26. J. J. Cowan, *From 1846 to 1932*, privately printed, Edinburgh 1933, pp. 156, 168.

9. Crisis and Fulfilment (pp. 139–153)

1. Glasgow University, Revillon 1955, H/11. Letter dated April 1897.

2. Whistler wrote this article on Mallarmé with Herbert Vivian, under the title 'Brouhaha'. Barbier, *Correspondance*, p. 75, note 2.

3. Arthur Symons, *Figures of Several Centuries*, London 1916, p. 861.

4. 'For we must have the Nuance still, /Not Colour, only the nuance! /For shades alone can affiance /Dream unto dream, of flute to viol!' Joanna Richardson (ed. and trans.), *Verlaine*, Middlesex 1974, p. 173.

5. 'A pale sky, over a world dying of decrepitude, will perhaps depart with the clouds: the rags of the sunset's worn-out purple are fading in a river sleeping on the horizon covered in sunbeams and water.' Anthony Harley (ed.), *Mallarmé*, Middlesex 1965, p. 117.

6. George Moore, *Confessions of a Young Man*, London 1937, p. 46. Poe too had declared a long poem to be 'simply a flat contradiction in terms'.

7. Pourville was a spot Whistler visited fairly often. There is a letter, dated 10 August 1899, from Whistler at Pourville to his pupil Inez Bate, in which he mentions that he would like to do a sea piece. From the freedom and from the style of the butterfly, this painting would seem to date from about that time.

8. *Art Monthly Review*, vol. 1, no. 9, 30 September 1876, p. 117. This was a translation of an article which first appeared in *La Renaissance Littéraire et Artistique* in April 1874.

9. The manifesto of a member of the Impressionist group, as devised by Mallarmé, indicates his own sympathy for the ideals of the 'new art', as he calls it:

> That which I preserve through the power of Impressionism is not the material portion which already exists, superior to any mere representation of it, but the delight of having re-created nature touch by touch . . . I content myself with reflecting on the clear and durable mirror of painting, that which perpetually lives yet dies every minute.

10. Barbier, *Correspondance*, p. 199.

11. Symons, *Figures of Several Centuries*, p. 858.

12. Rewald, *Pissarro. Letters*, p. 204. Letter dated 2 October 1892.

13. Glasgow University, Revillon 1955, W/60.

14. Glasgow University, Revillon 1955, W/64.

15. Glasgow University, B.P. II 13/56.

10. Friends and Followers (pp. 154–173)

1. A. S. Hartrick, for example, when elected to the Chelsea Arts Club relates that the first person he encountered there was Walter Greaves, whom he first mistook for Whistler. A. S. Hartrick, *A Painter's Pilgrimage through Fifty Years*, Cambridge 1939, p. 132.

2. Mortimer Menpes, 'Reminiscences of Whistler', *Studio* XXIX, 1903, p. 245.

3. Mortimer Menpes, *Studio* XXIX, p. 246.

4. Mortimer Menpes, *Studio* XXIX, p. 245.

5. Mortimer Menpes, *Whistler as I Knew Him*, London 1904.

6. See Wendy Baron, 'Sickert's links with French Painting', *Apollo*, March 1970, p. 186.

7. In August 1895, for example, Oswald Sickert wrote to Edward Marsh that his brother Walter, Degas and Whistler were all in Dieppe. See Christopher Hassall, *Edward Marsh: Patron of the Arts. A Biography*, London 1950, p. 59.

8. A. S. Hartrick, *Painter's Pilgrimage*, p. 145.

9. Quoted by Wendy Baron, 'Sickert: a Chronological and Critical Study of his Development', Ph.D. thesis, Courtauld Institute, London 1966.

10. See Chapter 9, note 9.

11. Frank Rutter, *Théodore Roussel*, London 1926.

12. My thanks to Guy Roussel, the painter's grandson, for access to these effects.

13. John Lavery, *The Life of a Painter*, London 1940, p. 109.

14. See Bruce Laughton, 'Steer and French Painting', *Apollo*, March 1970, p. 210, for a detailed discussion of the development of these early paintings.

15. Bruce Laughton, 'The British and American Contribution to Les XX, 1884–93', *Apollo*, 86, 1967, p. 372.

16. Rewald, *Pissarro Letters*.

17. Bruce Laughton, *Philip Wilson Steer*, London 1971, p. 6.
18. Bruce Laughton, in *Steer*, p. 113, reproduces a brief autobiography written by Rose Pettigrew. She relates how she often posed for Whistler in the 1880s, for his 'charming little pastels'. He was apparently upset when Rose could only sit four days a week, instead of five; she spent one day modelling for Steer. She relates Mrs Whistler's reaction to this, presumably a reflection of Whistler's own: 'She said "He's old enough to be your father, and will never make a name" . . . she said that Sickert was much more clever than Steer.' This was, of course, at a time when Whistler and Sickert were close friends, so the opinion is not surprising. It is, nevertheless, interesting and indicates the gap there always was between Steer and Whistler.
19. See A. Thornton, *The Diary of an Art Student of the Nineties*, London 1938, p. 8.
20. Glasgow University, B.P. II S/53.
21. Glasgow University, B.P. II S/52. Letter dated 22 June 1897.
22. Of this group of painters James L. Caw wrote, 'the most powerful and individual factor in the formulation of their artistic aims and technical methods has been the genius of Mr. Whistler.' 'A Phase of Scottish Art', *Art Journal*, 1894, p. 75. Walton was particularly active in promoting the purchase of the *Carlyle* by the Glasgow Corporation in 1891.
23. Whistler had previously proposed, when President of the Society of British Artists, that no member of the Society should continue to be also a member of any other artistic society. When this was not accepted he suggested—again unsuccessfully—that no member of any other society should serve on the selection or hanging committee. Glasgow University, B.P. II b/44. Letter dated 12 April 1898.

11. Writers and Critics: the Impact of Whistler
(pp. 174–179)

1. Of these tomes Sickert wrote to Heinemann, 'We will let them scold their way solidly through 300 pages. And when their portrait of my fascinating and impish master in the character of the American Ecce Homo is complete, you and I might do a readable little monograph on the subject.' Library of Congress, Washington, Pennell Correspondence, letter 4238.
2. Walter Sickert, 'Abjuro', *Art News*, 3 February 1910, p. 104.
3. Walter Sickert, 'Idealism', *Fortnightly Review*, 12 May 1910, p. 217. One of the reasons for this image of Whistler as a dining room dandy must have been his association with the aesthetic movement of the 1880s and 1890s, which by 1910 was vigorously rejected.
4. Walter Sickert, 'Impressionist Forgeries', *Evening News*, 7 March 1927.
5. Alfred Thornton, *The Diary of an Art Student of the Nineties*, London 1938, p. 20.
6. In April 1892 MacColl showed *Umbrellas*, and in November *The Donkey Race* and *Whitby*. From the titles alone one can gather something of MacColl's interest in illustrative subject-matter.
7. D. S. MacColl, *Nineteenth Century Art*, London 1902, p. 24.
8. MacColl, *Nineteenth Century Art*, p. 24.
9. By 1931 MacColl was insisting that Whistler and Ruskin should have seen one another as allies: '. . . the whole point of his

Nocturnes was to reduce contemporary reality to its lowest terms, to a tenuous film, to make warehouses look like palaces and gas lamps like jewels. Whistler was a mediator, after all, between fancy and realism.' *Confessions of a Keeper and other papers*, London 1931, p. 15.
10. MacColl, *Confessions of a Keeper*, pp. 90, 99.
11. George Moore, *Confessions of a Young Man*, London 1937, p. 229.
12. George Moore, *Modern Painting*, London 1893, p. 6.
13. Moore, *Modern Painting*, p. 82.
14. George Moore, *Impressions and Opinions*, London 1913, p. 209.
15. Frank Rutter, *Art in My Time*, London 1933, p. 15.
16. Pennell, *Life*, II, London 1908, p. 177.
17. R. A. M. Stevenson, *Velazquez*, new edn London 1962, p. 47.
18. R. A. M. Stevenson, *Velazquez*, p. 79.
19. R. A. M. Stevenson, *Velazquez*, pp. 129, 136.
20. Denys Sutton (ed.), *Letters of Roger Fry*, London 1972, p. 312. Letter dated 16 February 1909.
21. Roger Fry, *Nation*, 2 August 1913.
22. Frank Rutter, *James McNeill Whistler. An Estimate and a Biography*, London 1911, p. 72.

Selected Bibliography

Whistler's background
Baldry, A. L., *Albert Moore*, London, 1894.
Barbier, Carl P. (ed.), *Correspondance: Mallarmé–Whistler*, Paris, 1964.
Baron, Wendy, *Sickert*, London and New York, 1973.
Blanche, J. E., *Portraits of a Lifetime*, Paris, 1936.
Boime, A., *The Academy and French Painting in the Nineteenth Century*, London and New York, 1971.
Buckley, J. H., *The Victorian Temper. A Study in Literary Culture*, London, 1952. Illustrated edn Cambridge, Mass., 1969, and Oxford, 1970.
Cooper, D., *The Courtauld Collection. A Catalogue and Introduction*, London, 1954.
Courthion, P. and Cailler, P. (eds), *Manet Raconté par Lui-même et par ses Amis*, Geneva, 1953. Trans. by Michael Ross as *Portrait of Manet by Himself and His Contemporaries*, London, 1960.
Du Maurier, Daphne (ed.), *The Young George du Maurier. A Selection of his Letters, 1860–7*, London, 1951.
Fry, Roger, *Vision and Design*, London, 1921.
Guérin, M. (ed.), *Lettres de Degas*, Paris, 1945. English trans. by M. Kay, Oxford, 1947.
Hamerton, P. G., *A Painter's Camp in the Highlands*, 2 vols, Cambridge, 1862.
Hamilton, Walter, *The Aesthetic Movement in England*, London, 1882. Reprinted New York, 1936.

Hartrick, A. S., *A Painter's Pilgrimage through Fifty Years*, Cambridge, 1939.

Jullien, A., *Fantin-Latour, sa Vie et ses Amitiés*, Paris, 1909.

Lang, C. Y. (ed.), *Algernon C. Swinburne. Letters*, vol. 1 1854–69, vol. 2 1869–75, New Haven, Connecticut, and London, 1959.

Laughton, Bruce, *Philip Wilson Steer, 1860–1942*, Oxford, 1971.

Lavery, J., *The Life of a Painter*, London, 1940.

Lindsay, J., *Gustave Courbet. His Life and Art*, Bath, 1973.

Ludovici, A., *An Artist's Life in London and Paris*, London, 1926.

MacColl, D. S., *Nineteenth Century Art*, London, 1902.

Mayne, J. (ed.), *Charles Baudelaire. Art in Paris 1845–62 : Salons and Other Exhibitions*, London and New York, 1965.

Moore, George, *Modern Painting*, London, 1893. Enlarged edn London, 1898.

Pater, Walter, *Studies in the History of the Renaissance*, London, 1873. New edn with title *The Renaissance. Studies in Art and Poetry*, London, 1877.

Quinn, A. H. (ed.), *Complete Poems and Stories of E. A. Poe with Selections from his Critical Writings*, New York, 1946.

Rewald, J. (ed.), *Camille Pissarro. Letters to Lucien*, London, 1943.

Rossetti, W. M., *Rossetti Papers, 1862–1870*, London, 1903. Reprinted New York, 1970.

Rothenstein, W., *Men and Memories*, London, 1931–2 (2 vols) and New York, 1931 (3 vols).

Ruskin, John, *The Stones of Venice*, London, 1851–3 and New York, 1865.

Rutter, Frank, *Evolution in Modern Art*, London, 1932.

Sitwell, Osbert (ed.), *A Free House! or The Artist as Craftsman*, London, 1947.

Spencer, Robin, *The Aesthetic Movement. Theory and Practice*, London and New York, 1972.

Stevenson, R. A. M., *The Art of Velasquez*, London, 1895. New edn with title *Velasquez*, 1899. Edited by Denys Sutton and T. Crombie as *Velazquez*, London and Chester Springs, Pennsylvania, 1962.

Swinburne, Algernon C., *Essays and Studies*, London, 1875.

Symons, A., *Studies in the Seven Arts*, New York and London, 1906.

Thornton, A., *The Diary of an Art Student of the Nineties*, London, 1938.

Whistler, James McNeill, *The Gentle Art of Making Enemies*, London, 1890. Reprinted New York, 1967, and London, 1968.

Biographical and critical studies of Whistler

Duret, Théodore, *Histoire de J. McN. Whistler et de son Œuvre*, Paris, 1904. English trans by Frank Rutter, London and Philadelphia, 1917.

Eddy, A. J., *Recollections and Impressions of James Abbott McNeill Whistler*, London and Philadelphia, 1903.

Gregory, Horace, *The World of James McNeill Whistler*, London, New York and Toronto, 1959.

Holden, Donald, *Whistler. Landscapes and Seascapes*, London and New York, 1969.

Kennedy, E. G., *The Etched Work of Whistler*, New York, 1910.

Laver, James, *Whistler*, London, 1930. Revised edn 1951.

Levy, Mervyn, *Whistler Lithographs*, London, 1975.

McMullen, Roy, *Victorian Outsider. James McNeill Whistler*, London and New York, 1974.

Menpes, Mortimer, *Whistler as I Knew Him*, London, 1904.

Pearson, Hesketh, *The Man Whistler*, London and New York, 1952.

Pennell, Elizabeth R. and Joseph, *The Life of James McNeill Whistler*, 2 vols, London and Philadelphia, 1908.
The Whistler Journal, Philadelphia, 1921.

Rutter, Frank, *James McNeill Whistler. An Estimate and a Biography*, London, 1911.

Sickert, B., *Whistler*, London and New York, 1908.

Sutton, Denys, *Nocturne: the Art of James McNeill Whistler*, London, 1963, and Philadelphia, 1964.
James McNeill Whistler. Paintings, Etchings, Pastels and Watercolours, London and New York, 1966.

Way, T. R., *Mr. Whistler's Lithographs*, London, 1896. Revised edn London and New York, 1905.

Way, T. R. and Dennis, G. R., *The Art of James McNeill Whistler. An Appreciation*, London, 1903.

Exhibition catalogues

The Early Years of the New English Art Club, 1886–1918, Birmingham City Museum and Art Gallery, U.K., 1952.

James McNeill Whistler (A. McLaren Young), Arts Council, London, Sept. 1960, New York, Nov. 1960.

The Influence of Whistler, Anthony d'Offay Gallery, London, Nov. 1966.

James McNeill Whistler (Frederick A. Sweet), Art Institute of Chicago, 1968.

Romantic Art in Britain (A. Staley), Philadelphia Museum of Art, 1968.

James McNeill Whistler, Etchings, Dry Points and Lithographs, Colnaghi's, London, Nov. 1971.

From Realism to Symbolism, Whistler and his World (A. Staley), Wildenstein, New York, and Philadelphia Museum of Art, 1971.

British Art 1890–1928 (Denys Sutton), Columbus Gallery of Fine Arts, Ohio, Feb. 1971.

Index